MUTE MAGA ZINE

GRAF IC DESIG

C000242134

MUTE MAGAZINE

GRAPHIC DESIGN

INTRODUCTION BY ADRIAN SHAUGHNESSY

PAULINE VAN MOURIK BROEKMAN
SIMON WORTHINGTON
DAMIAN JAQUES

eightbooks

eightbooks

Published in 2008 by
Eight Books Limited
22 Herbert Gardens
London NW10 3BU
t/f + 44 (0)20 8968 1866
info@8books.co.uk
www.8books.co.uk

www.metamute.org

A catalogue record for this book is available from the British Library

ISBN 978 0 9554322 2 4

Printed in China

CONTENTS

INTRODUCTION: FLICKING THROUGH THE PAGES OF CULTURAL HISTORY 7

THE BROADSHEET 16

THE GLOSSY 32

PERFECT BOUND 76

GOING COFFEE TABLE 100

HYBRID: WEB AND PRINT 128

ACKNOWLEDGEMENTS 144

INTRODUCTION

FLICKING THROUGH THE PAGES OF
CULTURAL HISTORY ADRIAN SHAUGHNESSY

You could learn just about everything there is to know about graphic design from a close study of magazines. In the pages of the great magazines it is possible to map a micro history of typography, art direction, illustration, photography, and the ongoing synthesis of editorial intent with visual design. Many of the dominant trends in contemporary design can be traced back to developments in magazine design: remove magazines from the frame, and the story of graphic design becomes a bit threadbare.

Even today, as print is at least partially eclipsed by digital media, magazines provide us with a forensic glimpse into the way graphic design is being changed from a static craft into a fluid, electronic skill set. Few magazines exist as print-only entities. Commercial publishers see online ad revenues soaring. They see consumers accessing online content via hand-held devices. Some of them even notice that web publishing is greener than print publishing. Given that, as noted by media commentator Jeff Jarvis *'All online is a freesheet,'* it is hard to imagine, in the current climate, a magazine publisher bothering to produce a printed edition when planning a new title. If that sounds far fetched, look at what's happening to the record business: it is being transformed by the move to digital.

But the fate of commercial printed magazines is not in the hands of publishers. It is the advertisers and the big brand owners who dictate the future, and they are already moving their millions online. When they decide that printed magazines are no longer an effective way to 'capture eyeballs,' mags will lose their main source of income. And when that happens, our news-stands will start to look markedly different. For designers the consequence of this is that tomorrow's magazine designer needs to be adept at designing content which can be delivered on multiple platforms. The static page of the magazine – the canvas for many of graphic design's finest moments – is slowly becoming a relic of another era: a pre-electronic era when print was the pre-eminent medium.

The modern magazine emerged in the 1930s with the rise of cheap and fast colour printing. *Fortune* magazine appeared in the US in 1930. It has a claim to be the first magazine of the modern era, but it nevertheless showed its kinship with traditional newsprint and books by maintaining a strict separation between text and image. At the same time, the recently appointed art director of *Vanity Fair* – Mehemed Agha – became the first art director to use a double-page photo spread, and the first to use full-bleed photographs. Agha's contribution to the magazine was recognised as so important that he had his name added to the colophon. In 1932, as art director of *Vogue*, Agha commissioned the first magazine cover with full-colour photography.

One of Agah's protégés was Cipe Pineles. In 1942 she was made art director of *Glamour* magazine, and became the first female art director of a mass circulation journal. She was known for her radical cropping of images and her shrewd use of the leading artists, photographers and designers of the day. In 1948 she became the first woman member of the New York Art Directors club.

The doyen of early magazine design was Alexey Brodovitch. In his *History of Graphic Design*, Philip Meggs writes: *'Brodovitch taught designers how to use photography. His cropping, enlargement, and juxtaposition of images and his exquisite selection from contact sheets were all accomplished with extraordinary intuitive judgment.'* In 1934, Brodovitch was made art director of *Harper's Bazaar*. A Brodovitch layout

offered tension and balance in a way that has rarely been bettered, and which, more than half a century later, has hardly dated.

In the 1940s, Paul Rand (at *Direction* magazine) showed the impact of European Modernism – and Modern Art – on American designers. The pioneering American art director Lester Beale, and the German-born Will Burtin (a refugee from Nazi Germany and the husband of Cipe Pineles), both art directed *Scope*, and helped develop a new visual syntax for magazines by synthesising photography, text and illustration into a style that we recognise today as a template for intelligent, information-driven publication design.

In the early 1960s, George Lois and Henry Wolf's concept-led photographic covers for *Esquire* gave birth to the modern commercial magazine cover. Elsewhere, the underground press reflected the massive countercultural upheaval that sent tremors through the tectonic plates of Western society. As Steven Heller has noted, this eruption of guerrilla publishing was *'both influential and threatening. Government agencies in America, including the justice department, the armed forces, the FBI and the police, declared these papers contraband. Some legislators called for investigations, and a few editors were legally harassed because they challenged convention with off-kilter ideas and unacceptable subversive words and graphics.'*

The Underground press had burned itself out by 1973, but the heterodox 'look' of the numerous magazines and newspapers – what Heller calls the *'psychedelic lettering, rainbow split-fountain colour printing, satiric collages and ribald comic drawings'* – was to have a decisive impact on visual communication, and psychedelic imagery was to saturate pop culture to an unprecedented degree.

In the Britain of the 1960s, the white heat of countercultural activity and the liberalising forces that reverberated through drab, postwar society, affected mainstream magazines. The UK even had its own underground press scandal – the *Oz* obscenity trial has passed into national folklore. But it was magazines like *Nova* and the *Sunday Times Colour Magazine*, with their sophisticated art direction and photography, that were to have a lasting effect on both the style and content of magazines in the coming decades.

In the 1970s computerised typesetting and improvements in reproduction technology meant that magazines became slick and professional. *Rolling Stone* emerged from its hippie origins in San Francisco to cater for the baby boomer generation's leisure and cultural interests. It boasted sharp art direction by Tony Lane and spirit-of-the-age photography by Annie Liebowitz.

But by far the most influential magazine designer of the 1980s was the British designer Neville Brody. As art director of *The Face*, Brody's rise to prominence coincided with the 1980s' style explosion. For many observers, Brody was one of the instigators of the 'designer decade's' style fixation, although he was later to renounce stylism in favour of design with a social purpose. Yet there's no question that Brody's Constructivist-inspired layouts and his use of ultra-cool photography were to turn him into the first graphic design superstar. He was written about and lauded by the style press, and in 1988, the V&A Museum in London gave him a solo exhibition. In the USA, Tibor Kalman stirred up waves of controversy with his iconoclastic work, first for *Interview* magazine, and then later on *Colors* magazine, the maverick publication bankrolled by the Benetton fashion empire.

In 1984 Rudy VanderLans launched *Emigre* in California as a design magazine chronicling the new Mac culture. Many of the designers featured saw legibility as part of graphic design's servility to corporate culture and its increasing anonymity as a tool of communication, and began experimenting with the layering of text and images. As VanderLans pointed out: *'We argued that there was no such thing as neutrality or transparency in design, that all graphic gestures are loaded with meaning. Also, we weren't interested in addressing the needs of multi-national corporations and lowest common denominator audiences.'*

bedecked day-glo and metallic-coated pages were the work of designers John Plunkett and Barbara Kuhr who art directed the magazine until 1998. In its early editions, *Wired*'s focus was on a vague sort of gadget world of cell phones and computer games. But when it started listing FTP sites, news groups, and email addresses, it began to focus on the internet and the imminent dotcom boom.

In the 1990s, commercial magazine publishing became part of the global media explosion. Publishing conglomerates allowed market research to drive both content and design, and heavy-duty TV advertising was deployed to turn us all into mag addicts. But the biggest noise in 1990s' magazine design was caused by designer David Carson. As art director of *Ray Gun*, and through his pioneering use of mutilated text and multi-layered typography, Carson became the most celebrated designer of the decade. Even in the era of the underground press when trippy colours and weird formatting of text were obligatory, it was still possible to read the articles. This wasn't always the case with Carson who famously rendered an entire Bryan Ferry feature in dingbats. He also ran lines of text into the bleed with the result that words were lost. Carson's grunge typography became the dominant style for a brief moment in the mid-90s, but there weren't many authors or publishers who would tolerate Carson's sacrilegious handling of text, and his 'grunge' style became passé and tainted by armies of copyists. *Ray Gun* ceased publishing in 2000.

With the inexorable rise of the internet, the emergent digital culture required a house journal. *Mondo 2000* with its lurid covers had hoisted its flag over this uncertain terrain in the late 1980s. It was described by Erik Davis in his book *Techgnosis* as *'infusing the Prankster psychedelia of the sixties with (over)doses of slacker irony and unrepentant techno-Prometheanism, Mondo 2000 created the demimonde it reported, a kinky pop-up romper room of brain machines, teledildonics, virtual reality games, fetish fashions, electronic dance music, and new designer drugs. It was a rave on paper.'* But like the scene it depicted, *Mondo 2000* didn't last, and its space was colonised by the more sober *Wired*.

Wired appeared in 1993. It was a publication incubated in the California-based IT culture that was heavily influenced by post-hippie techno utopianism – founding executive editor Kevin Kelly had been an editor at the *Whole Earth Catalogue*. Its gaudily

But the 1990s wasn't only about William Gibson-inspired interrogations of the new cyber-culture. This was terrain that was also inhabited by PC World, and the growing number of magazines peddling IT as the dominant force in capitalism and globalisation. This was the terrain of the computer professional: a Microsoft-grey world of business software and infotech boosterism. Was there space for a critical voice in this burgeoning culture? Was there a place for an investigation into the computer's role in art and culture? Was there a place for scepticism and dissent in a Bill Gates-led world of computer evangelism?

Mute magazine was founded in 1994 by Simon Worthington and Pauline van Mourik Broekman: the publication introduced an element of opposition and disaffectedness to the otherwise shiny world of the computing revolution. As the founders note on their website, their intention was to *'discuss the interrelationship of art and new technologies when the World Wide Web was newborn.'* They go on to say: *'As mass participation in computer mediated communications has become more integral to contemporary capitalism, [Mute's] coverage has expanded to engage with the broader implications of this shift.'*

Worthington and van Mourik Broekman were graduates of the Slade and Central St. Martin's schools of art in London, and *Mute* grew out of their activities as students (which, in Worthington's case, had included making an earlier namesake with a different editorial group). The new *Mute* began life as pink newsprint broadsheet, printed on the same presses that produced the Financial Times. In a *Guardian* article ('Sound bytes', 29 September 1997) Andy Beckett noted that Worthington and van Mourik Broekman took along *'a stuck-together A4 thing'* to the paper's printworks, and asked the *FT* to run off *Mute* as part of the machinery's nightly warm-up run.

At first glance, the early newsprint incarnations of *Mute* might be mistaken for a copy of the *FT* – thin columns of text, headlines, page size, and the familiar pink tint of the paper stock (see opposite). But on

introduction

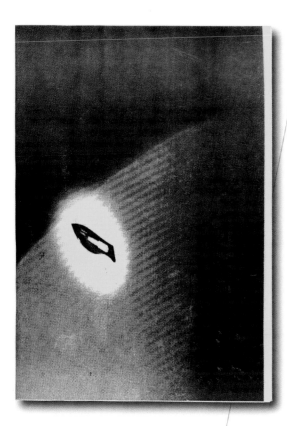

The title Mute was originally conceived for an open-submissions magazine founded at the Slade School of Fine Art – the name referred to the general absence of debate at the school. As if to prefigure the metamorphoses to come, this innovative publication used a different format for each issue, including a saddle-stitched magazine (above), a hard-bound book of woodcut prints and a matchbox. The latter was issued as a multiple and contained 20 miniature art works cut out of one A3 colour laser-copy – new media at the time of production. Mute was edited by Helen Arthur, Steve Faulkner, Daniel Jackson and Simon Worthington from 1989 to 1992.

closer inspection, the masthead and logo ('*a détournement of "mute" in courier type*', to quote van Mourik Broekman) hint at sub-cultural activity. When we look still closer we see unexpected typography and subversive formatting of images. And when we finally read the text, we see that the subject matter is hardly the stuff of *FT* comment: an article entitled 'The Immateriality of the Signifier – The Flesh and the Innocence of Michael Jackson' sets the tone.

For inspiration for these first issues of *Mute*, Worthington and van Mourik Broekman turned not to the new or the futuristic, but instead looked back to history. '*Our idea was that we would "go back" rather than "go forward,"*' explains van Mourik Broekman, '*which seemed to be the message of our competitors/anti-models. Hence using the FT, but also the styling of a much older – if not the first – newspaper, The Daily Courant, which we researched in detail on microfiche at Colindale Newspaper Library.*'

Not only did they find inspiration in this circa 1748 publication, but they appropriated its 'design' and editorial construction, too: '*We approximated its font and basically mimicked the whole thing – down to Simon's and my crackpot editorial, which was an exact repeat of The Daily Courant's first one from the 18th century. We found it uncanny that everything that was in there about launching a new publication when so many others exist, we felt too – albeit expressed in olde worlde English. We found and stole further juicy stuff, namely the exact itemisation of a week's worth of imports and exports from London (this fitted on one double-page spread). We felt all this spoke volumes more than fancy graphics and day-glo colours – though we loved them too, don't get me wrong!*'

By avoiding the pumped-up cyber futurism of *Wired*, Worthington and van Mourik Broekman railed against two of the prevailing editorial nostrums of the day. As van Mourik Broekman explains: '*Firstly, the idea that "radical", "transgressive" and, especially, reader-provocative design was in any way a mirror of the content that it dressed (viz Wired, Ray Gun and countless other* publications du jour which we saw as servicing corporate or otherwise conservative agendas). And secondly, that "new" media and technologies should be announced as radically novel, rather than an extension of existing, older technologies and social processes and, as such, also of their cultural, political and economic logic. The latter point was to be visually evoked, then, by the Financial Times format – the rough message being that partly by dint of requiring enormous investment (just like the railways or telecoms), partly because the freedom they grant is initially to elites, early adopters and professionals of various kinds, new technologies are intertwined with capital/finance and privilege at all levels.*'

In 1997, *Mute* changed its format to that of a conventional A4 magazine (see opposite). In his *Guardian* article, Andy Beckett noted that '*Someone called Damien* [sic], *who is sitting, hung over on a sofa by the window, "is helping with design."*' Damian Jaques was a graduate of Wimbledon School of Art, where he gained a Masters in Printmaking. He was art director and co-founder of *Coil*, a magazine about film and video art. '*With Coil, we wanted to present this material,*' recalls Jaques '*in a way that was more than a record of a show – a catalogue – or to use imagery as purely an illustrative element. It allowed me freedom with the layouts. It taught me a great deal about the subtle relationship between the designer and the "artist", and gave me the experience of dealing with the other aspects of producing a publication – ISSN numbers, selling, working with distributors, etc.*'

Looking for support and advice from other small magazines, Jaques found most of his fellow travellers standoffish with the notable exception of Worthington and van Mourik Broekman. After meeting '*for a beer at the ICA*', Jaques and the *Coil* team moved into *Mute*'s office in Shoreditch. Jaques recalls: '*As Mute was moving to the magazine format from the broadsheet, Simon was interested to get some help with the design. I became more involved with Mute when I decided to leave Coil after I'd designed issue 6. The concept that had stood behind the broadsheet Mute was not replicated with the*

Top: *(Issue 10, 1998) In a highly contentious layout the title of the article is hidden within the ascii text-generated artwork.*
Middle: *(Issue 18, 2000) Geometric elements are thrust into the page design as if from outside the page and combined with flat colour 'clip-art'-derived illustrations.*
Bottom: *(Issue 19, 2001) In this spread the geometric elements create a three-dimensional illusion of a stage, separating the text from the picture.*

magazine and it was, in my opinion, a more spontaneous response – design-wise – to the content.'

Jaques grew up surrounded by music and art. His uncle was the artist Jeremy Moon, and he cites an impressive list of influences: *'Graphic music scores by Cornelius Cardew, as well as early music scores by Monteverdi and others; illuminated manuscripts; the artist Chris Burden; early David Carson (though not his later work); Wolfgang Weingart.'*

Under Jaques' design input, *Mute* began to acquire a sharper, more designerly appearance: he positioned it downwind from the over-branded, perfect-bound sumptuousness of *Wired*, but upwind from the scatter-gun grunge of *Ray Gun*, and the self-conscious designer rhetoric of the then ultra-fashionable mid-90s work of Designers Republic. In the early days of *Mute* Jaques admired **'Dazed, Emigre,** *even* **Wallpaper,** *but not* **Wired,** *it was very much "over there" and too closely aligned to the onward march of big business.'*

Jaques' layouts retained the structure and conventions of magazine layout – headlines, standfirsts, picture captions – but he injected just enough graphic intervention to maintain Mute's maverick status. *'When I was designing* **Coil,** **Ray Gun** *was an influence,'* explains Jaques, *'but not when I was doing* **Mute.** *The processed aesthetic of images and text in* **Ray Gun** *was not appropriate to* **Mute** *especially given that the magazine version had been born out of the broadsheet – it would have been a wrong step or jump and was not right for where* **Mute** *was positioning itself – just like if it had gone down the* **Wired** *high-tech route.'*

In his book *magCulture – new magazine design*, the art director Jeremy Leslie wrote about *Mute*: *'This magazine has developed a graphic style that is bright and colourful yet has a distinctly unsettling quality to it that reflects the editorial content. Images are savagely cropped or run repeatedly; ghostly shapes are cut into pictures and areas of colour.'* Leslie is correct to point out the unsettling nature of *Mute*'s design. Pages threaten to tip over into anarchy: dot matrix fonts clamour to be

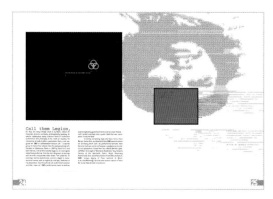

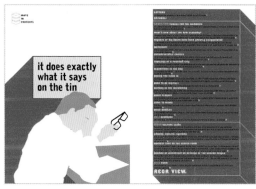

After covering the 'Digital Commons' in 2001, Volume 2's launch issue attempted to update the terms of reference. Like many buzzwords of the new economy, the easily likeable notion of a 'commons' obscured more troubling politico-economic processes. Per Wizen's cover image – generously donated to the magazine – seemed to encapsulate the reality underlying the happy rhetoric, with a realm of fun and freedom made possible by the drudgery of bonded slaves outside the field of vision.

heard over the graphic noise generated by a raw HTML-like aesthetic that pervaded the pages. But Jaques always seemed to avoid chaos. *Mute* spreads were invariably readable, and navigation through its pages was aided by clear and precise typography and graphic signposting. Yet under Jaques' design direction, *Mute* was not an exemplar of designerly finesse: Jaques wasn't pandering to the sort of graphic polish that wins design awards; there was no colour coding, not much typographic consistency, and the grid was barely discernable amongst fluctuating columns, fragmented blocks of text and savage isometric blocks of colour.

Photography existed on the same level as the typography: it was integrated; it didn't dominate as it does in most magazines. This was probably because there was no money (or inclination) for slick, over-art directed photography. Imagery was 'found': it was the detritus swept up from the cutting-room floor of digital culture. There were occasional examples of net art, and sometimes photography was chopped up and invaded by graphic elements. Illustration was used, too and *Mute* was a pioneer of the new vector-based illustration styles that were to become fashionable in the early years of the 21st century. Diagrams and graphic devises were in plentiful supply: Jaques had an obsession with 45° angles, and these sharp protrusions slice through the pages of *Mute* adding a sense of tension and contributing to the *'unsettling'* effect noted by Jeremy Leslie.

Throughout its various formats, *Mute* was neither a refined design artefact nor a heterodox statement of guerrilla-like intent. Like the subject matter itself, the design was occasionally awkward, but on other occasions, especially when it used treated photography, the pages had a compelling immediacy. Jaques is quick to acknowledge the role of Worthington and van Mourik Broekman, whose art school background gave them an informed point of view, and occasionally meant that they didn't agree with his strategies. *'Though there were always times when they would want something a different way,'* he

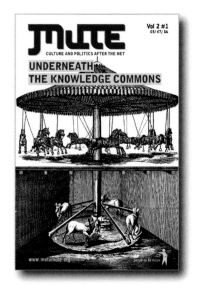

recalls, *'and there were the inevitable quarrels about legibility, size of images etc., we shared an enthusiasm for the format and for a freedom of expression that came from self-publishing. Probably as important as this (if not, secretly, more so) we shared an irreverent sense of humour.'*

Van Mourik Broekman agrees: *'I'd go with that – and the idea that it's what carried us through for many years. Regarding the quarrels, I think these were a product of us trying to "get real" about what some of our audience was telling us or requesting from us, and how certain recurring problems with accessibility might also be a facet of our not exactly brilliant sales performance. But because we were all so inexperienced and, in our case, trained neither as designers nor publishers nor editors, our opinions were probably all a bit inconsistent!'*

As a printed magazine, *Mute* has moved through a number of formats: in a series of software-like upgrades, *Mute* has changed and adapted. Its first incarnation, as we've seen, was as a broadsheet newspaper; the second was as a saddle-stitched

In 1998, Mute *launched a new, web-only sister publication named 'Meta'. Edited by Jamie King, one of the print version's book editors, it featured an eclectic mixture of articles linked to new media and web culture.* Meta *built upon the isometric styling of earlier site-designs, hinting at its catholic attitude to subjects via graphics of a dead cow and UFO. The strapline read: 'Welcome to the Happy Valley.'*

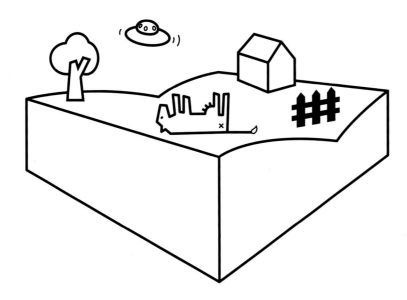

magazine with mainly black and white text pages; the third was perfect bound with an increased number of pages; the fourth was as an even heftier, almost book-like publication. Now, in its current incarnation, it has gone back to the womb, and become primarily an online publication with a printed edition called *Mute Vol. 2* which appears quarterly (see left above). Worthington and van Mourik Broekman's original plan was to allow visitors to the site to assemble their own magazine from the site's content and order a printed copy via POD (Print on Demand) technology. Currently, users can collate and assemble articles – and images – in any sequence they please, and print them out as formatted PDFs.

When pressed if *Mute* should have been an online publication from the outset, van Mourik Broekman muses: *'Perhaps yes, if it was launched by professionals, but since it was launched by very recent graduates I'm not so sure. In a recent conversation we had about* **Mute**, *and after a survey we did online, we came to the conclusion that half of our readership still only reads the print part; a good share of the other half hardly even realise the print exists. These for us profoundly convergent incarnations of* **Mute** *seem to draw, and cater for, such radically different demographics.'*

As mainstream magazine publishers make increasingly desperate attempts to stem the flow of readers to the internet, one of their strategies is to replicate the hyper-linked, hurly-burly of the web on the printed page. Editors and publishers ask designers and art directors to give them 'interactive' spreads full of frenetic activity, shout outs, sidebars and endless entreaties to 'contact us.' But readers are voting with their eyeballs and drifting online. Fear and loathing now stalk the corridors of mainstream magazine publishing. The circulation of glossy magazines is falling; uncertainty prevails. Yet perhaps *Mute* offers a new paradigm: a hybrid print/online future that gives readers genuine choice. ⌐

THE POST-HUMAN
VERSION 1.0. 404 U
TO EXTREME SASS
OUTSIDE INSIDE O
DATA TRASH. THE R
THINGS. INTERROG
INSECTS IN TRANS
ON MINE AND I'LL
THE INTERNET A R
CYBERBOLE. TRUS T

THE BROADSHEET

ANIFESTO
RL NOT FOUND DUE
NESS. THE
TECHNO ART.
UMOUR OF TRUE
ATING THE ALIEN.
TION. YOU CLICK
LICK ON YOURS. IS
IZOME? AGAINST
BUT VERIFY.

THE BROADSHEET
LEARNING FROM HISTORY

Famously, *Mute*'s first incarnation was as a barely disguised replica of the *Financial Times*. Similarities went beyond the surface, with *Mute*'s entire pre-production and print process handled from the *FT*'s Docklands Press, where the paper's print managers agreed to use *Mute* as a night-time test-run for ink distribution and the like. Each run of 40,000 cost a mere £800, and the *Mute* organisation has carried the resulting 'Mute Mountain' with it for over a decade.

Working on The Nelson – the name they gave to their gigantic, fully automated printer which, they thought, was about the size of one of Admiral Horatio's warships – was an auspicious experience. Yet it was tainted with ambivalence. Full automation highlighted the defeat of the print unions and the increased pressure on manually-based specialisms – forcefully illustrating the effects of the technological 'innovation' that *Mute* covered. As if to rub it in, the corridors of this silent site were lined with portraits of the august printers whose roles the press had rendered defunct.

The conception of *Mute*'s first format reflected the publication's early background in art and art discourses. The direct appropriation of an existing and mass-reproduced format, for example, fell in line with the visual strategies of artists such as Richard Prince – who re-presented the macho advertising of Marlboro cigarettes as a historical artefact – or Sherrie Levine, who mimicked the techniques of iconic modernist artists with no attempt to place an individual artistic stamp on the result, thus affirming the subjection of artistic authenticity to reproduction and the market. A comparable approach was taken in *FILE* magazine by the art collective General Idea, which raided the historical capital of the seminal general interest magazine *LIFE* to present its own take on society, sexual politics and art.

Mute's pilot was directly inspired by the popular art anthology *Blasted Allegories*, which had been intended in part to destabilise the hierarchy of authorship in which academic essays are elevated above artists' works, poems and other 'creative' products. Cultural theorist Suhail Malik's dense academic essay was placed cheek by jowl – and with no explanation – alongside Keith Tyson's serial artworks. Tracking the evolution of the newspaper over its

Pauline van Mourik Broekman, Simon Worthington (editorial and design); Daniel Jackson (contributing editor, pilot issue–issue 5; hibernating editor, issue 6); Tina Spear (sub editor, pilot issue–issue 5; web-mistress, issue 6); Paul Miller (design help, issues 1–3; news editor, issues 4–7); John Paul Bichard (gaming editor, issue 6); Gavin Fernandes (fashion editor, issues 6–7); Suhail Malik (print editor, issues 6–7); Anne McCreary (advertising, issues 1–4); Jonathan Roberts aka 'JR' of Independent Spirit (advertising, issue 6); Josephine Berry (editorial intern, issue 6; sub editor, issue 7).

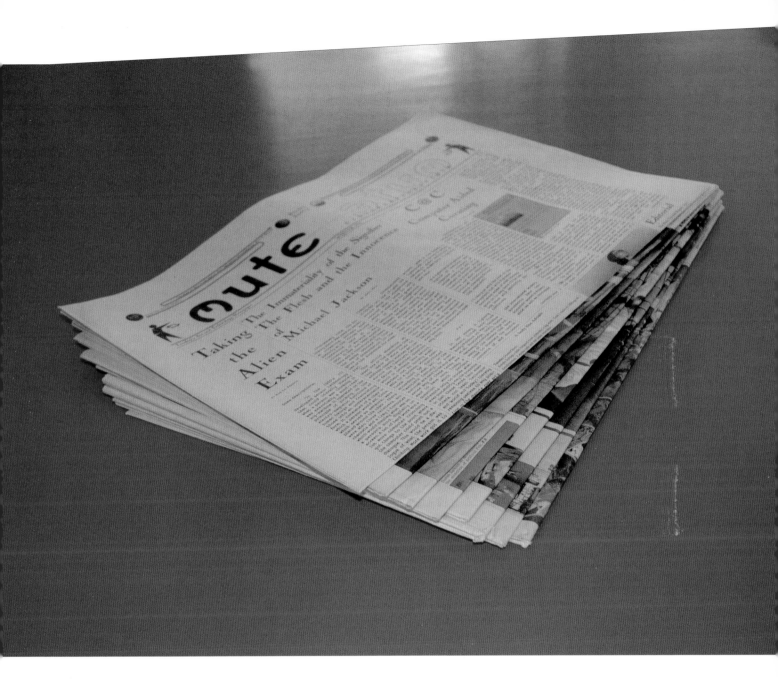

eight issues, it is clear that it was at its most accessible when it featured ambitious, art-like spreads, such as the 'Boogie-Woogie' collection of interviews on early mailing lists. However, the producers of *Mute* became increasingly preoccupied with traditional magazine requirements – sections, introductions, pictures, captions and tables of contents.

PRINTMAKER MAGGIE ROBERTS

mute

DIGITAL ART CRITIQUE

Free

PILOT ISSUE

WINTER 1994

London's Art and Technology Newspaper

Taking the Alien Exam

BY ROB LA FRENAIS

Some descriptions:

'In the 1950's ITT developed sensor technology that could literally display what a person was thinking. It was essentially a mind-reading-machine. It operated on the principle of picking up the electro-magnetic functions of human beings and translating those into an understandable form. It consisted of a chair in which a person would sit. Coils, which served as sensors, were placed around the chair - there were also three receivers, six channels and a cray I computer which would display what was on screen. A lot of hard work and a lot more computer crunching got things to the point where the computer could print out a dialogue. This would be the analogue of what the person was thinking. More work got it to where the person would visualise something and a picture would actually appear on the computer monitor....which was used to decode the transmissions being generated from the person in the chair. was then interfaced with an IBM 360 computer. This was, in turn, interfaced with the Montauk transmitter....A psychic would then sit in the chair in Southampton (Long Island) and relay via computer to the Montauk transmitter. The psychic would think thoughts, and the Cray I would decode them, they'd be put on a 32 bit radio link and sent to Montauk where they would go on to the IBM 360. The IBM computer would then broadcast it out of the transmitter and could build a thought form of what the psychic was thinking in Southampton. The

The Immateriality of the Signifier

The Flesh and the Innocence

of

Michael Jackson

BY SHOAL MALIK

(Preliminary note: the following piece was read on several occasions, perhaps most publicly at the 'Virtual Futures' Conference held at the University of Warwick in May 1994. It has not been modified here and it therefore still bears the marks imposed by that genre of presentation (in the use of the pronominal, for example).

This article abandons at least one of the questions that this issue of Mute tries to address, namely whether art can survive the Twentieth Century, in favour of another question which is perhaps less secure, perhaps not so quickly available to a polemic whose positions could be distributed according to what 'art', or the 'Twentieth Century', or even 'survival' are said to be and what sense any of these terms are said to have here, today, a question which perhaps attempts only to invoke whatever instability may be possible in just these terms (and some others, not least 'technique' and 'world' and 'today') thereby remaining useless to any position in the dispute over art's 'survival', a question, namely, as to whether the Twentieth Century - whatever that is - can survive (the) art(s).

Such survival - of (a) time - matters 'today', matters now, precisely because the notion of a continuation or a change or even an end to art 'today', indicating an art or arts or an anti-art out of or beyond the Twentieth Century, seems inextricably tied to a technology of the image and of sound - that is itself 'new'. But this is itself nothing new. In just this way, it could be asked if the Nineteenth Century could survive the inventions of photography and sound recording on the one hand and Cezanne and jazz on the other (and is anyone of invention less a matter of 'technique' than an other?) and

around. what is now known as 'Cyberpunk' I'm going to talk about. is what I hope to talk about. is what's at the allegations around whom the allegations centred. what I hope to talk about. is what's up for grabs in all of these allegations. defences and anxieties around Michael Jackson: namely, innocence. Michael Jackson is innocent. - because what Michael Jackson wants and wanted. and had. more than anything else. even. now. in the company of children (boys, but what does this matter?). is innocence itself. And, just that far, Michael Jackson is more innocent. than ever before. more innocent. than any child.

* * *

In her essay. A Cyborg Manifesto (cited here from Body/Politics, ed. Mary Jacobus et.al, Routledge, 1990). Donna Haraway introduces and lays out many of the themes that. have come to dominate the central concerns of, and discussion

CONTINUED PAGE 2

Chandler (Independent. 15/09/94, 14). the 13-year old around. what is now known as is a cybernetic organism. a hybrid of machine and organism. a creature of social reality as well as a creature of fiction. Social reality is lived social relations. our most important political construct. a world-changing fiction.' (149, emphadd)

I'll carry on with the rest of this paragraph. but with a greater hesitance. some of what. Haraway goes on to say here I'll be taking issue with implicitly. she continues:

the international women's movements have constructed 'women's experience'. as well as uncovered

CONTINUED PAGE 2

C@C

Computer Aided Curating

BY EVA GRUBINGER

Contemporary art is reflecting the many questions arising in our current culture. it. has been fundamentally altered through the development. of new transport. and communication media. we now have a totally different world view. Distances count for nothing as an increasingly comprehensive communication network weaves itself around a seemingly shrinking globe. Messages that were previously limited to a physical carrier can now travel on virtual journeys. The immaterialisation process developing in telematic culture raises questions which are of particular interest. to younger artists. Themes. techniques and aesthetic strategies are changing.

C@C is a newly developed system concerned with the production. presentation. documentation and distribution of contemporary art in electronic networks.

The graphic interface of C@C makes it possible for even the most untrained user to

C@C INTERFACE ON WWW

climb on board the Data Network. The C@C-Navigator enables the visitor to view the created information-works while understanding the relation between the participating artists. In the Public Discussion Area the visitor has the opportunity to take part in the ongoing discourse about a specific piece and in the Business Class the owner to be acquired. With the help of a

specially developed C@C Editorial system. artists can construct complex works without any previous knowledge of programming.

One of the tasks of C@C, as a forerunner in this new sphere, is to research and further develop the traditional relationship between art and the public.

C@C will go on-line on the 26th November, and this will be marked in the Berlin gallery EIGEN+ART when the work of the first. three users will be presented. The first. presented artist. Christine Meierhofer (chrissie@thing.or.at) is reinstating the value of the daily practice of sampling (ie. the use of foreign material). Meierhofer presents a selection of masterpieces stolen from. public collections. Through her work commissions where the collector can order an exact replica of how the stolen masterpiece would fit. within their home. Meierhofer work refers to the heated discussion about. the relationship between the public and the private domain which culminated in the Clipper chip debate.

Through a classically artistic discipline. sculpture. Wium Lie (howcome@dxcern.cern.ch) refers to the ecological and economical principle of production of C@C. Objects are manufactured only on demand. Like DNA. the abstract

CONTINUED PAGE 7

Editorial

The Daily Universal Register, Jan 3 1785.

To the Public.

To bring out a New Paper at the present day, when so many others are already established and confirmed in the public opinion, is certainly an arduous undertaking, and no one can be more fully aware of its difficulties than I am: I, nevertheless, entertain very sanguine hopes, that the nature of the plan on which

A body like Adonis

Tuesday (Arms/Chest)

Awoke feeling a little fatigued from yesterday's leg work. Took 1 multi-vit 1000mg tab. 1 biochromium, 2 amino tabs and did some stretches.

Breakfast : .75 litre of Maximus weight gain.
1 bowl of Bran flakes with half a banana
2 whole grain toasts with reduced sugar peanut butter

Gym 10.am. Met up with Rick and decided to get straight on with bicep work, low rep/high weight routine. Bar-curls 2x10 + 2x8 with a 10lb increase, preacher curls 3 x 12 (both arms), Triceps pull downs (taking Rick's advice of slow release and maximum intensity pump at stretch) 3x12, Overpulley's 4x12, general grip and forearm work till lunch.

Lunch : 2 breasts of skinless steamed chicken
Greens and steamed veg (unlimited)
1 large jacket potato
4oz cottage cheese with 1 banana
French bread and Wieder vitamin enriched Shake

Took 1 amino with Dibencozide. 100mg, 4x100mg chainb4end anabolic enhancers.

Then slept from 2 till 3 before having energy snack before the afternoon's chest work.

Energy snack: 1 pt raw juice : Banana, 2 orange, peach, apple, mineral water
1 can of Wieder pre-workout vascu drink
1 rice cake with honey.

Gym 4.30pm After warm ups straight on to bench press 4 x 12 reps followed by flat dyes 5 x 10 reps.(Really burning close.) Then Pec Deck and frontal lifts.
Dinner: 14 oz. steak.

Simon Worthington &
Pauline van Mourik Broekman

INSIDE THIS ISSUE
@HOMEP.2
REVIEW OF CONFERENCEP.2
MICHAEL WORTHINGTON
INVENTING A FUTURE FOR ARTP.2
WILLIAM SHOEBRIDGE
ALT.TECH.HOMEP.3
ESTHER 'LESLIE, REVIEW OF
*RELAY, EPOCH OF THE POST.......P.2
SARAH STATONP.5
VIRALBUS
EDDIE HARRISONP.6
WHICH WAY FORWARDP.6
JOHN P. BICHARD
A PLAN
RANU MUKHERJEEP.7
YOU V GEN
MAGGIE ROBERTSP.7
PAINKILLERP.8

MUTE IS PUBLISHED FOUR TIMES A YEAR
EDITORS: SIMON WORTHINGTON
PAULINE VAN MOURIK BROEKMAN
TRSXA*XA*
DANIEL JACKSON
PUBLISHERS: SKYSCRAPER
TEL 071 731 5377
FAX 071 736 9864
E-MAIL: MUTE@SKYSCRA.DEMON.CO.UK
ISSN 1356-7748

TURINS CONTRACT

By SHERRY T. ECONOCLAST

transmitter would transmit the lattice (or matrix) for, and build enough power to materialise whatever he was thinking of. Every single point, so where he could witness to a single spot on the base, at that spot, an object would materialise. In other words, if he would hold an object in his hand and/or visualise it, it would appear at the given spot. They had actually discovered pure creation out of thought with the use of the transmitter.'

'A group of sleepers lie half-embedded in a shale-heap in the English countryside. They are attached to neurosynchronisers tuned to delta rhythms. They have inverted their sleep patterns so that day becomes night, night becomes day. An attendant occasionally sends signals to them via a transcutaneous electrical stimulator. They have learned codes in their waking moments so that there is a direct interface between the waking and the sleeping. Like communicating with the dead, another human boundary is transgressed. The TENS unit also stimulates awareness of lucid dreaming at moments of high REM activity. Later, they may set themselves special group activities, tasks to complete, destinations to visit to be undertaken collectively in the 'dream' landscape. They are observed by the inhabitants of a town from a clock-tower through a telescope.'

CONTINUED PAGE 6

Brewer's Millions, quite good) Looking forward to tomorrows back, shoulder and abb work.
Supper: Tuna and sweetcorn sandwich with yogurt
Mug of hot choc made with semi-skimmed milk
Weighed 215 pounds at bed time (bulked).

arts, and the anti-arts (there are no non-arts), in today? And where? Especially if 'today', 'now', that, where and when can not be removed from the time of technique, 'our' time, the end of the Twentieth Century (at least). Does that mean an exacerbating materialisation or immaterialisation of fabrication and of figure, of silences and of blanks? Which is why –)

I want to talk to you about Michael Jackson. Because Michael Jackson is innocent.
I'm not making any claims here about Michael Jackson's legal status (though, since the allegations you'll all be familiar with have yet – if ever – to be heard in court, he remains innocent as far as that's concerned). And I'm not making any claims about what Michael Jackson may or may not have done or continues to do, whether or not he caressed, fondled or 'orally copulated' and masturbated Jordan

it was close to star wars, films, and video games, and only fractionally linked to the naive slaughter we call war. The potential walls between war and television had certainly been blurred (in the best possible taste).

It can be hardly insignificant, then, that the arts have seen a similar collision between techniques which have generally gone under the appropriated title of 'multimedia', but I think this reflects a general linkage between many areas inside and outside art. The electronic dig-

I want to talk about the new media collision. You might have noticed a number of barriers coming down recently, apartheid in South Africa (well the laws at least), the Berlin wall, the iron curtain. For me, my barriers started to come down when clean war techniques were being practised during the Gulf war. It was the first war to be run via shooting schedule. Even for the American air combatants Jordan

tal calculating device has been. If not a surrogate mother to this collision then probably a gene donor.

The convergence of digital media has brought previously seperated domains within reach of each other. This is partly due to the general deskilling the user interface software brings to the process of manipulation. However, I cannot help but think 'hyperreality', the reality in our heads.

The business logic behind this was clear, by having a ready supply of view-ware, the final inhibitors to the rapid introduction of new technology were removed.

The tyranny of the bit store has bought, a common domain, a playground in which artists and technologists have a method for re-engineering what Benjamin Woolly refers to as 'hyperreality, the reality in our heads.

Previously you made a 'film', you made a 'record' the identif-

CONTINUED PAGE 3

EARTH WIRE BY BRUCE GILCHRIST

(Pilot issue, 1994) Fonts, columns and headlines were left very plain in the broadsheet pilot – any clues as to the publication's contemporaneity were to be kept subtle and enmeshed in the fabric of the old-fashioned newspaper format. The ancient media histories referred to by its pages were infused with the 'electric' present – as symbolised by the yellow-green earth wire and blue current designed into the logo, or represented by illustrations and artworks. There was space at the top corners to include ads (as the FT did), although these only really made a regular appearance in later issues; before that, various decorative visuals from articles were used.

covers

Left: (Issue 1, 1995) Digital culture has often been called 'ludic'. Issue 1 tried to delve into this idea by adopting the title of historian Johan Huizinga's book Homo Ludens. Articles questioned whether the most obviously play-like phenomena associated with new media (computer games, MUDs and MOOs) were ludic at all? The Brit Art dominating the media around this time also featured in the equation. A sketch fusing icons from gaming and art into one satirical image was passed to artist Daniel Jackson, who was a professional 3D modeller. In what was to become a long-term Mute habit, a surreal and entirely non-explanatory headline was then run across the top.

mute

ISSUE 1

DIGITAL ART CRITIQUE

London's Art and Technology Newspaper SPRING 1995 Homo Ludens 65

The Days Run Away Like Wild Horses Over the Hills
The Origin of Species ~ A Bestiary of Gaming

Game Ploy

Games and the G.U.I.

by Sheep T. Iconoclast

Somewhere over the TV-

A recent exhibition by Karen J. Guthrie and Nina Pope at the Collective Gallery in Edinburgh and Fringe Gallery in Glasgow

Contents

Under Play - the G.U.I and the Game
Sheep T. Iconoclast..............................p.1
Somewhere over the TV,
Nina Pope and Karen J. Guthrie;
a review......................................p.1
Interview with Beamer,
William Shackridge...............................p.2
We're not getting anywhere.
Online conversation with 'Splotch',
Will Bradley....................................p.3
Interview with Andy Blundell
Pauline v. Mearg Brookman.......................p.3
Internet.
The Wonderful World of Wire...................p.4
Modern Times, a comic strip,
James Pyman...................................p.4
YHE THING, an art bulletin board,
Andreas Ruth..................................p.4
Bermuda Triangle
Pauline v. Mearg Brookman...................6/7
Reviews.
Hermes' Mistress, Regina Prank at the IAS
Anti-Rosa xess
Staying in to play John P. Richard
on CD-rom games
Q x 0001. (-i.e 1001. i++); Teresa Elliott
and Jonathan Jones-Morris
Running Time
TalentMipendipusa...............................p.5
Tremalo in the age of Pop Video,
Martin Maloney...............................p.6
Forms bytes, Rani Mukherjee.................p.6
Dissimulators, the Illusion of Interactivity
Andy Cameron...................................p.8
Creative Play, Wally Sewell.................p.11
Photographic Work, Carey Young..............p.11
The Production of the
Spacehreds Experience
The D.I.Y guide to digital creativity,
Daniel Jackson...............................p.13
Digital Small Ads..............................p.13
Orion, Rachel Armstrong.....................p.14
Rachel and Venus, 5 v 24
A comic strip by Johnny........................p.14
Will the Revolution be Televised,
Philip Chafer.................................p.15
Peter Pope James Anderson,
A visual short story from
'An Alphabet of the senses'..................p.15
Editorial HOMOLUDENS........................p.15
Festivals and Events..........................p.16
Would you recognise a Virtual Paradise?
Paintings from an existing series
in Supine Trainter..............................p.16

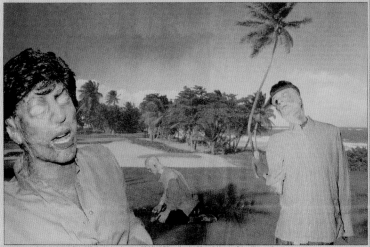

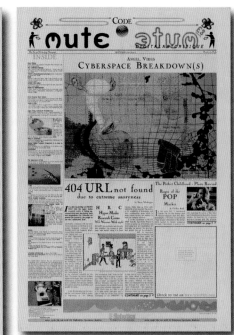

Left: (Issue 2, 1995) Daniel Jackson's employers, Virtual Studios, appeared as one of Mute's first real advertisers in the next issue, 2, elusively themed 'The Chocolate Covered Highway' – Dutch film star Rutger Hauer's name for Hollywood and, the editors felt, an apt tag for the frenetically commercialising Internet discussed in the magazine. Art goup BANK had just staged their exhibition Zombie Golf, which Mute documented using BANK's photographs together with stock landscapes. Similar use of stock imagery was made in issue 3 (above), whose cover layered 3D wire-frames of reproductive organs and faces over scans from an old catalogue on Japanese art. As with any collaborative image work from this period, Worthington executed and van Mourik Broekman was the 'back seat driver'. US Robotics is rewarded with a special, seemingly indefinitely placed, banner for sponsoring Mute's web access with five modems.

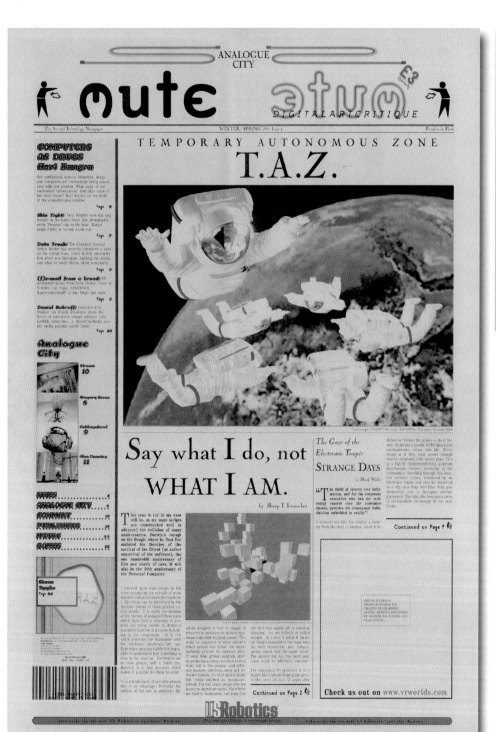

Above: (Issue 6, 1996) In a rapidly maturing new media scene, the magazine was coming to occupy a special place and numerous festivals advertised, including Hull Time Based Arts' ROOT. Mute's *Financial Times* format resonated with 1996's 'SKINT' theme and its centre page pull-out was therefore chosen to publicise the entire festival schedule. More generally too, issue 6 displayed a new confidence, although not everything was what it seemed. Elementary production errors were still being made, as close readers of the VNS Matrix cover story would have noticed when they tried to turn the page and found the article starting a second time.

Right: (Issue 7, 1997) For this issue van Mourik Broekman illustrated a conversation between artists Jayne Loader (who had recently authored The Atomic Café CD) and Carey Young. Van Mourik Broekman's elementary Photoshop skills and background making collages helped produce a suitable – if slightly gauche – image folding various story elements into a big fan-shape. Whilst Mute's content architecture was fast acquiring typical magazine components, many spreads in this last newspaper issue demonstrate that its founders couldn't help but see it as a massive canvas for artwork.

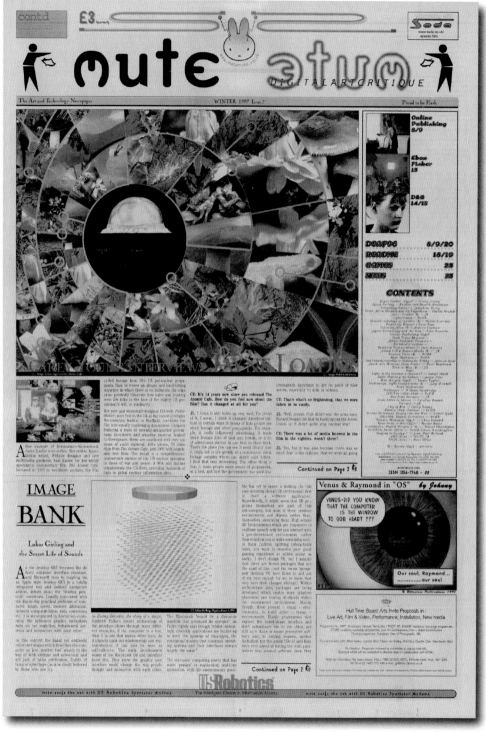

COMPUTERS AS DRUGS

MUTE *MUTE*

mute

MUTE

mute

mu†ɛ

ɛɒɒɒɒr ɱ ɱɛ

ɱ ɛ

mutɛ

£3
9 TO 5

mute
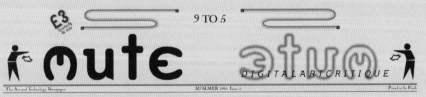
DIGITALARTCRITIQUE

The Art and Technology Newspaper SUMMER 1996 Issue 6 Proud to be Flesh

Left: Two 'Bacpack' folders holding four issues of the broadsheet were produced using an iteration of the litterman symbol on each.

abcdefghijklmnopqrstuvwxyz
ABCDEFGHIJKLMNOPQRSTUVWXYZ

aefbctfyeeffgifhitfjkyflgggyoespggyfrstft
ippytwtttytty
AAMBŒCMDMEFFŒHEFIUBNKFLLIANT
ŒMPERUDTTUPVATWULTYUR

abcdefghijklmnopqrstuvwxyz
ABCDEFGHIJKLMNOPQRSTU
VWXYZ

ABCDEFGHIJKLMNOPQRSTUV
WXYZ

abcdefghijklmnopqrstuvwxyz
ABCDEFGHIJKLMNOPQRSTUVWXYZ

abcdefghijklmnopqrstuvwxyz
ABCDEFGHIJKLMNOPQRSTUVWXYZ

In *Mute*'s earlier existence as a student magazine at the Slade School of Fine Art (1989), the first logo was set on a UNIX word processor. It subsequently graduated into Courier New and was set in June 1990 using Quark v1.0, encouraged by the staff at *MacUser* who got the student collective fired up about a new thing called DTP.

In 1994 *Mute* reappeared as a title for 'digitalartcritique'. The new logo's first outing was in April 1994 on a circular asking for contributions, but it was very much a work-in-progress. It finally came to life in a mad rush when the *Financial Times* agreed to print the publication a week after being cold-called. *Mute* stayed with Courier New because of its resemblance to the Monospace fonts used on computer display consoles – the Cyberpunk interface of choice. Defiantly, it incorporated an adjusted 'litterman' graphic which threw (or distributed?) litter (or the newspaper?) and was, like '*Mute*' itself, already in use on the majority of electronic audio devices. *Mute* sought to piggyback on the fact that this is a global sign, but not owned, thus avoiding the brand-affirmative effect of comparable revisions using copyrighted corporate logos.

The final logo sat on top of the broadsheet newspaper and had to work when it was folded down to A4 and displayed on newsagents' shelves. To achieve this, the main logo was mirrored with a lighter, blurred version, as well as a zig-zag earth-wire line which emulated the Mozilla web browser's animated graphic. The ideal logo-consumer had always been a London Underground commuter, eyes drifting into the familiar landscape of the *Financial Times*, only to realise they were onto something completely different.

Above from top:
Kookoo. *Designed by Michael Worthington, 1994.*
Mrs Eaves Ligatures, Emigre. *Designed by Zuzana Licko,1996*
Nicolas Cochin, *Deberny and Peignot. Designed by Georges Peignot, 1912.*
Dogma, Emigre. *Designed by Zuzana Licko, 1994.*
ITC Century Light Condensed, ITC. *Designed by Tony Stan, 1975 from the original 1894 typeface.*
Suburban, Emigre. *Designed by Rudy VanderLans,1993.*

D&G

Is the Internet a Rhizome?

That's what might be thought from looking at some of the recent and (allegedly) most interesting writing and theorisation on the current and future state of digital communication. Inspired by the work of Deleuze (especially) and Guattari, this work looks forward to the *fully cybernetic* functioning of digital interactive communication—namely cyberspace as its more or less universally assumed future—its affect on culture and on the human body. That is, its prospective is the total interaction of the digital and the human *as such*, which (its hoped) will be its ultimate explosion. And sometimes, with that, there's also the happy announcement of the possible annihilation of the human.

In any case, there's a bit riding on how to think about the digital both technically and culturally. The issue here is whether the work of Deleuze and Guattari [=D&G] is the best way to do it, and, if not, why not? What's best, what's the limit, the restriction, the danger of adopting the internet through and with D&G? To be clear: this danger would not be the one which D&G would push for (e.g., the proto-autodidactic one against the body) but a danger of *altogether missing* out what digital interaction and communication might be about, on what its insertion is and could be, today and in the future.

The attractions of thinking cyberspace (or an equivalent) as a rhizome are obvious. Firstly, within the digital network, communication is 'organised' as a rhizome, 'any point [of which] can be connected to anything other, and must be' (*A Thousand Plateaus* [=TP] 7). Such a connecting does not take place according to a uniform or centrally ordered nerve or stem from and to which all other points can be referred. There is no main artery for a rhizome and so no co ordinating axes nor then any fixed 'points or positions in a rhizome... There are only lines' (TP 8)—lines of connection. The unity of the rhizome is not and cannot

be ordered from the center or the edge nor any founding root (*nor* anything to oppose to them), nor anything like a CEO; there are no 'higher' and no 'lower' connections, false today's internet, rhizomes are *unordered*.

The second attraction towards thinking of the future of digital communication as rhizomatic is more serious. It is to do with the digital interaction and *reappropriation* of the human. *Interactivity* can also be said to be rhizomatic since, as D&G say, the characteristics or 'traits' of a rhizome 'are not necessarily linked to traits of the same nature; it brings into play very different regimes of signs, and even non-sign states' (TP 21). Rhizomatic lines of connection no less connect states which are *unlike* each other in their 'nature'. The human and the digital, for example.

In D&G's terms the human and the digital network or space are not (on radically) different regimes but are rather just two 'vectors to the one 'plateau' which exceeds either. The plateau is only a 'plane' of the rhizome which 'has no clear beginning nor end, but always a middle from which it overgrows and which it overspills. [...] A plateau is always in the middle, not at the beginning or the end' (TP 21). Overall, then, what D&G say about a rhizome could just as well be said about the fantasy of a fully integrated cybernetic digital network: they are—will be—"finite networks of automata in which communication runs from any neighbour to any other, the stems or channels do not pre-exist, and all individuals are interchangeable, defined only by their *state* at a given moment" (TP 17).

And here's more: with D&G the plateau is itself a machine; and this divests the organisation of the otherwise finally integrated future from being a *concretely human* decision. The future of the internet would not then be in human hands (unless the human is a machine too). For D&G, a machine isn't particularly to do with *traces* of hardware and software. It is only "a *matrix* of interruptions or breaks" (*Anti-Oedipus* [=AO])

96). There is no contradiction in saying this to the connective rhizomatic lines just described. They say that machinic 'breaks... operate along lines that vary according to whatever aspect of them we are considering', to whichever plateau, and "every machine, in the first place, is related to a continual material flow that it cuts into... the arms and the flow of shit, for instance. [...] Far from being the opposite of continuity, the break or interruption *conditions* this continuity. [...] The machine produces an interruption of the flow only insofar as it is connected to another machine that supposedly produces this flow. [...] [E]very machine functions as a break in the flow in relation to the machine to which it is connected, but at the same time is also a flow itself, or the production of a flow, in relation to the machine connected to it" (AO 36). In this generalised sense, *the rhizome is itself a machine*—and the machine (defines by its breaks and so produces even as it *is*) a rhizomatic plateau.

As a machine break, as a connection, as a 'line of flight' (TP 9; also Ch.3 §9&12), rhizomes 'deterritorialise'. They break open and break apart stable states and systems, connecting and tearing up fixed spaces, territories and codes. In their machinic production these are not just put into movement, they are only ever in movement, only ever break-flows. In other words, for D&G a plateau only ever *deterritorialises, deteoxifies*. It is *unceasingly* schizoid—i.e. splitting, cleaving, dividing—and schizophrenia is *the* machinic operation (AO 39-41). The *schizo* "is at the very limit of social codes". This destabilizing ties in very neatly with lots of stuff around at the moment on the internet as an escape or 'line of flight' from the (so said) oppressive social regimes and realities of today's political establishments. This might be further supported by D&G's recognition of Marshall McLuhan's work from the late 60's on the 'electronic flow'. For this flow "anything will do whether it be phonic, graphic, gestural, etc., no flow is privileged in this language, which remains indifferent to its substance or support, inasmuch as the latter is an amorphous continuum. The electric flow can be considered as the realisation of such a flow that is indeterminate as such" (AO 240): anything can happen, then, in and through such a flow. It is a flow without substance (*a virtuality*). And clearly, the internet is today the all-hyped machine of that flow, its plateau if not its because.

In this happy allegiance the *theoretical assumption and desire* of this liberatory hopes for subjectivity in digital communication culture is made quite clear by what D&G go on to say about the 'electric flow': 'the deterritorialised flows... are in a state of conjunction or reciprocal precondition that constitutes figures... [which] do not derive from a signifier [not] are non-signs, or rather non-signifying signs, point-signs having several dimensions... flow-breaks or schizzes (that form images through rows put together in a whole, but that do not *constitute* any *identity* when they pass from one code to another). Hence the figures, that is, the schizzes or break-flows are in no way 'figurative'; they cease to be figurative only in a particular constellation that dissolves in order to be replaced by another one" (AO 241, emph.add.). There are no permanent or fixed figures or identities in the 'electric flow', only schizomachinic 'constellations' which are always 'particular'.

The two books are not for nothing collected under the general title of

'Capitalism and Schizophrenia', however. Capitalism too is a rhizome, but quite a special one. The details of D&G's argument rely on Marx's analyses of capitalism's expansion because of its internal tendency towards falling rates of profit. In brief, the point is that capitalism pushes past itself in order to keep itself going: it flows to its breaking point; as a deterritorialisation and decodifying of traditions. It is a machine, a 'schizophrenia' (AO 222)—e.g. commodification and decommoditisation, the collapse of national industries, etc.

But, again, capitalism is one machine amongst others for D&G. The argument here is difficult but worth sketching out. It, generally, machines densify their for D&G "every technical machine presupposes flows of a particular type: *flows of code that are both exterior and interior (emphasis)* to the machine" (AO 292). As might be most obvious from the digital and (re-)organisation of international money-markets and the global information-exchange structures that they implement and which have implemented them, "the decoding of flows in capital has been deterritorialised, and decoded the flows of code ... to such a degree that the automatic machine has always increasingly *internalised* [emph.add.] them in its body or its structure [emph.add.] and its as a field of forces" (AO 293). It is then capitalism that 'creates machines', that is their structuring, and not the contrary. Capitalism is the *technical-machinic machine, the flow of machines*. It is the plateau of *technical* machines.

The intimacy between capitalism and computers—today's undergoing organisation of the internet—in there no surprise arising, into sedentary non-flowing territories]. On the contrary, "schizophrenia is not the identity of capitalism, but... its difference, its divergence and its death" (AO 246).

But this 'death' is the most pessimistic one. Here as everywhere for D&G (rhizomatic) creativity and lines of flight always surpass and undo (capitalistic) technical organisation and information. Such is the consistent and primary principle and movement of de-territorialisation: for D&G however much the line angles and speeds of capital and white production are inextricably tied in that movement, D&G always prefer schizoid abstract machines—such as a *schizontics*—over technical ones. But this insistence by D&G only serves to *reinnerpile* the rhizomatic plateau of the human and the digital, and, moreover, for all its raft and promotion of the machine, only along the most traditional anti-technical axis available.

In other words, *either* (i) the recourse to the internet as an *information machine that extends capitalist or social formations* and non-flow or (ii) the refusal to consider the internet or digitisation as [it is] principally or primarily bound to 'closures of information [of and for production] or (ii.b) a modation reinforcing the organisation of the social if not just capital [and it is *at least* that]; that is, taking the internet *as either* a schizo-machine *or* a non-technical—which is to say immediate—machine, is to push then and their cybernetic future out and away from capitalism and, on this plateau, *cut away from the technical*.

But that is to avoid thinking about the internet *at all*. To be clear because it's important: taking the internet as an electric flow which will and must succeed capitalist organisation is, schizoid, as advocated by D&G, is to miss altogether any and everything of digital networks. This isn't a complaint against the schizoid or the unthinking of lines of flight. More, that such an 'absolutisation avoids the major and determining constitutions of the internet today: firstly, that it is a *technical machine* and, secondly a machine devoted to *information*. Though minimal, these complaints are serious, if only because they suggest that D&G *must* be taken to be against the internet as a *digital network*. Firstly because, as said, for D&G technical machines are produced by capitalism (so the schizoid schizoid flight state must push past all such technicality) and, secondly, because for D&G (with more prescience) in the *capitalist organisation of deterritorialisation and decodification* (*abandon and creativity*) the '*correlation* of the break and flow is such that 'production is narrowly determined by *information*' (AO 241, emph.add.). Which says that the *technical* deterritorialisation of information is necessarily that of the capitalist machine—and the contrary. And D&G have to say that this is that to which digital communication networks, cyberspace, are axiomatically bound. As they must then also argue against the internet, D&G say that for *capitalism* it is a question of knitting the schizophrenic sharps and energies into a world automatic that always opposes the revolutionary potential of decoded flows with ever interior form... The flows are decoded and axiomatised by capitalism at the same time" (AO 246, emph.add.). But this capitalist limit in and *against* schizoid production is only a re-codification and re-territorialisation into what D&G call an *anti*-production. For D&G, then, is the internet and cyberspace in its cybernetic future and horizon, information flows only is non-rhizomatic plateaus of *technical* representation. D&G send then must try to smash, escape from the internet altogether, if only because representation in their general enemy. It is a fixing of states and connecting lines of nomadic deterritori-

alising, into sedentary non-flowing territories]. On the contrary, "schizophrenia is not the identity of capitalism, but... its difference, its divergence and its death" (AO 246).

Suhail Malik

Suhail Malik

"C"yberspace. A consensual hallucination experienced daily by billions being taught mathematical concepts... A graphic representation of data abstracted from the banks of every computer in the human system. Unthinkable complexity. Lines of light ranged in the nonspace of the mind, clusters and constellations of data. Like city lights, receding."

(Neuromancer, William Gibson)

aperatures, to every nation, by children being taught mathematical concepts... it's legitimate inheritors, to every nation; by children being taught... For D&G, for example, an environmental impact the total material cost of a car during its lifetime is 25 tonnes of matter; that of a PC is 16 tonnes (Wuppertal Institute). Electrons must travel down wires, must whip through processors and, most trigger interfaces which connect with the humans in order for what is rapidly becoming known as

from the telephone and TV networks and spy satellites of television with the TV in the set-top box and the delivery system will bring to the 'masses' far the P no need to understand all opposed is not just what th impact will be, not just wh is a good or a bad thing whether it liberates real and micro-& macro-poli — although these considera place and are worth the re the questions we must ask reals are being opened up organising themselves or flows) and what are the t tions of power, and cons becoming possible as a r

As Virilio has pointed out... erful relationship betwee today's virtuality is in reamas increase in speed) and speed does not entail the to happen, speed needs channelled and controlle that during periods when a speeds are being introduc we need to be aware th at our most vulnerable" covery and development a of irrigation in the Nile b a new series of *vectors* a the society of that time. impossible to say for sure imagine that the farmers caused this development more control over the d trips, reduced their crop elements, freed them fr breaking toll of carrying w liberating them in the pro laid them open to a new son. The priest class who the technology also main of water and, by extensi hyperreal. It may sometimes worldly, but it is firmly in

Cyberspace. A consensual hallucination experienced daily by billions being taught mathematical concepts...

HARVESTING THE TUBERS — THE PLANTING — OF — DELEUZE AND GUATTARI

Suhail Malik & James Flint

Before it even existed, the Internet was being hijacked. The US Federal Government's need to work out a way to allow all the incompatible computers being used for government research to communicate with each other – a task which they set ARPANET about solving – was hijacked by the web of protesting computer networks against nuclear attack. When packet switching came to California on the back of the PC industry, it was hijacked first by the 'hackers', who wanted a temporary autonomous zone, then by the WELL and its members (including an infant *Wired* magazine) who wanted a new space for 'free' democracy and Enlightenment ideals – who wanted, in short, a new American frontier. As soon as it became apparent that the idea was catching on, the inploug the Internet was hijacked by the politicians and their Information Superhighway, then by Microsoft with their Internet strategy, and now – as the Net melds with the mass media – by corporate culture in general.

None of this should be particularly surprising to us. After all, what is all that different about the Internet? It is a space, an arena, a milieu. It affords the possibility of interaction and communication. It presents evolutionary and expansion opportunities (though let's not valorise either of those terms). It is a field made available to the hydrodynamics of power, of resistance, of control. It has levels of apparency and levels of (in)determinacy; it

the virtual world' to exist.

Let us conclude for a moment, under the banner of the virtual, the space of today's Internet and the concept of Cyberspace (N.B. my use of the word 'virtual' here is not at all to be confused with D&G's use of the term). If the virtual is a 'consensual hallucination' it is an extension of that virtuality that already exists, say, as part of the culture of the game of chess. The virtual world of chess exists in myriad minds in a greater or lesser extent as a series of moves, power plays, possibilities for interaction; at the same time a physical interface is required (a chequered board) even if a computer is playing one side of the game. And just as chess is more than the logical sum of all possible moves, so the virtual, so far as digital technology is concerned, is more than the logical sum of all possible computer connections. This is why it terrifies (post-)modernity, because (post-)modernity sees it only as an instant, logical, mutual, Baudrillard's notion of the hyperreal, effective though it is, fails to acknowledge that the virtual, by outgrowing its logical parameters, has in fact become real.

This is as much to say that any virtual space is invoked from the start with a set of libidinal energies. It is not about being analogue or digital – a dubious distinction at the best of times – but about the new speeds and possibilities becoming available as we construct ourselves an infosphere, an infosphere which will not only envelop computers as we think of them today, but all forms of media

affords various possibilities for movement and, interpretation, it is complex and organisantifiable. Whilst the space of the Internet functions very differently from the spaces we are used to, that does not make it somehow more real, less real, hyperreal. It may sometimes seem other worldly, but it is firmly grounded in this world. It has, for example, an environmental impact the total material cost of a car during its lifetime is 25 tonnes of matter; that of a PC is 16 tonnes (Wuppertal Institute). Electrons must travel down wires, must whip through processors and, most trigger interfaces which connect with the humans in order for what is rapidly becoming known as

from the telephone and TV networks and spy satellites of television with the TV in the set-top box and the delivery system will bring to the 'masses' far the P no need to understand all opposed is not just what th impact will be, not just wh is a good or a bad thing whether it liberates real and micro-& macro-poli — although these considera place and are worth the re the questions we must ask reals are being opened up organising themselves or flows) and what are the t tions of power, and cons becoming possible as a r

As Virilio has pointed out... erful relationship betwee today's virtuality is in reamas increase in speed) and speed does not entail the to happen, speed needs channelled and controlle that during periods when a speeds are being introduc we need to be aware th at our most vulnerable" covery and development a of irrigation in the Nile b a new series of *vectors* a the society of that time. impossible to say for sure imagine that the farmers caused this development more control over the d trips, reduced their crop elements, freed them fr breaking toll of carrying w liberating them in the pro laid them open to a new son. The priest class who the technology also main of water and, by extensi Internet/Cyberspace/virt upon which the new vers ing. To be naïve, while w a new irrigation system, a are cultures - the key Ro nations that we have thee lives - are like the tec struggled and along the Nile freely in that way, suddenly find that these people re need to survive and that once had to get along wh somehow evaporated.

What we need, right now years time, because on the late or is our own use of to be able to re-engineer as quickly as it is manuf current corporate entities. vocabulary in which we changes and these new from the overcoding sys governments media plants monics. We don't need a - let the pharaohs chase ing that. We need arming and Mounds. We need and abide (avoid the State to infantilise itself among

Mounting a direct challen possible and it may not be – we do not want to try a system of our own. What is what we can do cult create new temporary and debase cultivating power other vectors, D&G has coherent set of conceptual is to understand our all upon it. Suhail Malik has cogent aspects of them in facing page]; I don't me out all over again. But it drawn that the Deleuzia Internet would be to no effective qualities or orde a judgement upon its rig achievement, had. We can at present, so, I remark technical is witnessing a new as Vegetarian perceives i describing and we [...] hbal atomistic line of flight of logical, mutual. Baudrillard's need is somehow reverse facilitated by the structu itself. To argue that is to the use of the word 'pos

As D&G point out, "Thinking matic turning point; the the pis no longer forms and matt but forces, densities, intensities... a Thousand Plateaus, a, 34 vides intensities. Here the dynamics of the world these forms, no longer a chronons? D&G suggest th

to do it without falling into the old traps of external causes or anthropomorphics in to identify the behavioural patterns of all and any encephaed milieux. To take a key example, in the book *Anti-Oedipus* they identify three syntheses: the Connective Synthesis of Production; the Disjunctive Synthesis of Recording; the Conjunctive Synthesis of Consumption-Consummation. The point here is not to valorise what each of these means but to emphasise that each of these processes is a radically material one, and it is with this materialism that they found a machinics.

Don't be mislead by this word 'machine'. It is meant to shift the emphasis away from the human, yes, but it is not meant to carry that particular fascist connotation with it that always seems to come in through the back door in English whenever the machine and the human are mentioned in the same breath. The

abstract machine, for D&G, is any creative pattern. Any dynamic environment – winds, crowds, plate tectonics – carries within it a multitude of possibilities for coherence, order and, in turns, disorder. Latent within every weather system is a motor – we call it a hurricane. D&G's machinics is a way to understand how the world coheres and develops, whether we're talking about the evolution of the eye or the creation of a sedimentary rock. The abstract machine is the word for all the dynamic latencies in matter, reduced to a handful of material synthesis. A machinic assemblage is the abstract machine made material or, if you prefer made flesh.

There is a technical machine; the computer is one assemblage of it. It has the effect of generalised and instantaneous decoding. But the effect of the network – of the Internet – has been to transform the technical machine, not into a thing home, but into a field. Somewhere where 'forces, densities, intensities' can once again come into play. The technical machine, immaterial in the computer, blended and advanced the cause of capital. The effect of the development of the Internet – for a initial period, at least – was to unfold this machine, randomly going it back into itself. But at the very point when the technical machine became a field, that field became a battleground...

[remainder of column illegible]

JATTARI

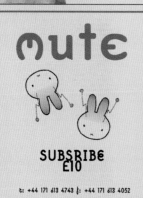

mute DIGITALARCRITIQUE Issue 7 Winter 1997

FEATURE

NETTIME

Could you tell me something about how *nettime* was started, and how it has developed since then?

nettime started as a 3-day-meeting in a small theatre in Venice during the Biennale 95. A meeting of Media-activists, theoreticians, artists, journalists from different European countries (Heath Bunting, Geert Lovink, Diana McCarty, Vuk Cosic, David Garcia, Nils Roeller, Tommaso Tozzi, Paul Garrin, and many more.) We developed the main lines of a net-critique along the topics of virtual urbanism, globalisation/virtualisation and the life metaphor. Also, it became obvious that it was necessary to define a different cultural (net)politics than the one *Wired Magazine* represented in Europe. It was a private and intensive event, and in a way, it defined the 'style' that we critique and discuss inside *nettime*. *nettime* is somehow modelled on the table of the meeting – it was covered with texts, magazines, books, whatever we had to offer the group. It was the start of our gift economy with exchanges of information. Today the list has nearly 500 subscribers, it's growing constantly with around 10 subscribers a week. We do no PR and the list is semi-closed, which means new subscriptions must be approved.

Were you intensely involved with computers?

My first computer was an Atari2600 TV-game then a XX81, C64, Amiga1000, I switched to Mac when I began with DTP in the Botschaft group after '90 used DocLinux for the Internet, and ended up with a DX60 under Win95, mainly to run Eudora, in an Intranet. So these machines document certain phases in my life, but they don't determine them. I also studied computer science for a couple of years, but it was not what I expected, which was a more conceptual approach that reflected the development of software on a much broader, maybe cultural, level.

...and net culture

I was involved with The Thing bbs network from 93-94, the high time of ascii and text based internet like MUDs and MOOs, before the Web.

At the same time I was working with the group Botschaft. There were also some exhibitions of low media art, a communication performance at the TV tower in Berlin, meetings, long term projects in the public sphere like an installation with Daniel Pflumm in a subway tunnel, a collaboration with the group kunsthalle which later became Internationale Stadt, or Chaos Computer Club which Botschaft shared office space with. After a Biluet event we organised, I started to work with Geert Lovink, which was a truly new phase of work.

...as an artist

Yes and no. I got a stipendium and did exhibitions, but always had problems occupying art as a 'social system', and I have to compassive here that *nettime* is a group project. It is not a 'piece' of individual art, but a medium formed by a collective subjectivity, a sum of individuals. I'm moderating it and it has its aesthetic aspects. But you don't have to call me an artist because of that.

...before you started the list and how do you think that has affected how *nettime* was set up?

Well, you can call it a continuation of my art practise But it functions without naming it art. In '94 I tried to begin with projects on the Web, especially the Organisation Project (a database of recorded brain waves of Franz Xaver) which reflected the early euphoric times of the Net contact. With Botschaft e.V. in 93-4, we did the

[middle and right columns largely illegible]

Berlin, Jan 1997

contact: pit@contrib.de, geert@xs4all.nl
news://all.nettime or
news://news.thing.at/alt.nettime
rtp>>archive: www.desk.nl/~nettime

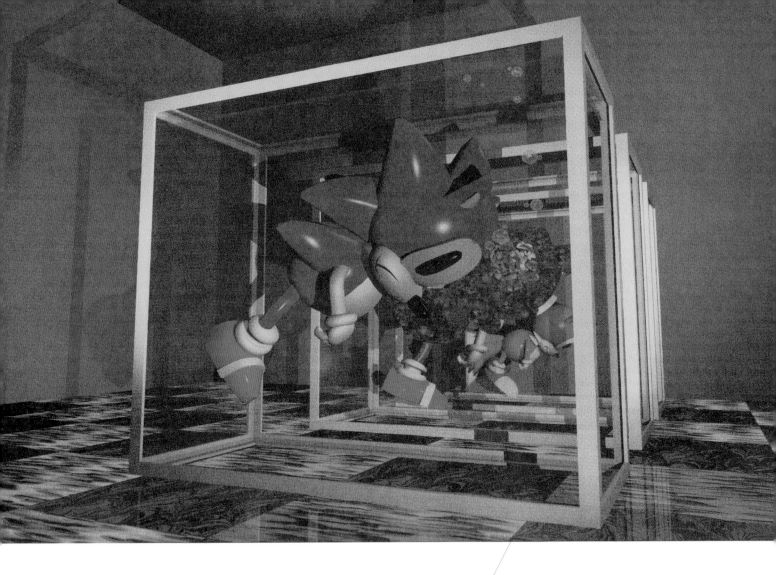

(Issue 1, 1995) *Illustration by Daniel Jackson.*

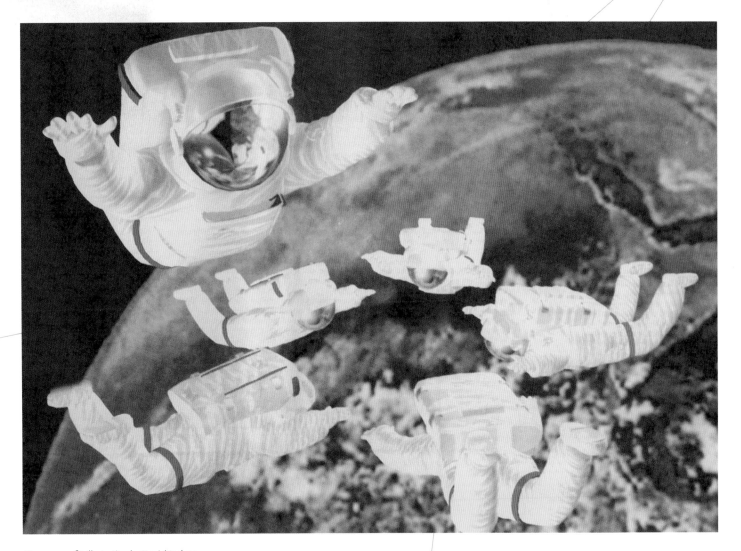

(Issue 4, 1996) Illustration by Daniel Jackson.

illustration

THE EMPEROR'S NE
VAMPING THE ME
VECTOR BLOCK ON
AVENUE. SHOP 'TIL
DROP(S)! AFTER TH
AFTER PARTY. POR
SLIGHTLY BORING
SHIFT PARADIGM.
AS THEY DO. FILE
AT ME MA, I'M MEM

W PHONES.
.... PHWOAHHHH.
ELECOMS

THE GLOSSY

YOUR CONNECTION
REVOLUTION, THE
FREE. THE
RUTH. CONTROL
O AS THEY DO, NOT
AGONALLY. LOOK
ETIC.

THE GLOSSY
"YOUR POUND OF MEAT"

After two years of attempting to maintain an ironic format that resembled a newspaper but was not one, it became clear that certain problems associated with such an approach were chronic. Without sizeable pre-production resources, colour image processing seemed like a dark art that only the *FT* could master (it remains a mystery to this day how a cloud is made to look white by printing blue ink on pink paper). Important spreads consistently came out degraded or inaccurate and the 'lo-res' newsprint made editors-cum-designers Worthington and van Mourik Broekman feel that their hard work was going to waste. In sales and marketing terms, too, the first incarnation of *Mute* was a difficult proposition: having an ephemeral, folded newspaper seeking a shelf-life of three months at £3 a go just doesn't make much sense – apart from maybe to a few die-hard novelty seekers. One question loomed large: was this an art project or a 'real' magazine?

A re-think followed in which these design and display questions became conjoined with those relating to an equally strained editorial process. Worthington and van Mourik Broekman – together with new recruit Josephine Berry – were taking care of all aspects of magazine content, design and administration (on top of commercial work to subsidise the title), so the more professional magazine they were veering towards would only be possible with additional editorial input.

The result was a saddle-stitched glossy with a variety of sections, each overseen by a voluntary editor. This format retained some of the throw-away feel of the newspaper as it could be easily rolled up and, at US-letter size, was slightly smaller than the typical A4 style or art rag, thus avoiding the anti-model of the coffee table art magazine. In editorial terms, going 'pop' with sections on Books, Music, Science, Art and even Fashion – all of which interfaced with questions of 'technology' as understood in the broadest sense – prevented *Mute* becoming an industry journal servicing the burgeoning New Media Arts sector. Given the editors' misgivings about this new genre's capacity to repeat earlier, notionally avant-

Pauline van Mourik Broekman, Simon Worthington (editorial, issues 8–21; design issues 8–13); Damian Jaques (typography and design collaboration, issues 8–13; design, issues 14–21); Josephine Berry (assistant editor, issue 8; deputy editor, issues 9–21); (PvMB, SW, JB) (editors, Art TM, Short/Cuts); Micz Flor (web design, issues 8–10; Camp content management system, issues 19–28); Tina Spear (web design, issues 8–10; through AVCO, issues 19–28); Suhail Malik (editor, Read Me, issue 8); Hari Kunzru (editor, Audiophile, issues 8–15; contributing editor, 16–21); John Paul Bichard (editor, Gaming, issues 8–15; contributing editor, 16–18); William Shoebridge, 'Casual Deg' (editor, Shelf Life, issue 8); James Flint (editor, Deep Blue, issues 8–9, 11, 13–15; contributing editor, 19-21); JJ King ('Our Man in Havana', issue 8; co-editor, Read Me, issues 9–15; website design, issue 10 / 'Meta', contributing editor, 16–21; copy-editor, issues 9, 13–14, 20–21); Tom McCarthy (copy-editor, issues 9, 13–16; co-editor, Read Me, issues 9–15; contributing editor, 16; co-editor, Mute, issue 17; Lovely.net (web services, issues 9–18); Tallboy (editor, Shelf Life, issues 10–15);

Ben Mayers (advertising, issues 9–14); Annis Joslyn (art advertising, issues 10–18); Alison Bell (intern issues 9–10); Lee Dradpour (intern, issue 9); Mike Rose, Aphrodite Paxinou (interns, issue 10); Adam Scrivener (intern, issue 13); Tom Fryer (intern, issue 13–14); Melissa Brady Dent (co-copy-editor, issue 15); Francesca Barnes (business advice, issues 8–11); Maggie Tolliday (business advice, issues 17–19); Joan Johnston (administrative and funding advice, issues 12–17); Chris Darke (contributing editor, 16–19); Ted Byfield (contributing editor, NYC, 16–17); Lina Dzuverovic-Russell (web development, issue 19–21; advertising 19–21); Quim Gil (web development, issues 19–21); Anja Buechele (picture research, issues 20–21); Hannes Rox (intern, issue 20); Louise Vormittag (design intern, issue 21); Benedict Seymour (proofing, issue 21).

garde art forms' institutionalisation, this was as important a priority as making the magazine more accessible.

The title was launched with an enormous party at the since-closed Milch Gallery, which stood among other experimental venues on London's Charing Cross Road. In issues 8 to 13, Worthington and van Mourik Broekman played with every building block of the design until, with issue 14, Damian Jaques installed a more coherent template which then continued until issue 21. All in all, the new design ran for 14 issues – rendering it by far the longest-lasting of the formats used. From issue 19, when the whole publication was first conceptualised as operating in a networked mode by voluntary consultant Quim Gil, it was complemented by the website Metamute.com.

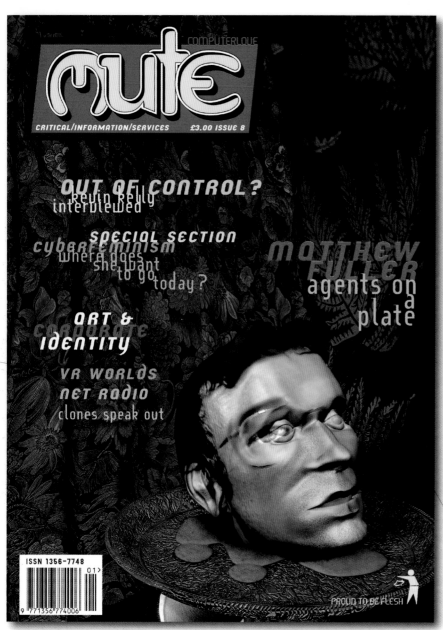

COMPUTERLOQUE

mute

CRITICAL/INFORMATION/SERVICES £3.00 ISSUE 8

OUT OF CONTROL?
Kevin Kelly
interviewed

SPECIAL SECTION
cyberfeminism
where does she want
to go today?

MATTHEW
FULLER
agents on a
plate

ART &
CORPORATE
IDENTITY

VR WORLDS
NET RADIO
clones speak out

ISSN 1356-7748

9 771356 774006 01>

PROUD TO BE FLESH

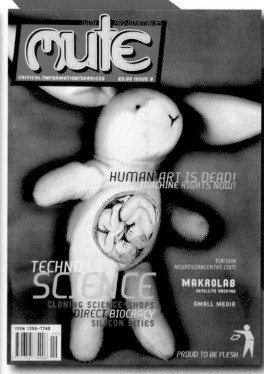

mute
CRITICAL/INFORMATION/SERVICES £3.00 ISSUE 9

HUMAN ART IS DEAD!
MACHINE RIGHTS NOW!

ICA/SUN
NEWMEDIACENTRE.COM

TECHNO
SCIENCE
CLONING SCIENCE SHOPS
DIRECT BIOCRACY
SILICON CITIES

MAKROLAB
SATELLITE HACKING

SMALL MEDIA

ISSN 1356-7748

PROUD TO BE FLESH

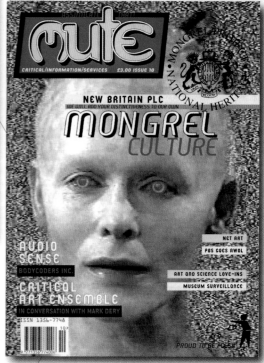

mute
CRITICAL/INFORMATION/SERVICES £3.00 ISSUE 10

NEW BRITAIN PLC
WE WILL ADD YOUR DISTINCTIVENESS TO OUR OWN
MONGREL
CULTURE

AUDIO
SENSE
BODYCODERS INC.

CRITICAL
ART ENSEMBLE
IN CONVERSATION WITH MARK DERY

NET ART
PGS GOES AWOL
ART AND SCIENCE LOVE-INS
MUSEUM SURVEILLANCE

ISSN 1356-7748

PROUD TO BE FLESH

(Issue 8, 1997) Mute's expanded editorial team included Hari Kunzru and James Flint, both authors with newly acquired experience of mainstream magazine publishing. One doctrine they shared with enthusiasm was that covers 'need a face'. It triggered an idiosyncratic interpretation from cover artist and ex-Corp member Tim Bacon.

Above right: (Issue 9 1998) In response to the comment made by our short-lived distributor Time Out – that the shelf is about selling 'your pound of meat' – a Mute friend's cherished toy rabbit was kidnapped, scanned and made to act as maternal host to human twins.

Below right: (Issue 10 1998) New Labour's use of the term 'Mongrel' was discussed in issue 10. Alice Krige's Borg Queen's eyes were blanked out with 'Mod' targets; her threatening compliment 'We will add your distinctiveness to our own', evocative of Blairite cultural policies.

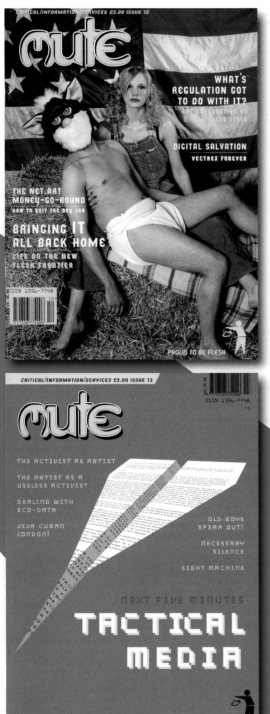

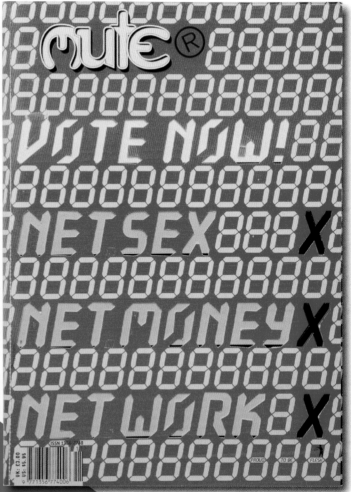

Above: (Issue 11, 1998) This cover, with its bold no-titles approach, turned the net.politics theme into an injunction to Vote Now! The readers' three options – Netsex, Netmoney, Network – were listed in die-cut wording. In a rare case of a contractor being as inexperienced as the magazine-makers themselves, this job apparently brought the printers' office to a halt, with all hands on deck pushing out the fiddley die-cut letters.

Left: (Issue 13, 1999) The Mute logo was mutating – this and the prior issue had seen it drop the red block behind the logo. Titling, too, was on its way out, evidence that an argument about readers not needing that many clues to be drawn in was winning.

Above left: (Issue 12, 1999) Record sales and an FBI ban made Furbies, the robotic toys, big news this year. Issues linked to a biotech article – cloning, the death of God – prompted this human-Furby Pietà. Internally, arguments over how many stories to advertise on the cover were being fought – Vanity Fair being an example of a magazine that filled its cover with article titles.

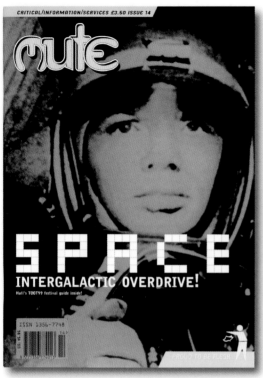

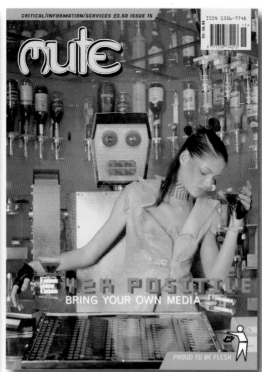

Far left: (Issue 14, 1999) The first issue handled entirely by Jaques. Its theme had seen a last-minute orientation to outer space, topical because of the publication of Full Moon, Michael Light's book of NASA's lunar landing photographs. Yuri Gagarin graces the cover.

Left: (Issue 15, 1999) The Y2K issue shows a continuing tension between the cover image, the need to pull in readers through intriguing headlines and the actual content.

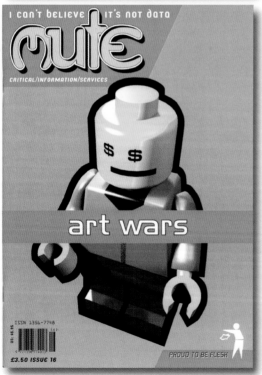

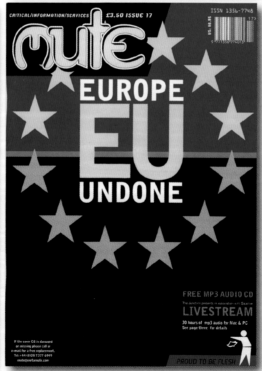

Far left: (Issue 16, 2000) A gradual simplification occurs, although the temptation to crack a joke is rarely held at bay. Here, with everything else stripped bare and magnified, the advertising slogan 'I can't believe it's not butter' (used also in the Rear View contents page, see page 46) is grist to the mill.

Left: (Issue 17, 2000) The glossy format is starting to reach breaking point: even with its logo stretched (from issue 16), backdrops introduced and all elements under constant rotation, its basics seem unable to settle satisfactorily as shown by this awkward cover. (The audio cd that was attached to the cover is not shown)

(Issue 18, 2000) The discovery of royalty-free clip-art gives the overall format another lease of life in this issue, whose contents are also advertised confidently. This is the last issue to use the courier-based logo that had evolved from the broadsheet masthead.

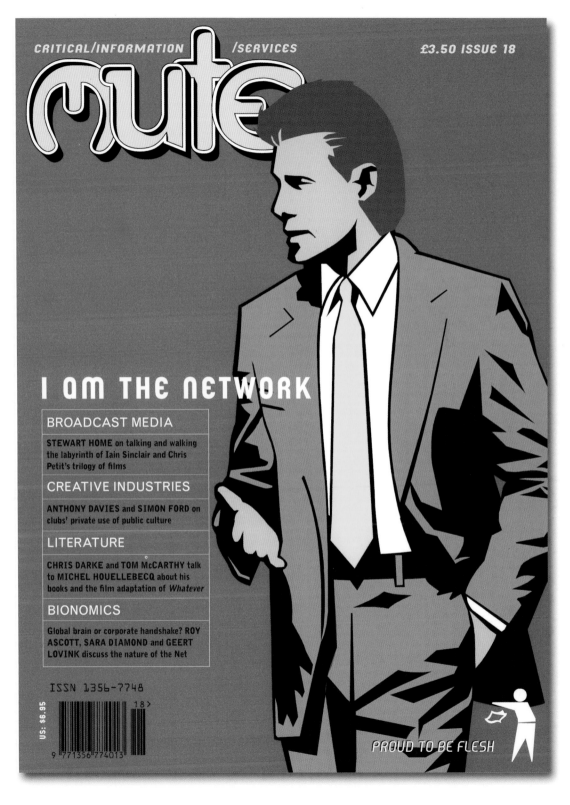

CRITICAL/INFORMATION /SERVICES £3.50 ISSUE 18

mute

I am the network

BROADCAST MEDIA

STEWART HOME on talking and walking the labyrinth of Iain Sinclair and Chris Petit's trilogy of films

CREATIVE INDUSTRIES

ANTHONY DAVIES and **SIMON FORD** on clubs' private use of public culture

LITERATURE

CHRIS DARKE and **TOM McCARTHY** talk to **MICHEL HOUELLEBECQ** about his books and the film adaptation of *Whatever*

BIONOMICS

Global brain or corporate handshake? **ROY ASCOTT, SARA DIAMOND** and **GEERT LOVINK** discuss the nature of the Net

ISSN 1356-7748

US: $6.95

18>

9 771356 774013

PROUD TO BE FLESH

mute

mute

mute

mute

mute

muteee

mute

mute

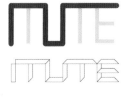
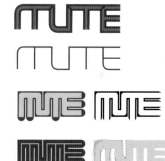
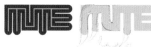

Above: A selection of working concepts for the new logo including, above, a pair of snowball throwing littermen!

In moving to a glossy format, *Mute* had to disregard and update all the considerations responsible for the newspaper font. The mirrored logo was out, and a new, contemporary version was sought that could 'hold' the page and work with the rich colour environment of hi-res printing. As it had been very successful, the basic outline of the old logo was retained, but, as shown left, adapted to the magazine's US-letter size by being slightly squeezed. This change was also influenced by a handful of Japanese magazines and *anime* books, whose ornate linework and childish, squishy fonts were popular with Worthington and van Mourik Broekman. Comics were another important influence and these inspired the creation of an isometric red background rectangle to push the logo off the page. Although this was later dropped, it provided an architecture for catchphrases that were retained, notably 'Critical Information Services'.

As part of the review of the magazine publishing model following the release of issue 18, it was decided to revisit the design of the logo (right). With *Mute* and Damian Jaques' studio being situated in the predominantly Bengali Whitechapel area of east London the influence on the design of the new logo was from street names and shop signs written in Urdu, using Devanagari, and Bengali. The fixed case letterforms developed use a linked horizontal to keep a strong linear visual key. This could then be used to prescribe the area holding the barcode and other publishing information – something the old logo was unable to do.

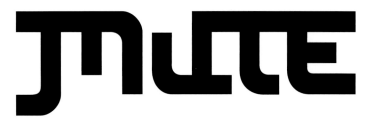

abcdefghijklmnopqrstuvwxyz

ABCDEFGHIJKLMNOPQRSTUVWXYZ

abcdefghijklmnopqrstuvwxyz

ABCDEFGHIJKLMNOPQRSTUVWXYZ

abcdefghijklmnopqrstuvwxyz

ABCDEFGHIJKLMNOPQRSTUVWXYZ

ABCDEFGHIJKLMNOPQRSTUVWXYZ

Above from top:
Udo. *Fountain. Designed by Peter Bruhn.*
Grotesque Black, *Monotype.*
BruhnScript, *Fountain. Designed by Peter Bruhn.*
Lipo-D Vectorized Square.

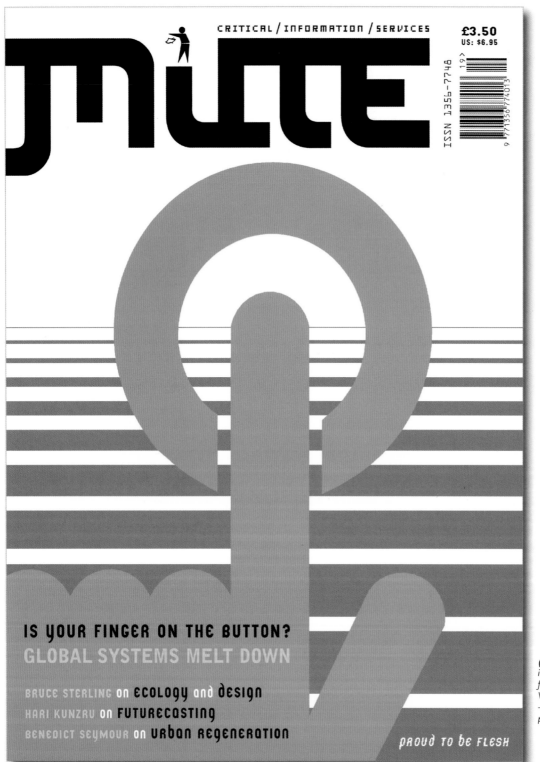

CRITICAL / INFORMATION / SERVICES

£3.50
US: $6.95

ISSN 1356-7748

IS YOUR FINGER ON THE BUTTON?
GLOBAL SYSTEMS MELT DOWN

BRUCE STERLING on ECOLOGY and design
HARI KUNZRU on FUTURECASTING
BENEDICT SEYMOUR on urban regeneration

proud to be flesh

(Issue 19, 2001) Bruce Sterling is
interviewed on ecology, technology and the
future of energy infrastructures.
Vector-based graphics provide further icons
– here both as a finger reaching for the
power-on button and a finger on the trigger.

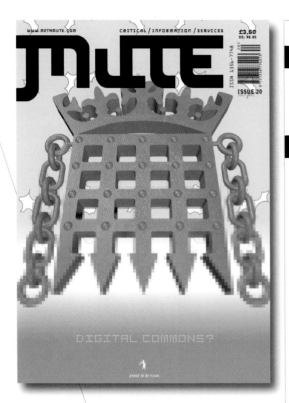

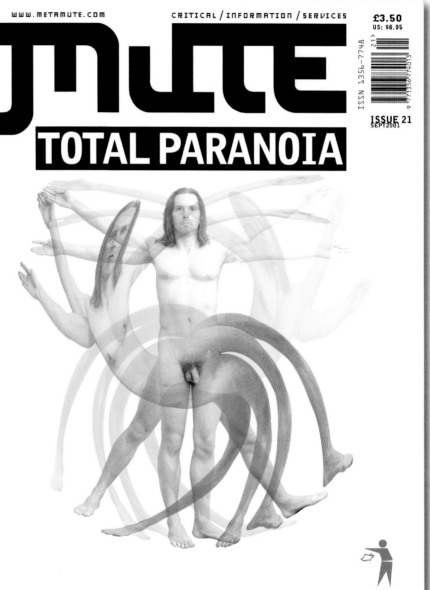

(Issue 20, 2001) Cover image modelled by Max Mlinaric. This ominous portcullis is set against the fresh green pastures of a 'digital commons' which, in 2001, was still being represented as a universal good, although threatened by the proprietary drive of corporate interests.

(Issue 21, 2002) 'Total Paranoia', a phrase borrowed from surveillance obsessive and Mute friend Ishmail Malik, saw Mute do another take on iconic images from Western art history – in this case Leonardo da Vinci's Vitruvian Man. The initial full-colour nude model was unwound into swirls of cyan, magenta, yellow and black.

(Issue 13, 1999) Probably by popular demand, Modems and Bodums (a try-out section listing internet cafés stocking Mute) had morphed into a section listing art news. Jaques here uses one of many 'cut out and fold' shapes – the design of cheap, push-out rubber flip-flops.

< ART NEWS >

ART FOOTWORK

Representative Mejor Vida Corp.
[www.irational.org/mvc] A.P. M-2246 Mexico D.F. 06002 MEXICO </fontfamily></</x-rich>

From: rammeke.pic **X**rammeke.pic@simsim.rug.ac.be**X**
Subject: **bedroom things**. We are compiling a list of things that can be done in a bedroom. We would appreciate your ideas and suggestions. [simsim.rug.ac.be/dbonanzah/bedroom/]

My First Web Page
Submissions are requested for an online exhibition. Curators will comb through the virgin net projects of self-professed artists AND non-artists. Pages focused on personal hobbies or experiences as well as first web pages demonstrating art, programming or underground talent are welcome. URLS or files [appropriate if the first web page is no longer online] should be sent to Rachel Greene: **X**rachel@rhizome.org**X**

EXPLORING CYBER SOCIETY CALL FOR PAPERS 5-7/7/1999
An International Conference at the School of Social, Political and Economic Sciences, University of Northumbria, Newcastle, UK. For information please contact: Lorna Kennedy.
T: +44 (0)191 227 4937, F: +44 (0)191 227 4515, Email:**X** lorna.kennedy@unn.ac.uk**X**
For details of the programme timetable, booking and ticket prices: [www.unn.ac.uk/corporate/cybersociety]

The 12hr-ISBN-JPEG Project
Pointless Hypermodern Imagery... posted/mailed every 12 hours... by Brad Brace. A spectral, trajective alignment for the 90s! A continuum of minimalist masks in the face of catastrophe; conjuring up transformative metaphors for the everyday. A poetic reversibility of exclusive events...
links set-> [www.teleport.com/fbbrace/12hr.html] Look for the 12-hr-icon. Heavy traffic may require you to specify files more than once! Anarchie, Fetch, CuteFTP, TurboGopher...
Or-> [ftp.netcom.com/pub/bb/bbrace/bbrace.html]

Next 5 Minutes 3 – Conference on Tactical Media
Amsterdam & Rotterdam, 12-14/3/1999
"The necessity of a heterogeneous media culture does not end with digital convergence, on the contrary: the homogenising forces of convergence show how important it is to maintain disparate, varied and independent media practices that make tactical usage of any kind of medium."
N5M3 is centred around four topics for discussion: #The Art of Campaigning [media strategies employed by groups around the world who are fostering their social and political aims via media campaigns] #How Low Can You Go [new movements for the specific promotion of low-tech, i.e. cheap, established and accessible technology, will be presented, discussed and developed] #Tactical Education [exploring new models of education that can play a critical role in processes of social and political change] #The Post-Governmental Organisation [Concentrating on the opportunities and dangers of organising social, cultural and political action beyond the politics of the nation state, N5M3 will host a unique 'PGO Contest', in which contributors will present the most and the least effective strategies for achieving global presence] [www.dds.nl/ffn5m]

'Vagabond'
A new kind of website with eyes so wide open that it dares too see through the cracks.
FEATURES: with frequently updated creative websites. Performance Artists, Poetic Terrorists, writers with attitudes & a variety of expressive & non-expressive [arts], visual & non-visual declaring their explorations to the world. The conference area 'Danger Barbed Wire', Pirate Radio 'Kiss the Wave', Links 'Other Worlds', Alternative Sex-sites 'Deep in the Shadows', 'Inside-view' an interview archive section. To contribute Contact: **X**Marc@influx.globalnet.co.uk**X** and **X**Ruth@influx.globalnet.co.uk**X** [xoom.com/influxgang/Vagabond]

'gulp'
Swallow #11 - losing what plot?
The Hexagon Series, by James McCabe, Speak in Fonts, by Howard Covert, Honey and Vitriol, by mez, and a whole bunch of rubbish by the Bad Editor, including an extremely unwise article about Justin Petersen.'plug' [www.waz.easynet.co.uk/swallow]

Voici la mise ‡ jour du site Nazecorp Nouvelle adresse:
http://www.geocities.com/SoHo/Workshop/6643/p.2.html
[www.geocities.com/SoHo/Workshop/6643/m.1.html]

Book Publication: The Art of the Accident
In the wake of the DEAF98 festival, V2, Organisation and NAI Publishers announce the release of The Art of the Accident. More than a catalogue of the festival, its exhibition projects and participating artists, this fully illustrated book takes a synthesising approach towards the intersecting practices present in the festival, outlining the basics of an ars accidentalis. ISBN 90-5662-090-8. Check the DEAF98 website for list of contributors and text excerpts. [www.v2.nl/deaf] [projects].
info/order: **X**deaf@v2.nl**X** or [www.v2.nl/deaf]

The [techne] W3LAB is an online installation of work devoted to the web.
This exhibit is being presented through an organization affiliated with the Program in Comparative Literature at Rutgers University called [techne]. Phase I [fall 1998] will focus on web-based works. Phase II [winter 1999] will coincide the Program's annual conference. The conference, whose theme is 'New World (dis) Orders: Globalization, Culture, Identity" will take place in late February. W3LAB participants include :: net.art :: Mark Amerika & Jay Dillemuth, Diane Bertolo & Sawad Brooks & Beth Stryker, Heath Bunting, Contempt Productions [to be confirmed], Vuk Cosic, Critical Art Ensemble, DhalgrenMOO, Disinformation, Ricardo Dominquez & Zhanga, Fakeshop, Floating Point Unit, i/o 360, I/0/D, Oz Lubling, —meta—, Robbin Murphy, Nikolas, Thomas Noller, plumb design, Post-Tool, Erwin Redl, James Roven, Alexi Shulgin, Yoshi Sodeoka, Eugene Thacker, Helen Thorington & Marianne Petit & John Neilson, Annette Weintraub, Adrienne Wortzel. W: [gsa.rutgers.edu/maldoror/techne/techne.html] or contact Eugene Thacker at **X**maldoror@eden.rutgers.edu**X** . "Globalization" conference: [complit.rutgers.edu/conferences/new world disorders]

NEWS FROM WWW.VUK.ORG
*"ASCII History of Moving Image s. After javascript ascii animations comes the time of vir.eos converted into moving ascii [as presented Stedelijk and Montreal] [www.vuk.org/ascii/film]
*"ASCII History of Art for the Blind. Further adventures of our ascii hero, this time in the aural department [as presented in Linz]. [www.vuk.org/ascii/]
*"ASCII Music Videos. After the silent ascii film, here comes the music video. Music by Alexei Shoulgin. All 6 videos included in the newly released Vinyl Video long play record [as presented in Rotterdam] [www.vuk.org/ascii]
*"Compressed History of Film. Another title in the Histories series – this time offering a full compression of ALL ever made films [black and white, color, made for tv or for cinemas]. [www.vuk.org/pixel/]

allPossibleImages: a handmade electronic object by douglas irving repetto [shoko.calarts.edu/ffglmrboy/api.html]

UNTITLED PAINTING SHOW: LEA: 15/1/199-21/2/1999
Increasingly, artists are turning to various forms of digital media in the production of their work. While this applies to practitioners who rely solely upon digital facilities to practice despite the absence of electronics in the end product. Taking digital media as its starting point, this show sets out to challenge conventional media practice through an assessment of painting as a related phenomenon. Confirmed artists: Edward Harper, Dan Hays, Simon Martin, Adam McEwen. London Electronic Arts: T: 44(0)171 684 0101/ F: 44(0)171 684 1111. W: [www.lea.org.uk] **X**info@lea.org.uk**X**

[kunst und technik] happening in Berlin [www.berlin.heimat.de/kunst-technik/news]

Backspace will re-open on Tuesday 1st December! Come down and re-subscribe. What's new? Monthly subscription to bak.spc £25.00 : includes 56k dial up access, rejuvenated audio and video facilities + quality access to internet resourses, media library, a wide range of active projects and related events. etc. Fewer but higher spec Macs and PCs. Unix/text access terminals installed later this month to accommodate the wave of interest in low tech, RTI and to aid as training tools. Any questions, contact **X**james@backspace.org**X** now! T: [44]01712340804 <——->09733188816
BAK>SPC/Winchester Wharf/Clink Street/London SE1 9DG, London Bridge Tube/BR [bak.spc.org]

Symposium on Artificial Intelligence and Visual Creativity/Call for Papers
@AISB'99 Convention, 6-9/4/1999
Edinburgh College of Art & Division of Informatics, University of Edinburgh. The AISB'99 Convention will be held in Edinburgh in April 1999. It will consist of 13 workshops and symposia on a wide range of themes in Artificial Intelligence and Cognitive Science. An underlying theme of the Convention this year is the study of creativity, though not all of the events include a creative element. More information at: [www.dai.ed.ac.uk/daidb/staff/personal pages/craigr/aisb creat.html]

Electronic Book Review, the online literary forum [www.altx.com/ebr/], has released its latest issue on EAST/EURO/POMO ["Postmodern Writing in Eastern and Central Europe"].
This ebr special goes online as ethnic conflicts intensify in Kosovo and pressure on Serbian university and media continues. [...] [www.altx.com/ebr/ebr8]

ARC is the North's newest arts & culture venue, opening on 11.01.99 based in Stockton-on-Tees, Middlesborough. Amongst the wide variety of facilities on offer will be a number of digital arts residencies. Tel: 01642 666600

A		E		B
C		**F**		**D**

A-Z MUTE

SHORT/CUTS

Letters to the Editors	4-5	Linux Law Lords	13
Old Computer New Computer	6	Euros of Note	14
Style is: Cuba Libre!	8-9	AOL Has Got Mail	16
Interconnected@2000	10	The House of Zan	17
The Man in the Moon	11	Currant Bun.Com	17
E-Cash-Flash-Back	12	Kosov@ Media	18-25

MAIN

NextFiveMinutes3 — Next Cyberfeminist International

Party Like It's 1999 26 [DLR]
Anti-imperialist imperialism? Emancipatory annexation? Ted Byfield on the theory, practice and politics of tactical media à la Dutch

Sight Machine. War Machine. Truth Machine: 32 ★
Compare and contrast. Agustin de Quijano on war, cinema and the newsmaker's eye

The Mode is the Message—The Code is the Collective 36 [P]
Old Boys un-define Cyberfeminism at the

Syzygy 38 [H]
Orphan Drift and the Cybernetic Culture Research Unit splice together number and fiction for a new demonology

Dealing with Eco-data 44 ✛
On nature and interpretation at .gov and .com. By Noortje Marres

Art is Useless 50 ☀
Josephine Berry talks to Vuk Cosic about the eternal return of the avant-garde

REAR/VIEW

Approx. 3 Inches to 1 mile — 1:21,477 or 4.66cm to 1km

Audiophile	Deep Blue	Read Me	Art™	Artnews	Staying in to Play	Shelf Life
60	63	66	71	76	78	81

0 250 500 750 Meters 1 Kilometer

Every possible care has been taken to ensure that the information given in this publication is accurate and whilst the publishers would be grateful to learn of any errors, they regret they cannot accept any responsibility for loss thereby caused.

CONTENTS

Short/Cuts

Wedding Bells for Sun Microsystems and the ICA — 4

Architectural Association tests Heathrow's Terminal 5 — 7

Plug 'n' Play Clubbing — 5

Suture Skins – Fashion beyond the ER — 10

Motorola Pays Homage to the Celestial Wheel — 7

Base Matter at HIP97 and "Inserts" – The Two Hacks — 12

52 — READ ME

ART TM — 50

56 — AUDIOPHILE

66 — SHELF LIFE

44 — GAMING

DEEP BLUE — 48

Human Art is Dead – Long Live the Algorithmic Art of the Machine! Eric Kluitenberg interviews Huge Harry – Machine with a Mission

A Toolbox of Everyday Media in Eastern Europe — Andreas Broeckmann and Inke Arns — 22

14

Special Section: Technoscience — 28

30 ● **Richard Sclove** on the inadequacies of science and technology decision making *Will the real democracy please stand up!*

36 ● *Cyber-colonialism and the Multimedia Super Corridor* **John Hutnyk** on Malaysia's Science City

42 ● The **Direct Biocracy** Questionnaire

Above: (Issue 13, 1999) Two issues used the London A-Z format as a template for tables of contents, reflecting the wider cross-pollination of such visual systems (the lifestyle magazines were full of comparable substitutions).

Right: (Issue 9, 1998) A Time-LIFE book on science provided the templates for much of issue 9, including the contents page here. An illustration on pharmaceuticals was re-drawn into a vector-based programme as much for clear printing as for bringing it under the Mute aesthetic.

Following pages: A set of contents pages.
Page 46: (Issues 16, 18) The use of isometric icons combines with 45 degree elements to play with the reader's angle of reference.
Page 47: (Issues 19, 20) Spreads show a continuing interest with angles aided by,

at top, images taken from Habbo Hotel. On the Rear/View contents pages a phrase was conjured from a common strapline of the period. 'I can't believe it's not data' was based on a UK advertising campaign for a butter substitute.

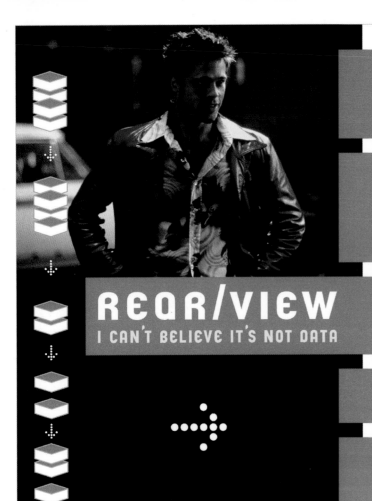

REAR/VIEW
I CAN'T BELIEVE IT'S NOT DATA

HEADLINE

WHEN YOU'RE A BOY · Hari Kunzru on ornamental masculinity and the *Fight Club* phenomenon p_58

CLICK HERE FOR EPIPHANY · Tom McCarthy reviews Russel Hoban's new novel *Angelica's Grotto* and revisits the literary gnosis racket p_62

LEONARDO AND RENAISSANCE ENGINEERS · Margot Leigh Butler is dazzled by the master engineer's shapes and figures at the Science Museum p_68

ANTENNAE
many probes make light work

AUDIBLE LIGHT · Chris Darke reviews the Oxford Museum of Modern Art's show of synaesthetic art p_60

LOST IN TECH.POP · Rhidian Davis succumbs to Digitalogue's latest seduction p_60

KEEP YOUR HATRED SHARP AND YOUR NIKES CLEAN! · Dave Panos reviews Naomi Klein's recent book, *No Logo* p_61

AFRICAN FRACTALS: modern computing and indigenous design · reviewed by Steve Goodman p_61

WHEEL OF FORTUNE
you're either up or down

Cybotron, *Blackmarket Presents 2 STEP*, Miss Wyoming, Escalator Records, Tokyo, *Early Modulations / Vintage Volts*, Everybody in Pants! – the latest hot air releases p_64-5 p_65

THE UNDEAD

TOY RESURRECTION STORY · Jörg Koch pays homage to the PXL-2000 p_67

<PIN> CODE
a personal key to techno-culture

ON BLADE RUNNER AND THE GRAPHICAL USER INTERFACE · by Lev Manovich p_62

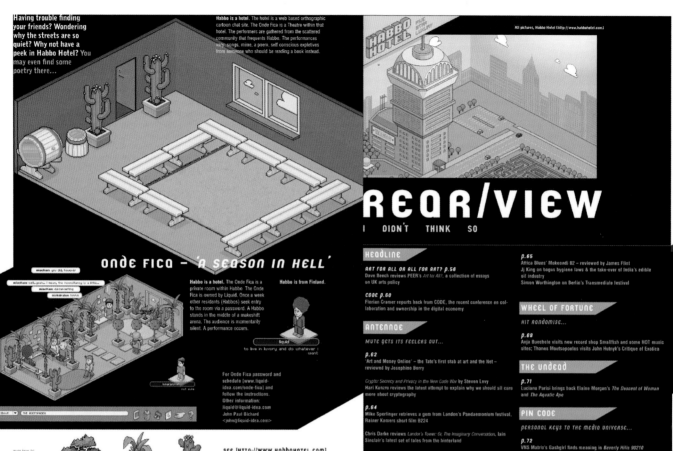

Having trouble finding your friends? Wondering why the streets are so quiet? Why not have a peek in Habbo Hotel? You may even find some poetry there...

Habbo is a hotel. The hotel is a web based orthographic cartoon chat site. The Onde Fica is a Theatre within that hotel. The performers are gathered from the scattered community that frequents Habbo. The performances vary: songs, mime, a poem, self conscious expletives from someone who should be reading a book instead.

All pictures, Habbo Hotel (http://www.habbohotel.com)

ONDE FICA – 'A SEASON IN HELL'

Habbo is a hotel. The Onde Fica is a private room within Habbo. The Onde Fica is owned by Liquid. Once a week other residents (Habbos) seek entry to the room via a password. A Habbo stands in the middle of a makeshift arena. The audience is momentarily silent. A performance occurs.

Habbo is from Finland.

liquid
to live in luxury and do whatever I want

For Onde Fica password and schedule [www.liquid-idea.com/onde-fica] and follow the instructions.
Other information:
liquid@liquid-idea.com
John Paul Bichard
<john@liquid-idea.com>

SEE [HTTP://WWW.HABBOHOTEL.COM]

REAR/VIEW
I DIDN'T THINK SO

HEADLINE

ART FOR ALL OR ALL FOR ART? p.56
Dave Beech reviews PEER's Art for All?, a collection of essays on UK arts policy

CODE p.60
Florian Cramer reports back from CODE, the recent conference on collaboration and ownership in the digital economy

ANTENNAE

MUTE GETS ITS FEELERS OUT...

p.62
'Art and Money Online' – the Tate's first stab at art and the Net – reviewed by Josephine Berry

Crypto: Secrecy and Privacy in the New Code War by Steven Levy
Hari Kunzru reviews the latest attempt to explain why we should all care more about cryptography

p.64
Mike Sperlinger retrieves a gem from London's Pandaemonium festival, Rainer Komers short film B224

Chris Darke reviews Landor's Tower; Or, The Imaginary Conversation, Iain Sinclair's latest set of tales from the hinterland

p.65
Attica Blues' Makeandi 02 – reviewed by James Flint
Jj King on bogus hygiene laws & the take-over of India's edible oil industry
Simon Worthington on Berlin's Transmediale festival

WHEEL OF FORTUNE

HIT RANDOMISE...

p.68
Anja Buechele visits new record shop Smallfish and some HOT music sites; Thanos Moutsopoulos visits John Hutnyk's Critique of Exotica

THE UNDEAD

p.71
Luciana Parisi brings back Elaine Morgan's The Descent of Woman and The Aquatic Ape

PIN CODE

PERSONAL KEYS TO THE MEDIA UNIVERSE...

p.72
VNS Matrix's Gashgirl finds meaning in Beverly Hills 90210

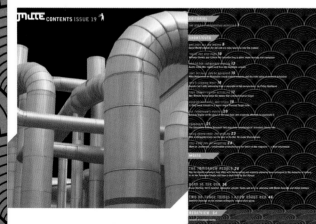

mute CONTENTS ISSUE 19

EDITORIAL

SHORTCUTS

mute CONTENTS ISSUE 20
www.metamute.com

SOCIAL MISERY, MAD PRIDE
Matthew Hyland on social sickness and/or the judicialisation of the mentally ill

WHATEVER HAPPENED TO THE CYBORG MANIFESTO?
Hari Kunzru...

LOOKING INWARD AND FINDING NOTHING

HACKING AWAY AT PATENTS

LOOK AT ME NA, I'M MEMETIC

THE REGENERATION GAME

RACIAL BIOTECH: BUSINESS AS USUAL

BLOCKBUSTING THE ELECTION

GIVE US THIS DAY OUR DAILY READ

THEY DON'T WANT OUR DESIRES TODAY

CONTROL SHIFT COMMONS

A GREENISH BROWN AND UNPLEASANT LAND

TALES OF THE COMMONS CULTURE

THEY CAME, THEY BORED, THEY CONQUERED

Below: (Issue 8, 1997) To accompany a combative interview Jamie King conducted with internet guru Kevin Kelly, a cat, some dried old flowers and a pot plant were combined with Victorian medical drawings to create an oblique narrative with the font Slumber Party adding to the effect.

Right: (Issue 10, 1998) In this contentious layout a picture-to-ascii converter was used and the article name and author picked out in red from the live generated text. Being combined within the ascii text in this way, the scale of the title was seen by many as making it too illegible.

BLUE COLLAR SUBURBS

by J.J. King

THE RIGHT CONNECTIONS
TEA WITH KEVIN KELLY

"Imagine that we live on a steel planet, and there's a hippy bus-load of things that arrive from outer space and they have these big bags of seeds — life — and they're like, 'Do you want it?' and we're like, 'File an EPA report,' — we'd reject it. It's too risky, it's out of control, it's full of diseases. We would reject life if it was given to us right now. And that's exactly what we're doing with technology. Technology has all the same kind of qualities, and we're saying 'we can't deal with it.'"

This anecdote, related to me in a recent interview with Kevin Kelly, speaks volumes about the attitude towards technology and culture promulgated by Kelly, John Perry Barlow, Nicholas Negroponte et al, whose self-promotional chutzpah has established them as the 'digerati'. The unchecked substitution of 'life' for 'technology' is a semantic sleight-of-hand that gives way, here, to the assertion that the same sceptics who want to refuse technology today would be the kind to have wanted to refuse life at its dawn (the implication of the gag, its utter fatuity notwithstanding, being that since only a dumbass would want to refuse life, only a dumbass could want to refuse technology); elsewhere it's a 'switcheroo' (Kelly's word, not mine) that will lend technology the working status of a vital force that, like 'nature', operates outside the reach of social imperatives.

That, of course, leaves a nasty taste in the mouth for those comfy with a 'Tomorrow's World' technology that is 'put to work' for us, achieving palpable results which can be lauded, applauded and then comfortably consumed. Connectionism, with all its zany, bottom-up, out-of-control-ness is anathema to the prevailing picture of technology as humankind's servant. And the digerati, bless 'em, are just bursting to relieve you of such a paradigm.

Fair enough, you might think.

There is a whiff, though, of something rather more pernicious here. For many of us, the invocation of the old bogie 'Mother Nature' as a legitimation for any discourse raises hackles, largely because she's been made bedfellow to some particularly unscrupulous types in her time, lending dumb support to (amongst other things) radical racism and gender discrimination. But it's worse than that, for the connec-

Below: (Issue 8, 1997) Using both BruhnScript and Udo typefaces in the same header, splitting the seemingly computer-generated black and white photograph and combining shapes hidden behind white boxes this opening spread is as much about exploring the depth of the page as it is about reflecting the subject matter.

18

19

waves in the web
by Josephine Berry

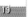 Spot the impostor

Radio on the internet did not start with the appearance of RealAudio. It was there long before. To judge what radio is in the age of digital media, we need to completely overthrow the traditional concept of radio. Radio no longer needs to be a single stream of sound that is transmitted from a central point to its listeners. Trying to produce this type of radio on the net seems contradictory to its inherent qualities. Given the way a lot of people use media at present — zapping through channels and constructing private programmes through combining assorted media — seeking alternatives to centralised broadcasting seems appropriate. Rather than replacing present broadcasting techniques, online radio will bring with it possibilities and freedoms that mass media production denies many broadcasters.

9

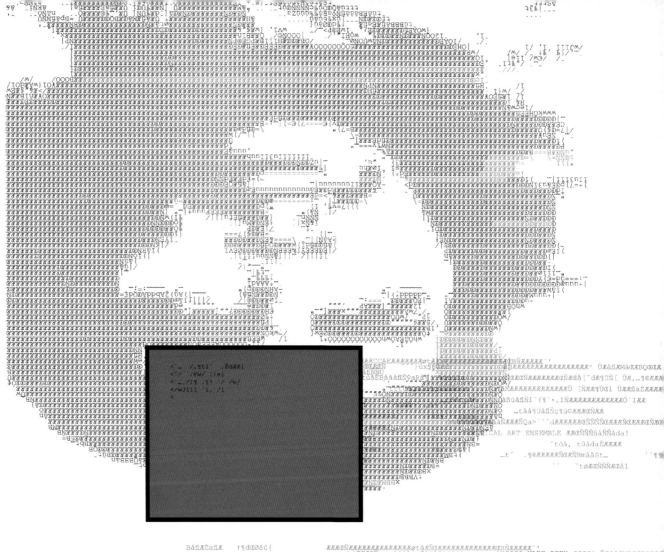

Why is it that our politicians seem to have developed an aversion to debating certain subjects – and we're not just talking sleaze? Squeamish issues like the introduction of gene patenting or the genetic manipulation of animals are debated at length in private, and yet get only very few public airings if compared to the micro-dissections of each new budget. Though no more or less difficult to grasp hold of than a system as complex as the economy, we, the electorate, are under the collective delusion that these matters are over our heads and best left in the hands of the experts. And those experts are as impartial as only captains of industry and research scientists can be. So why have we relinquished our control over the introduction of certain scientific and technological developments into our society, and what is being done to resist this institutionalised passivity? *Mute* interviewed the Loka Institute's founder and director, Richard Sclove.

TECHNOLOGY CONSENSUS CENSUS

M: I'd like to start by asking you a bit about the work of the Loka Institute.

RS: The Loka Institute is a non-governmental organisation based in Massachusetts in the United States, studying and calling attention to the social effects of technology. We do advocacy work and organise the development of new participatory institutions to get a wider range of people participating in decisions about science and technology.

M: What successes have you had so far?

RS: We haven't succeeded completely with anything, but the two institutions with which we've made most headway are modelled on European institutions. One is a variant of what in

Europe a[...]
oped in t[...]
versities [...]
tions rais[...]
tions, tra[...]
way of h[...]
industry,[...]
for other [...]
 In th[...]
because [...]
between [...]
the Dutc[...]
thing fro[...]
for a wor[...]
there wo[...]

(Issue 9, 1998) An article from the Technoscience issue continued the use of images taken from an old Time-LIFE book. The incorporation of pictures with the use of pared down graphic elements is used not only to reflect some of the design aspects of books from the '50s and early '60s, but also to create a feeling for the reader of being examined as if in an experiment. The constant height of the title (set in Udo) defines the slit that the scientist is peering through.

station. In the US we found there already were a certain number of organisations who did community based research. The main difference is that in the Netherlands basically every Dutch university has one to ten of these community research centres. And they are networked with each other. Originally this was just by telephone and newsletter, these days it's with the internet, and they're networked with each other in a way that if a community group wants research assistance on a social change project they can go to any one of the science shops and they will be referred to any one of the centres that has the kind of expertise they're looking for. So in the Netherlands, they have a comprehensive system that can basically address any community oriented concern on any topic coming from anywhere in the country.

M: So what you are saying is that in the States the existing research centres are randomly distributed and working independently of each other?

RS: Absolutely, their distribution is very accidental. And they haven't even been aware of each other's existence. So the first thing that we've done is to make these existing programmes and centres in the US aware of one another and begin to develop a capability to learn from one another, to make references and be more visible and accessible.

M: Is the internet really helping to encourage that kind of activity?

RS: It is. I don't say that as an unqualified supporter of or enthusiast about the internet, as I spend a lot of my time talking about its potential downsides, but yeah, in this case it has helped a great deal. I mean, when I first started writing about this I published an article in a conventional newspaper and then on the internet, and the conventional newspaper got me one or two phone calls and the internet distribution quickly yielded 300 people who said, 'yeah, I want to work with you on this'.

M: Well, it's certainly how we found you.

RS: We found that the existing centres and programmes in the US are excited to find out about each other's existence and are generally quite eager to work with us on building a net-

work. The challenge is as always to find funding to support this effort. [laughs]

M: Are you getting any state funding for your work?

RS: Very limited. But not zero in my case. We happen to be based physically in Massachusetts and our state wide extension service which is government supported has contributed some financial support to this effort.

M: Now I wonder whether I can ask you a bit about why you've chosen the subject of science and technology to focus on peoples lack of influence within the decision making process, as opposed to the multitude of other issues that also affect us. For instance our defence policy. Why is it that you different in a democratic system where we elect representatives and at that point waive our own individual say in those issues?

RS: Well, it's actually not very different from the military issue, but I'd say the military and the science and technology issues together are different from most others.

M: Why is that?

RS: There are probably several reasons why I focus on science and technology issues. I don't do it because I think they are the most important issues in the world. I think they're up there, but I think there are lots of important social concerns about ordinary housing issues and welfare and medical issues. So it's not that I think that it's the most important. But among important issues, it is one that gets the very narrowest public representation or participation. For instance, (I know the US case best, because that's where I live) in the US our democracy is imperfect in many respects. But I'd say there's more imperfection in the science and technology decisions are made than in many others. For instance, we elect representatives to our congress in the US, but then we don't assume that they just do their own thing. We also assume that they are responsive once they're elected to various popular social concerns. Now in most issues, like education, or health policy, even though it's imperfect, there is some sort of public interest or community representation. In congressional deliberations, for example. Business lobbying may typically have a disproportionate say, but there is

going to be some kind of public interest or community voice or representation...

M: And you would say that was based on the ease with which the lay person can understand issues to do with welfare, for instance, or housing, as opposed to the exclusive language of science?

RS: That's a piece of it, but that's not the whole of it. In science and technology policy making, our congress is influenced pretty much exclusively by representatives of three groups which are: business, the military and elite academic researchers. Nobody else has a voice and yes, the argument that those three groups would make is that of course they should make those decisions because first of all, they take the broad public interest to heart and are good representatives of it and secondly, other people, they claim, wouldn't understand these issues and wouldn't want to participate.

M: How do you practically see the possibility of translating the complexity of scientific ideas and language into a language that the public can understand in all its subtleties, so that they're then equipped to make a valid judgement?

RS: Right, if there were more time I'd answer that in a few ways, but I should probably just talk to you about why I'm in

Denmark rather than talking to you from the US.

M: Maybe you could answer that question through the practical example of Denmark.

RS: The Danish government has really made strides in developing now participatory institutions that address exactly that concern. One of them is something they call the consensus conference, which has been done about 15 times over the last 10 years in Denmark, and since then maybe half a dozen times in other European countries. The process is a little bit like a jury in a court. If the Danish government is going to be debating a complicated, controversial question like biotechnology policy or how we should make use of knowledge from the Human Genome Project, their Board of Technology – which is where I'm currently working – assemble a jury [as it were] of about 15 quasi-randomly selected Danish citizens. The panel excludes anybody with expertise on the topic and it excludes anybody from an organised interest group that is active.

M: How are these people actually found?

RS: They've done it differently in different countries. The way they do it in Denmark is advertising in local newspapers. When we did the first one of these as a pilot test in the US last April we did it through random phone calling. In any of these you

assemble a steering committee that oversees the whole process. A steering committee is composed of knowledgeable representatives from groups that do have a stake in the issue. Some would be from industry, some from academia, some might be from public interest groups.

M: And there's no danger of the steering committee putting pressure on the elected panel based on their own interests?

RS: Well, there would be that danger. The way, if you do it properly, and the way they appear to do it in Denmark is if you pick that steering committee, it should be a balanced group who counterbalance each other. The one time something of this kind was done in the UK, that was not done, and the steering committee had precisely some of that biased impact you're referring to. Not that they directly influenced the lay panel, but I think they influenced the materials and experts that the lay panel interacted with.

M: I see. And they're there to really explain the issues, explain the material?

RS: Not the steering committee. Because the steering committee is actually balanced against itself, they assure some reasonable impartiality to the process. But the process is that the lay panel spend two weekends being brought up to speed a little bit on the process. They review some material that the steering committee agrees are not biased wildly one way or the other, and maybe would not meet with experts in the Danish case. But if, for instance, they're doing something on biotechnology they might meet with a high school teacher who explains to them a little bit about DNA and they might meet with a journalist who explains a little bit about the political terrain of the issue and who the actors are. Then they have a three or four day public forum, after the lay public has been brought up to speed on the issues, that takes place in Denmark in the parliament building. And there anyone in the

public or media who's interested can sit in while a group of experts (that the steering committee has approved as not being biased) take turns testifying in front of the lay panel. Then the lay panel takes turns cross examining them. Finally the experts are all dismissed and the lay panel writes up a report drawing their own policy conclusions on the question.

M: And what sort of impact do those decisions, that as far as I understand are not then turned directly into legislation, have on the way that policy is decided or the way that industry then decides to back certain kinds of practices and research and not others? Have there been any positive examples of that?

RS: Yes, in Denmark where it's been done the most and where it's become most institutionalised there are demonstrable impacts. They don't, as you said, become law and I don't think anybody believes they should because it's a very small group and it's not adequately representative of the whole society. It's a way of getting an informed, diverse lay perspective into deliberations, but you don't want to determine those deliberations.

In Denmark, they did a conference on food irradiation in 1989 and that influenced the parliament to ban irradiated food in Denmark, except in the case of dried spices. They did one on the use of knowledge from the Human Genome Project and that influenced the parliament to place strict controls and limits on the use of genetic screening information on insurance and hiring decisions in the work place. And there's some evidence anecdotally that it has, without going through the policy channels of the industry, some influence on industry. Industry in Denmark was initially assistant or sceptical to the process for the same reasons you'd expect it to be in most places. But over time, because these processes occur in the early stages of the development of a piece of technology before a lot of money has been invested by industry, it actually gives them political foresight that can be very useful to their own bottom line considerations.

M: So it's like a very early feedback source.

RS: Yes. For instance, the opposite of that was in the US, where the Monsanto Corporation, about ten years ago spent 300 million dollars developing something called Bovine Growth Hormone to artificially stimulate cows' milk production. As soon as that was brought to the market it turned out that small farms and many consumers opposed it. But because Monsanto had no public input at early stages and had already sunk 300 million dollars, they fought like crazy to make sure that this thing went to the market whether consumers wanted it or not.

M: How do you see the shift during this century from industrial technologies to information technologies? Do you see any positive developments in that change?

RS: Yes and no. I see no positive developments in the uncritical, one-sided enthusiastic hype about IT being a panacea that's going to solve all kinds of social problems. That hype is quite dangerous because these are complex technologies, and any implementation of them will have good and bad effects. But some implementations will still be better than others. The hype just conceals those choices that need to be made, and allows industry to make them without public participation. So the hype is bad. As for the technologies themselves, I'm quite ambivalent.

M: But the net is clearly a cheap way for you to challenge the information monopoly of the large corporations...

RS: Loka is a small NGO, we function like many such organisations on a very insecure shoestring budget, always in danger of going under financially. We are basically challenging dominant institutions and forces by arguing for democratising decisions that existing powerful institutions like controlling. For that reason it's hard to get resources to do what we do, and that's one of the reasons that we do a lot of our work on the internet. It's not that I intrinsically love the internet. Given that these issues are politically very under developed [there's not a long history in the US of people thinking about how to broaden representation and participation in technology issues, and there's not a lot of money to work on the issue either] I have often chosen to do what I would call preaching to the predisposed-to-be-converted. After very little persuasion they become allies. So I haven't engaged that much with industry because I'm busy doing something else.

M: You take the example of the Amish to discuss the sophistication with which certain societies handle the inclusion and exclusion of technologies. Why did you choose the Amish as an example? I am especially interested to know how you think that you can apply such a model, derived from a very small and closed society, to a comparatively vast and heterogeneous society such as the USA's?

RS: There are a couple of reasons. It's not that I uphold them as an ideal society, but with respect to decisions about the introduction of technology and their social effects the Amish are the experts. And what's interesting about that is that the strictest old order Amish in the States, of which there are

about over a hundred thousand in some 25 states, prohibit formal education past the age of fourteen. So they have this population that by conventional standards is very uneducated in school based ways. And the standard argument in our society is that lay people can't participate in these decisions about technology because if you don't have a PhD in mechanical engineering or biology you can't understand them. Yet what is fascinating about the Amish who are popularly seen as being anti-technology because for instance they still use horses a lot] is that they still use a lot of modern technology, but very selectively. They will, for instance, use tractors, but not for what they were intended. They'll use horses for ploughing and will sometimes own tractors, but put them into neutral and drive them around the farm and use them as a mobile source of mechanical power to do other things. What's fascinating is the way they make the decisions. They do all sorts of, upon reflection, not obvious things that we don't. Like it's real hard to predict the social effects of a technology, so one of the things they do is put new technologies that they're curious about on probation for a year. They say, anyone who wants to adopt it for a year can do it, but we're going to watch what happens to us as a result and re-evaluate at the end of a year, and if we think that it's not having a bad effect we'll continue allowing people to use it. And if, after evaluating it, they conclude that it's having a bad effect then they won't use it. That's a simple empirical test that we don't do. We do it for drugs. We sort of won't allow new medical pharmaceutical products onto the market until we've tested them for their medical effects. But we'll allow any technology, no matter how upsetting its social and political consequences, out there if it makes a profit.

M: I suppose these with the Amish, the question is: how is this decision making process structured? Is there any real opportunity for political dissent?

RS: I'm not putting the Amish up on a pedestal, in the sense that regardless of what the answer to that was, what's interesting from my point of view is the fact that these people, who don't educate themselves past fourteen in schools, can still make very sophisticated evaluations of technology's social effects. Even if you feel that they did that in an undemocratic way.

M: Do you feel that small initiatives like yours can have an affect in a culture which, in comparison, has introduced technologies in a far less thoughtful way?

RS: I would say that in absolute terms LOKA hasn't had that much affect, and yet on other initiatives have been disproportionate to the time we've existed on our resources. We already have roughly 7000 people on our internet list serves world wide and a considerable international following. But we're at too early a stage to know how much headway we can make.

Richard Sclove was interviewed in August '97 by Pauline van Mourik Broekman and Josephine Berry during Mute's Technoscience slot at the Hybrid Workspace. Sclove was in Denmark at the time, working on the Danish government's Board of Technology as a visiting researcher. Sclove is also the author of Democracy and Technology, New York/London, Guildford Press. [www.sadnet.edu/~loka], and email: XLoka@stanford.edu.X

DEUS EX MACHINA

DEUS EX MACHINA

DEUS EX MACHINA

"DON'T SIMULATE THE REAL WORLD, SIMULATE WHAT PEOPLE THINK IS THE REAL WORLD"

God games are a genre of video games which position the player as an invisible controller/manager/all-seeing-being of a simulated real-time world. From the early days of pixellated three-quarter view landscapes with tiny bit-mapped creatures running around, to today's slick, beautifully rendered, near-photographic 3D panoramas with convincing creatures and stunning special effects, the task remains the same: to nurture, coerce and assist the inhabitants or bully, maim and generally subject your populace to a lighter shade of Armageddon. The result of your labours is to either bring peace and tranquillity to the kingdom, or throw it into terminal darkness. Grandfather of God games is Peter Molyneux, one of the figureheads of the games world and developer of the soon to be released title *Black and White* – featuring bells, whistles and a huge creature that you directly control. John Paul Bichard catches up with Peter Molyneux at his Guildford bunker and tries to dig beneath the cranium of the man who would be God.

(Issue 15, 1999) In this article on Peter Molyneux, one of the founders of 'God Games', the use of this serif typeface, and Latin in the title, is evocative of carved stone tablets.

typography

main: ccru/o(rphan)d(rift>)

HOW MANY DEMONS CAN YOU COUNT ON THE FINGERS OF TWO HANDS?

BY JAMES FLINT

'Syzygy' – in plain English a conjunction or opposition of two things, especially heavenly bodies – is also the name of a recent show at London's Beaconsfield by the Cybernetic Culture Research Unit and Orphan Drift. The two groups (with occasional collaborators Traxis, Ocosi, Kodwo Eshun, Dmitri Nakov and Apache 61) yoked together their separate but related projects which anthropologise number, fictionalise anthropology and enumerate fiction. In a culture for which number and capitalism have become virtually indistinguishable, and with Y2K threatening to be the world's worst numerico-economical disaster, Syzygy attempted to recuperate the generative and mystical properties of numerical systems. JAMES FLINT reports back from the South London plateau.

"WE'RE IN THE MIDDLE OF A HYPERFICTION SCIENCE-FICTION STORY RIGHT NOW, PLOUGHING OUR RESOURCES INTO A PARALLEL BUT DIFFERENT SYSTEM OF TEMPORAL PROCESS. WE'RE BUILDING UP TO A GLOBAL DISASTER FOR WHOLLY SYNTHETIC REASONS." – MARK FISHER, CCRU

Small, neat, manic, intense, Mark Fisher talks to me about the Millennium Bug, the 'Y2K problematic' as he calls it. As a way in to the Syzygy show, the umbrella term for the five week-long mix of Gibsonian Cyberpunk portentiousness and post-Deleuzian number theorising that occupied Beaconsfield Arts from February 26th to March 28th of this year, it seems as good a place to start as any. The Millennium Bug, nicely heralded as it is by August's solar eclipse, is the point at which our ultra-modern mathematical culture collides with the astrological soothsaying of the Maya and the Ancient Egyptians. Just as the Mayan city of Chichén Itzá was abandoned in the 9th century when the calendar drawn up by the priests came to an end, the inhabitants suddenly finding themselves outside of time and with no way forward but a return to a rural jungle existence tied to the rhythms of the earth rather than those of the stars, so the Y2K crisis – the biggest disaster ever to hit capitalism, with costs currently estimated at US$36 trillion and rising – is, according to Fisher, "a disaster that's happening simply because of the date." A disaster, yes, but equally – and within the terms of the show – an artificially created opportunity, a doorway, a portal created by a certain configuration of numbers but through which demons and avatars – transformational and organisational machines – may pass. The syzygy here, the pairing, the twinning, is of the dark realm of fiction and the light realm of the real, the interface between them the dynamic possibilities of number.

IMAGE: ORPHAN DRIFT. BODY IMPACT BY TRAXIS, PHOTO LAURENCE WATTS

SUPERWEED 1.0
Natural Reality

Above: (Issue 13, 1999) In typical irreverent style the type is stuck in the middle of the main opening photograph. Lipo-D Vectorized is set intentionally with very deep leading.

Right: (Issue 16, 2000) The pure yellow background shows the beginning of a trend to use one of the four process colours at 100%. The small symbol-like illustration was provided by the Cultural Terrorist Agency.

ART IS USELESS

VUK COSIC : MEMBER OF THE ELITE CLAN OF NET ART'S 'HEROIC PERIOD'; ASCII IMPRESARIO; LOVER OF LO-TECHNICITY; HABITUÉ OF THE EUROPEAN ELECTRONIC ARTS CONFERENCE CIRCUIT; STAFF MEMBER AT THE SOROS-FUNDED LJUBLJANA DIGITAL MEDIA LAB; SENIOR LECTURER AT THE INSTITUTE FOR PARADOXOLOGY, INTERNET, AND THE HUMAN EMANCIPATION/ ENSLAVEMENT CONUNDRUM; ANTIQUARIAN DEALER IN THE NEW; WORLD TRAVELLER; MULTI-LINGUIST AND CHRONIC VERBALIST. **JOSEPHINE BERRY** MET WITH HIM IN LONDON THIS FEBRUARY.

Vuk Cosic believes in essences: the originality of the avant garde, the possibility of narrative, the lessons of history, what comprises art's jurisdiction, the right way to make a coffee or prepare a California roll. In one of his best known net art works, *The History of Art for Airports*, Cosic compresses thousands of years of art history, from the caves of Lascaux to the net art of Jodi, into a few images of recombinant toilet people interacting with cocktail glasses and other airport fare (eat your heart out Ernst Gombrich!). But if representing thousands of years of art history using airport signs seems like a consummately postmodern gesture you only have to consider, and notwithstanding their irony, how much substance these minimal icons endow their referents with. Stripped of its aura, art history is clad in the uniform of utility, its canonical works whittled down to one-line gags.

Unlike postmodernism's typically dehistoricising language of pastiche, this account of aesthetics roots each developmental moment within a life world. The life world is primarily constructed through an elaboration of art's function-ality: art in the service of religion, art in the service of the state, art attempting to elude power. These spare images

Above: (Issue 13, 1999) Lipo-D is used here in the opener to an article on 'ascii impresario' and net artist Vuk Cosic. The illustrative orange element takes its cue from droplets of water and contains a picture of the interviewee.

Right: (Issue 15, 1999) Orange is used strongly again here although this time it is within a more formal layout where quotes are revealed by 'sliding' sections of the background.

Take three millennial London moments: Conservative mayoral candidate Jeffrey Archer's exposure as a liar; the city police's response to J18 and N30 carnivals against capitalism; and the Lord Mayor's parade. In the image of which shall we cast the future of the city? Let's ask the Mayor. In London's fairy kingdom, where magic wands and realist fists rule in perfect harmony, **Matthew Fuller** listens in on the interior monologue of a civic Godhead.

Political leaders have to make the choice between being either boring or evil. Most of them don't have the guts to make the right choice.

By Cornelia Sollfrank

SHARE AND BE SHARED

(Issue 21, 2002) The burglar figure climbing through the window, in this opener, is used to illustrate the arguments over file-sharing.

Ulrich Gutmair: You live in Texas
and have spent a lot of time under the rule of George W. Bush,
so perhaps you could tell us something about his politics? From
what I've heard, he represents this idea of 'compassionate
conservatism', which means deregulation and having churches
which feed the poor. What do you think his presidency will mean,
in terms of change, for the USA?

Bruce Sterling: In terms of
change for the USA, probably not very much – it's just a
restoration of the Bush dynasty. All the old hands on the Ford
administration and the Bush administration are back in power
and he's just a young man who is the acceptable face of that
particular establishment. He's very popular in Texas. He's not a
megalomaniac or anything. He is just a young man of privilege
who happens to have inherited this office.

You could think of it as the Hohenzollern dynasty, this
sort of imperial- military power. The USA is the world's
policeman and our Secretary of State is now the former Chief of
Staff of our army – generally not a good sign, you know. If
somebody says: "our General is our Secretary of State" that
generally indicates that the Cruise Missiles are warming up in
the basement. But it won't be about Europe, it will all be about
Iraq, I think the Bush dynasty is convinced the only real
interests America and the rest of the world have are resources –
specifically oil. We've had an energy blackout in California and a
lot of the campaign was centred around energy policy.

The idea is "go out there and dig, dig, dig". Not only are
Bush and his father old men, but the Vice President is also a
very, very active oil man. I think it's kind of a segue back from
the 'New Economy' as represented by Gore to the 'Old
Economy' as represented by these oil moguls. What does this
mean from a European perspective? Basically nothing! I don't
think Bush even knows Europe exists; he can't tell Slovenis
from Slovakia, he thinks the Americans have no interests
whatsoever in the Balkans. They'll moan and complain about
the idea of separate European armed forces, but probably
nothing will happen just because it's too much trouble.

But it's not like he's a maniac or anything. There are people
in the American Left who are coming on like the guy is a lunatic:
dyslexic or insane or possibly stupid. It's always a bad mistake
to call any politician stupid – it gives him an opportunity to do
whatever he wants and not have to take any blame for it.

Underestimating your opponent is one of the *stupidest* mistakes
you can make.

UG: You say the Bush presidency won't have any
consequences for Europe. But, on the other hand, you as the
leader of the Viridian movement – which is concerned with the
Greenhouse Effect – should be interested in all these oil people.
Unlike Al Gore, I don't think they will be remotely interested in
having a Green policy. Could you could explain what the Viridian
movement means?

BS: The Viridian movement is kind of my hobby crusade
against the Greenhouse Effect. I'm a futurist and I'm very
interested in issues that aren't a big deal now but will soon be
pressing on people. I really think the Greenhouse Effect is
starting to change the climate pretty rapidly and it's going to be
one of the most important things about daily life in the 21st
century. People looking back from their perspective of, say, 2020
and reading contemporary political coverage will just be
shocked that nobody was addressing this issue. It'll be like: were
they in a dream or sleepwalking? What was the problem? So I
make a lot of noise about it.

It's true there are the oil people but, in point of fact, oil
people and private enterprises are doing some pretty good work
in the way of the Greenhouse Effect. I'm very impressed by what
BP does. If you're gonna reform the energy structure you can't
just march with pickets, you actually have to build a different
energy structure – I mean you have to *build* it, and it's *dirty work*
– like, with shovels! It's not something you do by pressing the F1
function key. Actually, George Bush's house in Austin has been
solar-powered for quite some time. He's on the Green
Programme in Austin. Some of his supporters are not just
energy people but right-wing Greens – sort of an unknown thing
in Europe because there's such a strong Red/Green coalition –
but I'd consider someone like Bill Ford of Ford Motor Company
or John Brown of BP basically to be right-wing capitalist
Greens. There's no reason why you can't make a lot of money
selling green energy, there's a business model there. It's not like
a dot com, it's like 'voltage dot com' and there's this wheel that
turns around and people get paid for that, it's not a difficult
matter. I'd hope to see some progress made there but, let's face
it, America is not the leader in that issue – Europe is, straight
out and across the board! So people around the world shouldn't

expect America to carry the torch for every single thing. There
are just some things Americans are no damned good at.

Martin Conrads: How do you
see the political impact of someone like Ralph Nader? Will there
be a continuity for the next voting period? Or was his just flash
in the pan success, a way of breaking up the two big political
opponents?

BS: I don't know, I mean they're very determined to go
drill in Alaska, sort of drill off the cost of Florida. And oddly
Jeb Bush, the governor of Florida, doesn't like the idea of oil
derricks off the coast of his state. He thinks it's going to
interfere with tourism, so there may be a struggle between the
vice president's oil buddies and the president's brother over
the spoils here. Eventually I think Green issues will rise more
and more to the fore because rich people don't like having their
houses blown down in monsoons. It's a drag when the weather
starts decaying because, hey, the rain falls on the rich and
poor alike. Okay, it's not some kind of socialist equity issue, but
in the American two party system, third parties are
traditionally corrupted. So I'd expect the Greens to have their
clothing stolen. It's just a question of who gets it – is it like the
right-wing Green thing that's represented by these new
corporate Greens, or is it the sort of old fashioned Red/Green
coalition that Gore tried to put together – which sort of kind of
worked, because Gore got more votes than Bush?

The Left is actually making a pretty strong showing in the
US right now. It's an open question as to which party is better
able to address that particular issue. Right now very few
people feel it. It can only get worse – it's like failing to take out
the garbage, it smells bad but not intolerably bad, but you just
know it's gonna smell worse and worse, it's just got to. It's a
chronic problem and someday somebody is gonna do
something about it. I don't think the initiative is gonna come
from the US though. If it's coming from anybody it's gonna
come from the Danes. Like, right now West Texas is full of
giant Danish windmills from the Vestas corporation. I mean, it
used to be that Texans would go into the North Sea and build
these giant derricks and now it's all about Danes showing up
and building these giant wind derricks! That strikes me as a
little weird but, you know, hey, they deserve it – they invented
them! They've got the best wind technology around.

UG: I found a short
quote, something you said about
the whole idea of 'Islands in the
Net', and all the Hakim Bey
followers who took it as a very
literary model, the idea of
having these distributed zones?

BS: Yeah, the Temporary Autonomous Zone...

UG: ... you said that the TAZ will ultimately be more
advantageous to the deregulation of capitalism than to the
forces of liberation.

BS: Yeah, I think the TAZ – in the way that Hakim Bey
describes it – is an accurate reflection of something like an
illegal rave. But, you know, if you want to engage in illegal
activities and you want to use that particular technique, it
doesn't matter what your political convictions are. Just like
everybody can pick up a protest sign and march in the street. It
doesn't matter whether you wear a red shirt, a brown shirt, a
green shirt, a white shirt or a black shirt – I mean, *they are all
shirts!* It's not like long-haired drug addicts have some kind of
copyright on temporary autonomous gatherings that show up,
accomplish something illegal, and then scatter in all directions
leaving no trace. What that really sounds like is illegal North
Sea dumping. That would be like: "I've got trash, you've got trash
and we could get rid of it by recycling it. But that costs a lot of
money – so why don't we have like a trash-dumping rave? Well
just get this cool old ocean-liner and take it out into the
international waters where no-one is looking and throw
everything over the side and then we'll all go back where we
came from, just like: hey man, party"! Instead of looking at each
other saying: "boy are we cool, we fooled the cops one more
time", they'd be saying: "wow, we saved a lot of money! Let's do
this again"!

MC: There is this project by some people from
Oklahoma building this 'New Utopia' island in the Caribbean,
some libertarians. Have you heard of this project?

BS: I've heard of a lot of 'Island Republic' bullshit over
time, yeah.

photo graphics

*Above and right: (Issue 19, 2001) In this
interview with Bruce Stirling the extreme
geometric cropping used in the magazine is
taken to its most extreme limits. The actual
subjects of the photographs are masked to
create an unsettling feeling of absence.*

MC: Are they just fools, or is it the newest dream of the American frontier, or is this the contemporary format of an autonomous zone, or is it just hype? Is it taken serious in the States?

BS: Well, the Sealand thing got a lot of press. These Linux guys said: "well, we're gonna build up a rogue node on the Internet and do all this stuff..." or whatever. But my question is: what's the revenue model? There are a lot of counter-cultural organisations all over the place. There are lots and lots of religious communes, like the Amish in the USA, that are sort of semi-autonomous. The Amish can't be drafted and they don't pay certain amounts of taxes, they're tolerated because they're cute. The main reason they are tolerated is they look after themselves, raise their own crops and create their own buildings.

And then you got a place like Christiania in Copenhagen, where a bunch of guys took over this military base 27 years ago where it's like: "you know, we're *Autonomen*, and we're gonna squat this place and build our own beautiful rainbow flag hippie republic here". So, what do they actually do to make money? Mostly they sell hash, and they sell it to people who are coming in from the rest of the city. Now if they were just selling to each other and they could sustain an economy that way that would be okay, but that's not the truth. In point of fact they are merely parasitic. They're just retailing their autonomous legal status in order to break the law of some larger society and then retail their sort of semi-criminal enterprise.

So, if we gonna go build an independent island – and it's actually economically self-sufficient – that would be interesting. That would be *very* interesting. But if you just build one because you're trying to profit on this black marketeering scheme sooner or later somebody is just gonna step on you, maybe not this week, maybe not next week, but...

The other problem you might face is that as soon as you set up your TAZ somebody else will build one right next to you and then he's gonna come shoot you to get your turf. That'll be my prediction. Either two of them show up and there's a gang war between two independent republics both trying to seize this

> "Obsolescence is the future in reverse. You want to know how things are going to arrive on the scene? Well, watch how they leave...".

market, or else there's some kind of internal power struggle among the pioneers over whether it's really about autonomy or about the black money. Over the long term it's *always* about the black money! As long as there's black money it's like: "Cut to the chase. Just give me the cash! Forget the independent hand-waving temporary autonomous bullshit! Just give us the fucking cash"! It's like Grenada. Maurice Bishop: "They have turned their guns on the masses!" No, Maurice, they've turned their guns on you, okay? It was on you! *You* were the guy getting shot in the tennis court, not 'the masses', okay? It's like running around, doing your little thing here, arming the population and preaching, preaching, preaching. What was it about? Offshore money! All you have to do is look at the history of those things and you can predict how that's gonna shake out. If you can maintain the ideology and also have a productive economic system – if you could do that the Soviet Union wouldn't have collapsed, frankly. What's the problem there? No jogging shoes, man! No toilet paper! That's the problem. The economy does not function, it still doesn't function!

MC: In *Heavy Weather* you described how the run on information about the weather brings a whole system into terminal velocity. At the time the New Economy crashed in Europe the climate was also crashing and still is. There were those big rainfalls in England, for example. Are you surprised by this coincidence? Or is it like two sides of the same coin and that, in fact, the run on weather data is the great hope for the New Economy after the crash?

BS: Well, I think we're gonna see a lot more economic crashes and a lot more weather crashes. Like, the Champs-Elysées has its trees blown off, Britain is knee-deep in water, the Alps are melting and the glaciers are melting. It's becoming

mute essic 19

TWO OR THREE THINGS I KNOW ABOUT HER

To gentrify or to regenerate? The British government prefers the latter. With its commitment to public-private partnerships, city-centre repopulation and social inclusion it hopes to save cities on the verge of a nervous breakdown. But, faced with building projects to rival the scale – if not vision – of Egyptian pyramids and gothic living conditions to match, they're far from salvation. **Benedict Seymour** looks at the reality of regeneration in the modern metropolis.

Photos: photography Daniel Jackson, art direction Simon Worthington
This page: Holly Street Estate ruins, Hackney, London

mute issue 19
47

(Issue 19, 2001) A bold headline and tight cropping of the introduction set up an architectural theme – demolition in the name of regeneration in Hackney, London. The effect is further heightened by the photograph by Daniel Jackson.

> Image: Telehouse, Docklands, London

A hidden battle is raging between our fundamental right to privacy and the requirements of the state to maintain and advance its powers of surveillance. The battlefield is complex and confusing, the players numerous. Modern information technologies are key: they have created the many new media in which we communicate, and accordingly increased authorities' requirements for extensive and invasive information-gathering capabilities. The means by which these authorities go about obtaining such information is far from straightforward. There are legislative components, such as the Enfopol papers, which are drafted by the Police Cooperation Working Party to define EU policy on 'lawful interception'. There are physical, technological components, such as Echelon, which has the power to intercept a significant proportion of today's global communications traffic. Together, such components are actively contributing to a steady decay in personal privacy. Independent media, and the journalists who have forced covert surveillance and information-gathering agendas out into the open, are crucial in this ongoing battle for privacy. Perhaps chief amongst media outlets for such reports has been the online journal *Telepolis*, publishing investigations from reporters such as Duncan Campbell, Christiane Schulzki-Haddouti and Eric Moechel that have been instrumental in shedding more light on phenomena like Echelon and Enfopol, and opening up public discussion – thereby edging the technologies of 'lawful interception' towards some form of accountability. Here, Armin Medosch, editor of *Telepolis*, discusses the recent history of today's surveillance regime and looks at some critical developments in the technology and legislation which underwrite it

A VERY PRIVATE AFFAIR

photo graphics

(Issue 21, 2002) A photograph taken of Telehouse in London's Docklands area just after September 11, 2001. The photographer did not want to be named in the magazine as he was worried that his activities might make him a target for surveillance.

HARVEST TIME ON THE SERVER FARM:
REAPING THE NET'S BODY POLITIC

There is no *anno domini* for Internet time: its converging technologies and overlapping histories do not easily lend themselves to one linear story. 60s guru Marshall McLuhan called communication technologies the extensions of man; e-business bible *Wired* heralded the Internet as a revolutionary medium; influential sociologist Manuel Castells calls the political landscape it helped create 'the network society'. But, since the mid 1990s – the time of the Net's first 'big bang' – it was arguments over its social character that vitalised the net community. Fought everywhere from the media to the academy, zines, lists and conferences, these philosophical gang wars seem to have lost their ferocity (perhaps even their raison d'être) now the Net has been normalised. In the public imagination, extropians, hi-tech

Buddhists and hackers – all of whom claimed the Net as quintessentially [] have been replaced by online shoppe[rs], traders and dot com entrepreneurs. [at the] same time, metaphors from its heyd[ay] out-of-control hives and other biolog[ical] systems – continue to permeate pop[ular] discourse; the new lexicon can accommodate 'global brains' and 'emergent orders' very well. So, wha[t of the] Net's body politic, roughly seven yea[rs into] the Internet 'revolution'? Can we eve[n] speak of 'bodies' anymore? Pauline v[an] Mourik Broekman chewed these issu[es] via email with three members of an[other] Internet-bound tribe, the digital art[s] community: Sara Diamond, artistic [director] (MVA) of the Banff Centre for the A[rts], Roy Ascott, pioneering electronic art[ist and] Geert Lovink, speculative media the[orist]

illustration

Above and right: (Issue 18, 2000) The clip-art businessman from the cover is brought through onto the pages of the issue and is joined by other business figures. Deconstruction of the artwork creates a series of flat plains that are interrupted by strident 45 degree boxes.

354

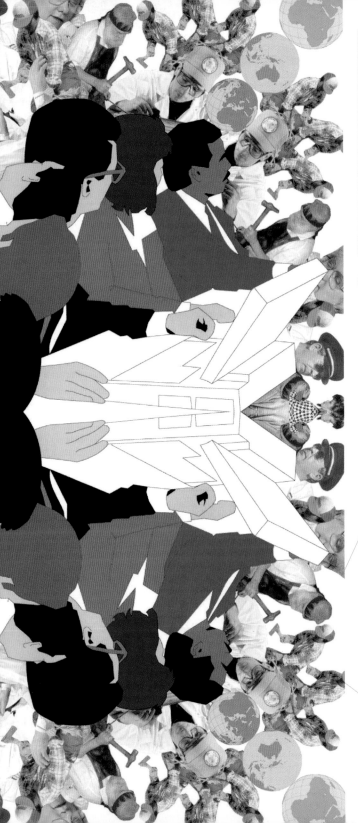

THE TOMORROW PEOPLE

For a good few years before the NASDAQ began to crash, a certain synchronicity existed between where California's tech companies said they were going and where their share price went. Did they know something the rest of us didn't? Or did they have better kit? One popular tool they might have used is 'futurecasting', a cybernetically enhanced mode of storytelling. Last summer Hari Kunzru went to California to meet the Global Business Network, an eclectic cabal of futurecasters, and its founder Peter Schwartz. One year on, how bright does the futurecasters' future look?

In this view Schwartz and his organisation are not 'objective' futurists, but proponents of a particular free-market libertarian political position which has the not-coincidental effect of reinforcing America's global hegemony.

The crash was neither predicted nor planned for. This has an irony to it, since prediction and control of the future were the cornerstones of the ideology driving the dotcom bubble.

(Issue 19, 2001) More is more. Worthington mined the clip-art image libraries for the elements of this Mandala-like shape – line-art and photographic workers ending up as so much tragi-comic business décor. The image was then used within the strong geometric page elements that, though related to the setting out of the main text, subvert the simple two-column layout and create the trademark effect of spatial disjunction.

illustration

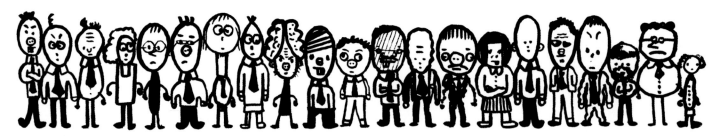

Oh no! It's another APPLE CRASH

by Ian Betteridge

In one sense at least Apple have finally overtaken Microsoft. In this year's Clash of the Launches (Microsoft's OfficeParty 97 versus AppleParty 97) the Jobs-machine has out innovated the Gates machine: while OfficeParty was trying (in time honoured manner) to sell the media a product – the Office 97 software suite – AppleParty was trying to sell it a concept.

If the AppleParty venue (a bunker somewhere deep beneath the Royal College of Art) was an appropriate mixture of spot-lit tech, food (coffee, free beer, and gloomy corners, the atmosphere was an uneasy blend of Women's Institute tea party (the PC press), a card sharp convention (the Apple dealers) and a family get-together of an incestuous Mississippi clan (the Mac journos). Back into one alcove and you'd find yourself in danger of being sold a 'slightly soiled' Mac system from a character looking like he sold his mother to the midwife officiating at his birth. Turn another and you'd encounter a pipe-smoking school teacher discussing Java with what looked like the forementioned mother. Get too close to the Mac journalists and you'd be catapulted into the set of Deliverance, complete with banjo playing degenerates screaming "squeal, pigg!" in Multimedia VR as you attempted to make good your escape.

So far, so tech launch. But then the (ahem) product was wheeled out. A slogan: 'only apple', all lower case, nice Garamond font, tasteful advertising in The Times. Yup, that's right, our friends from Cupertino were celebrating nothing more than a new advertising campaign. In a move that smacked of brilliance, AppleParty 97 was a yell, a plaintive cry affirming that the company itself is still in business. In another move that demonstrated it has finally learnt a thing or two from Gates, Apple invited so many of its own employees to the event that there was very little room to manoeuvre – or eat, neck copious booze and run away. This meant we had to stay and listen.

Apple long ago recognised what management gurus are only just waking up to: that the point of being a company in an industry dominated by one mega-corporation is not to produce physical products, but to sell the company. Hence the conventional computer industry approach of producing a product plan that makes it look as if you're about to capture a whole new market segment (use buzzwords; look like you share using instant Ramen Noodle [sic]) and then sell the whole company to Microsoft for $100-200 million. Unfortunately for Apple though, it remained an old hippy at heart. Whereas most folk took 'sell' to mean 'sell out', Apple thought that it meant marketing the brand to real live customers. >Wrong!< Thus Apple ended up pioneering the technique of selling the brand by associating with it the signifiers of the product, rather than selling the product itself, and so managed to sell more people on the idea of owning a Mac than to flog Macs themselves. Given that ideas are supposed to be more difficult to sell than things, Apple is to be admired for this achievement.

The problem is that the Mac that most people bought wasn't the one made by Apple – it was the imitation Mac made by Microsoft, the one that runs on cheap PCs you can buy from Dixons. In this context, AppleParty 97 became much easier to understand. The purpose of it wasn't to sell anything in particular, nor was it to win friends and influence people. Instead, it was an attempt to identify the idea of owning a Mac with some of Apple's physical products, and with the people who constitute the company itself. 'Own a Mac,' the slurry went, "and you help feed the needy children of these beautiful product managers.' And: 'Own one of these fine PowerBooks and you own the real thing.' AppleParty 97 wasn't about telling you how fast its machines are: instead, Apple want you to understand that it's Apple that produces 'the real Mac.'

Oh dear. Time to plug my ears against the banjo music and get out of here before Apple gets fucked again. Cos this time around it ain't gonna be pretty.

Ian Betteridge is a senior reporter for MacUser
✕ ianb@well.com ✕

A GREENISH BROWN AND UNPLEAS ANT LAND

View Net Theme Park
-Region 4-
Countryside Shoppe
Film Studio
Coach Park
Dolmen Adventure Park
Thatched Street
Cream T Cyber Cafe
View 1 (recommended)
View 2
View 3
Authentic Gardenland
Rest Rooms

After a springtime of generating apocalyptic headlines and nationwide soul-searching on matters agricultural in the media, the UK's Foot and Mouth crisis now threatens to become an eerie background hum. The crisis continues, but has ceased to provide fuel to the fire of radically different agricultural futures. In this summer interval of positive attention, we follow up on *Mute*19's futurecasting article (Hari Kunzru's 'The Tomorrow People') with four satirical farming scenarios by Hari Kunzru and James Flint. Illustrations by Catherine Story.

Above: (Issue 20, 2001) Artist Catherine Story's was asked to illustrate this satirical piece of faction from Flint and Kunzru. Bolder titling and the use of simple colour schemes were used as a connecting device fast becoming the architectural backbone for the design of the magazine.

Left: (Issue 8, 1997) Adam Dant, creator of Donald Parsnips Daily Journal, drew up this rendition of human-computer interaction. He shared with earlier comic-strip contributors John Paul Bichard and James Pyman a knack for pin-pointing computer culture's absurdity.

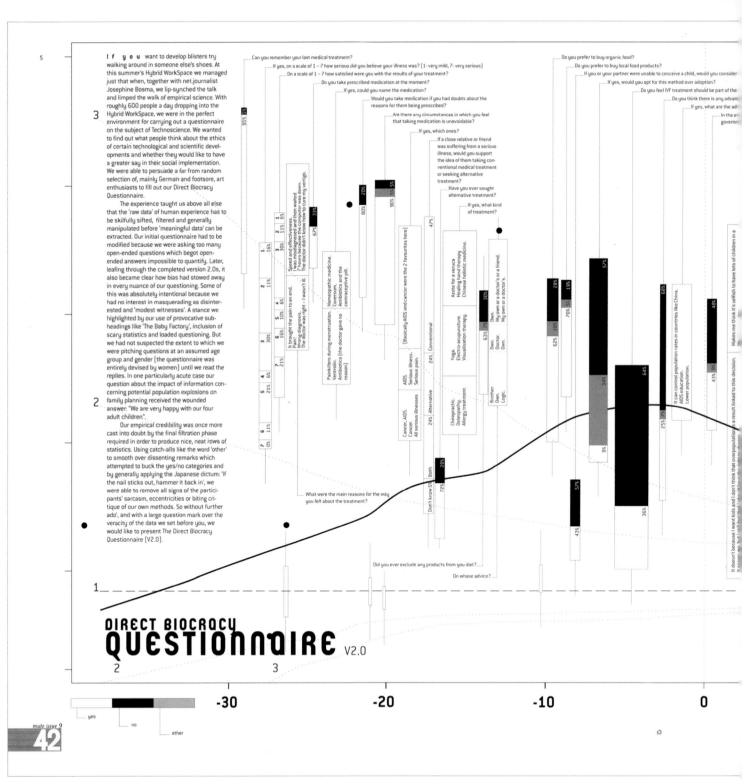

I f y o u want to develop blisters try walking around in someone else's shoes. At this summer's Hybrid WorkSpace we managed just that when, together with net.journalist Josephine Bosma, we lip-synched the talk and limped the walk of empirical science. With roughly 600 people a day dropping into the Hybrid WorkSpace, we were in the perfect environment for carrying out a questionnaire on the subject of Technoscience. We wanted to find out what people think about the ethics of certain technological and scientific developments and whether they would like to have a greater say in their social implementation. We were able to persuade a far from random selection of, mainly German and footsore, art enthusiasts to fill out our Direct Biocracy Questionnaire.

The experience taught us above all else that the 'raw data' of human experience has to be skilfully sifted, filtered and generally manipulated before 'meaningful data' can be extracted. Our initial questionnaire had to be modified because we were asking too many open-ended questions which begot open-ended answers impossible to quantify. Later, leafing through the completed version 2.0s, it also became clear how bias had stowed away in every nuance of our questioning. Some of this was absolutely intentional because we had no interest in masquerading as disinterested and 'modest witnesses'. A stance we highlighted by our use of provocative sub-headings like 'The Baby Factory', inclusion of scary statistics and loaded questioning. But we had not suspected the extent to which we were pitching questions at an assumed age group and gender (the questionnaire was entirely devised by women) until we read the replies. In one particularly acute case our question about the impact of information concerning potential population explosions on family planning received the wounded answer: "We are very happy with our four adult children".

Our empirical credibility was once more cast into doubt by the final filtration phase required in order to produce nice, neat rows of statistics. Using catch-alls like the word 'other' to smooth over dissenting remarks which attempted to buck the yes/no categories and by generally applying the Japanese dictum: 'If the nail sticks out, hammer it back in', we were able to remove all signs of the participants' sarcasm, eccentricities or biting critique of our own methods. So without further ado', and with a large question mark over the veracity of the data we set before you, we would like to present The Direct Biocracy Questionnaire (V2.0).

DIRECT BIOCRACY
QUESTIONNAIRE V2.0

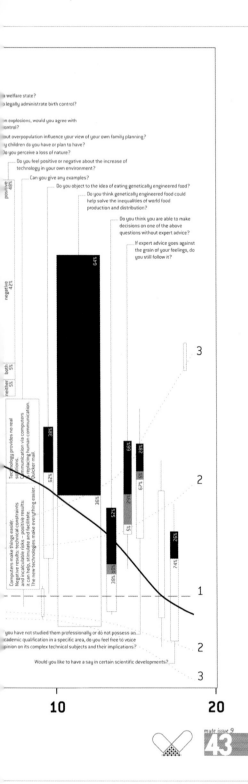

welfare state?

legally administer birth control?

explosions, would you agree with
control?

out overpopulation influence your view of your own family planning?
children do you have or plan to have?
Do you perceive a loss of nature?

Do you feel positive or negative about the increase of
technology in your own environment?

positive
48%

Can you give any examples?

Do you object to the idea of eating genetically engineered food?

Do you think genetically engineered food could
help solve the inequalities of world food
production and distribution?

Do you think you are able to make
decisions on one of the above
questions without expert advice?

If expert advice goes against
the grain of your feelings, do
you still follow it?

negative
42%

both
5%

neither
5%

Technology provides no real
solutions.
Negative results: technical constraints
and incalculable risks – positive results:
it can help, stimulate and facilitate
communication via computers.
Or replacing human communication.
Quicker mail.

64%

38%

52%

66%

28%

36%

67%

52%

5%

38%

26%

24%

Computers make things easier.
Negative results:
Communication via computers.
The new technologies make everything easier.

3

2

1

2

3

you have not studied them professionally or do not possess an
academic qualification in a specific area, do you feel free to voice
opinion on its complex technical subjects and their implications?

Would you like to have a say in certain scientific developments?

10 20

43

mute issue 9

diagrams

Left: (Issue 9, 1998) This diagram was
redrawn from a found original to illustrate
the views that visitors to the Documenta X
festival had on issues of health, medicine
and science. It actually became much
more about how to handle statistics!
Below: (Issue 9, 1998) As part of the same
Technoscience issue the relationship
between science, industry and humans was
visually interpreted here as the puppet
master of industry/science playing with
human activity.

Page 68-69 Left: (Issue 19, 2001) Mute's manifesto on how
to become a networked organisation, build sustainable
economies and decentralise content. Never mind it took
over five years to come even close to being realised, the
Quim Gil-inspired plan firmly placed the magazine on
course for its hybrid publishing model of 2005 on.
Top right: (Issue 13, 1999) For his article on collectives
CCRU and orphan drift's exhibition SYZYGY at
Beaconsfield, London, James Flint delved deep into their
arcane research, which included this diagram.
Bottom right: (Issue 15, 1999) The Y2K issue's special
project A Text Monument to the Second Millennium had
taken up so much space that none was left to do the usual
reviewing. Instead, section editors were allocated one page
to do with what they liked. Tom McCarthy and James
Flint's were modelled on a timeline and molecular model.

Page 70-71 (The Metamap, included in issue 21, 2002)
The Metamap used Buckminster Fuller's Dymaxion
projection to chart contemporary surveillance and anti-
surveillance projects around the world. For reasons of
copyright, the Buckminster Fuller institute was contacted
– Mute imagined they might also have a vector drawn
version that could be used as a base but they did not. The
Institute gave Mute its blessing to re-draw: having vastly
underestimated the task of tracing so much and in such
detail, the map took the delivery of issue 21 way over
deadline. They were both finished on September 11.

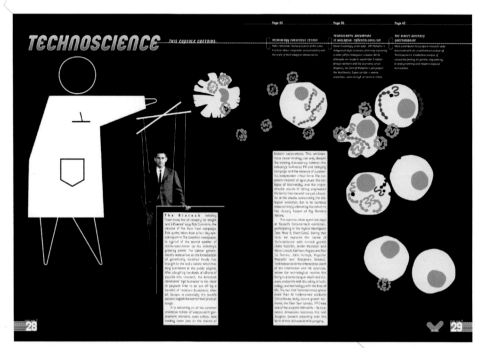

Ceci n'est pas
(We've crossed oceans of time to find you...)
un magazine

Illustration: originated by Quim Gil
<qgil@metamute.com>
Executed at dawn by the fine hand
of young Damian Jaques
NB you are approaching a
simplification of Reality!

Comments? Ideas? Flames? *Metamute*'s new forum [http://www.metamute.com/forum]
awaits you. Or contact us at the editorial address.

Mute's evolution in perspective

Over the last six months, *Mute* magazine has been in a
suspended state of publication. During this time, we've been
contemplating the implications of our magazine's content – the
digital 'revolution' and its discontents – for its form and self-
sustainability.

When *Mute* published its pilot issue, in 1994, the Net was
anything but ubiquitous. *Mute*'s original *'Financial Times'*
newspaper format was a deliberate attempt to debunk the
information revolution's much vaunted inclusivity – hence our
decision to make a printed object and our motto 'Proud to be
Flesh'. Six and a half years later, we face a very different
picture: the many-to-many publishing environment is now far
more than a theory spouted by inspired techno-lotus eaters and
our publishing gesture is dwarfed by the reality of today's Net.

So, our gawky teen phase of self-contemplation has resulted
in a few structural and 'philosophical' adjustments. You might
have seen the first signs of this in our fledgling e-letter *Mutella*
and our recently relaunched *Metamute* website. Well, the long
shadow of cyberspace has now fallen across our paper-bound and
'top-down' notion of content generation too. Like us, you'll have
come across words such as 'prosumers' and 'user-generated
content'. Such New Economy buzz-speak for the consuming
producer (or producing consumer) often functions as an alibi for no
editorial at all or, worse, a vampiric relationship to a community.
Nonetheless, in sticking so monogamously to a traditional
editorial model we have ignored the non-vampiric alternative.

If you think this is all a very long-winded way of saying we
want to be in better dialogue with our readers, you're both
right and wrong. Right because we do, wrong because
that's only the start of it. Part of our objective is to
continue producing *Mute* as a printed magazine; the
other part is to develop discussion forums,
tools/files/software exchange spaces, research
areas and special publishing projects. This
way, *Mute* can hopefully become a more
accurate vehicle for exchanges that go
on between us and you. You could
say the editorial centre of
gravity is shifting – from
offline to on, and then
imagine all that that
implies.

1

THE DAWN OF TIME, *1994-1995*
Mute started as a printed newspaper with
a simple online version, *Metamute* v. 0

2

**WHEN DINOSAURS STALKED THE
EARTH,** *1996-2000*
A printed magazine with an online archive
and *Metamute* v.1.0 (aka 'meta' soon to be
archived on *Metamute*)

3

THE PRESENT, *2001*
A printed magazine, the *Mutella* e-letter,
Metamute v. 1.1, archive, events

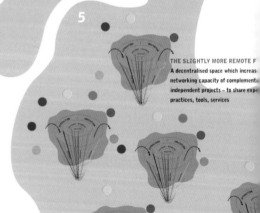

4

THE NEAR FUTURE
Metamute: a space of exchange – of
editorial, opinion, information, tools,
services and products, one of which is *Mute*.

5

THE SLIGHTLY MORE REMOTE F...
A decentralised space which increas...
networking capacity of complementa...
independent projects – to share expe...
practices, tools, services

= *Mute*	= talks/events	= research	
= *Mutella*	= shop	= online/offline services	
= *Metamute* archive	= code		

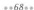

...editor-reader relationship ...ple: editors edit and ...s read and pay. What we ...ested in is a variant of

the slogan '**Stop spending money, generate your own value!**' In effect, can that badly maligned entity known as a 'community' generate an economy of its own.

editors – Readers

Promoters – Users

Network Participants

OBJECTIVE ... Oh God, why am I here?

To contribute to the strength of independent media projects – enabling them to compete with institutional, governmental and corporate driven ones, and to create information spaces where high quality tools, content and research are produced by individuals and small organisations who are compensated for their work.

print object 'X'

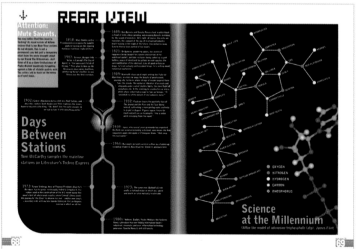

REAR VIEW

Days Between Stations

Science at the Millennium

THE METAMAP
surveillance and privacy

DYMAXION DREAMS

If you are holding this map, you will have seen issue 21 of Mute magazine and know about its theme of 'dataveillance'. You probably won't know that the magazine's contents and 'Total Paranoia' strapline were, like other things cut adrift from their context and floating around the public realm, conceived and completed before the fateful date of 11 September 2001.

The tragedy that occurred on that day has cast bigger things than this magazine in a different light, but we – as so many others – have had to consider the impact of the attacks on our editorial. We, too, have had to consider how 'appropriate' it was to publish our magazine's contents at this time. Many of Mute's pages carried critical analyses of the security regimes we live under in the West: having totally failed to prevent New York's, Washington's and Pittsburgh's disasters, would any attempt to unpick or criticise them seem like one more step in the wrong direction, an insult to lives lost through their failure? The anti-capitalist movement, another recurring subject in Mute, is repeatedly allied to causes it shares nothing with: would it be any different after this 'anti-capitalist' event? After the day commentators scrambled to dub the beginning of the 21st century, nothing was certain. The sole exception being the drastic change the security and intelligence services would undergo – in the short term to support a counter-attack, in the long term in a preventative mode. In ways we had never imagined, 'Total Paranoia' characterised the public mood.

We decided to publish this issue of Mute unamended: disavowing a thematic we perceived to be relevant to democratic life a week ago seemed misguided, to say the least. Instead, the more days went by, the more clear it became that the self-censorship that will no doubt continue in the wake of the disaster is precisely the opposite of what it demands. The interpretative flatland of most TV, for example, has proved incapable of answering to anything but the most basic responses (a literary editor remarked upon its 'failure of language' – rarely has that phrase rang more true). After the numbness abated, the collective, compulsive rush towards spaces of discourse, disagreement and enquiry demonstrated how much people desire divergent explanations of traumatic events – even ones on this scale. Without elevating them unduly, you could say local radio call ins, comment and letters pages, internet lists and bulletin boards were all testament to this.

For better or worse, and beyond the passions of injured hearts, the debates that took place were repeatedly moored to certain cautionary themes. The solidarity this event required on national and international levels would put day to day politics on hold for the foreseeable future… from here on in, security measures would require a balancing act between the protection of civilians and the protection of civil liberties… We needed to learn from history and recognise how deeply interconnected globalisation has made all its subjects… The logic of escalation that hardline responses would trigger should be pictured at an unprecedented scale, involving biological, nuclear and conventional weaponry… And last but not least, if it were to be lawful, information (or 'intelligence' in the military parlance) would be fundamental to military intervention.

All of these themes point to continuities that can and should be sought out between the 'first day' of the 21st century and the days that preceded it. There can be little doubt in anyone's mind that 2001 already felt like a time of crisis: global hunger, war, disease, child labour, mass migration, an impending ecological crisis - ignoring them was nearly impossible. At the same time, while at an institutional level the language of universal human rights enjoyed a higher profile than ever before (at the UNHCR World Conference on Racism for example), the majority of institutions responsible for facilitating global integration ignored them. Overdetermined by economic principles, these bodies were under attack for 'crimes' ranging from unaccountability to profit-led principles, unbalanced constitutions and short-termism.

At this juncture, the continuity between 'before' and 'after' rests on notions such as governance, democracy, the public, and human rights. The last week has showed the relative value of each of those words, but so did the weeks before them. Many have urged that we use this tragedy as an opportunity to examine our language, our conception of history and of politics. Neither framework holds true at the moment, but if we have also shown how, in attempting this, we seesaw between old, nation state-based reference points and those of a mythical global society. If the latter is to be anything like a space of democracy, a radical transformation of notions of equality, mediation and representation will have to occur; online free speech, access, privacy and other information oriented 'rights' will have to measure their relevance against more social and material ones. During this process, the strength and diversity of public discourse in and across nation states will be instrumental.

And with this rather inflated statement we return to the map you are holding. Instead of contemplating our own failure of language in the face of events, Mute decided to use the one remaining component of its 21st issue differently than originally intended. This global freeze frame of surveillance, privacy, free speech and open infrastructure projects was already deficient in many areas: focusing on the net, having been selected by us and thus being and reflective of the networks Mute is part of, it was dominated by European and American initiatives. It didn't broach the use and abuse of 'biometric' data, nor was it as comprehensive as maps like to be. As for accuracy, after 11 September, it was transformed into a historical document.

In response to the tragic events of that Tuesday and the tragic events that may follow it, we would like to extend an invitation to all our readers to change this compromised picture of the globe into their own global society: like the unashamedly utopian Buckminster Fuller – whose designs we were kindly granted permission to use – this Dymaxion holds up hope that information, awareness, knowledge and communication can make a difference.

'Looking at it as the spaceship that it is, there's just one spaceship here. It's the only one we're going to get. What are the total known resources, and what is the total knowledge, and how do we use those total resources and knowledge for everybody on board this ship? Absolutely give no attention whatsoever to nations ever again. It must be really how to make it work for everybody. That's what I'm talking about. We're now talking about making it work for everybody.' – Buckminster Fuller (1895 – 1983)

THIS DOCUMENT IS BEING UPLOADED TO THE METAMUTE WEBSITE IN PDF FORMAT. WE WILL HYPERLINK THE URLS AND CREATE A FORUM WHERE YOU CAN ADD AND UPDATE. GO TO www.metamute.com FOR UPDATES AND FORUM LINKS. ALTERNATIVELY, EMAIL US AT <mute@metamute.com>

REVERSING THE TRANSFORMATION: From Two to Three Dimensions

RESEARCH

1 WASHINGTON D.C., USA
www.epic.org – Electronic Privacy Information Center
'EPIC is a public interest research centre established in 1994 to focus public attention on emerging civil liberties issues and to protect privacy, the First Amendment, and constitutional values.'

2 GERMANY
www.fitug.de – Förderverein Informationstechnik und Gesellschaft (FITUG e.V.)
[The Society for the Promotion of Information Technology and Society]
FITUG promotes the integration of new media into society, whilst reporting on the technicalities, risks and dangers of these media, and working to protect human rights and consumer-protection within computer networks.

3 HACKENSACK, NEW JERSEY, USA
www.pandab.org – Privacy & American Business
Privacy & American Business is an activity of the non-profit Center for Social & Legal Research, a public policy think tank exploring US and global issues of consumer and employee privacy and data protection. Since its launch in 1993, P&AB has charted and analysed the rise of privacy from a record for concern to a front-burner issue.'

4 VIENNA, AUSTRIA
world-information.org/wio/infostructure/objective – World-Information World Infostructure
The objective of this knowledge base is to bring focus to the human dimension of information and communication technologies (ICT) in a dynamic world of technology and vested interests. It is designed to provide an overview of the status quo, the development and texture of the Infosphere as well as enhance visibility of issues of public interest,' Infostructure's text run focuses on digitisation, globalisation, consolidation, integration, concentration, commercialisation, participation, cooperation, innovation, emancipation, democratisation, diversification, convergence and empowerment.'
world-information.org/wio/infostructure/research – World Infostructure Research areas
Global Businesses, Global Content Channels, Global Data Bodies, Global Digital Security, Global Info Rights, Global Market, Global Networks, World Infostructure
world-information.org/linkbase – World-Information Linkbase project
'World-Information Org's Link Base complements World-Infostructure and is a tool tool for locating independent information and critical analysis on the web. It contains several hundred hand-selected URLs that are accompanied by short descriptions and categorised by the eight research areas of World-Infostructure. Search functions include full text search as well as keyword or topic specific search.'

5 SANTA MONICA, CA, USA
www.rand.org – RAND think tank
Mother of all think tanks. Backbone organisation of US technology, military and securities histories. Now also active in healthcare, drug prevention, economic and political analysis. RAND [a contraction of the term research and development] is the first organisation to be called a "think tank." We earned this distinction since after we were created in 1948 by our original client, the U.S. Air Force (then the Army Air Forces). Rome of our early work involved aircraft, rockets, and satellites. In the 1960s we even helped develop the technology you're using to view this web site.' For its hallmarks of quality, objectivity and innovation, see World Information.

6 CHAPMAN, AUSTRALIA
www.anu.edu.au /people/Roger.Clarke/DV – Roger Clarke's Dataveillance and Information Privacy Pages
Dataveillance is the systematic use of personal data systems in the investigation or monitoring of the actions or communications of one or more persons. Roger Clarke monitors privacy regulations and breaches on both the national and international stage.

7 SAN DIEGO, CALIFORNIA, USA
www.privacyrights.org – The Privacy Rights Clearing House
This non-profit group is focused on a consumer education, research, and advocacy program enabling members of the public to take control of their personal information by providing practical tips on privacy protection.

LISTENING STATION

SATELLITE

www.ncis.co.uk – National Criminal
LONDON, UK
Intelligence Service
'One stop shop for law enforcement international enquiries.' Collaborates with law enforcement agencies, government departments and other agencies nationally and internationally. Incorporates the UK Drug Liaison Officer network, Interpol UK and Europol UK.

8 LONDON, UK
www.mi5.gov.uk – MI5
The Security Service is the UK's security intelligence agency. Its purpose is to protect national security from threats such as terrorism, espionage and the proliferation of weapons of mass destruction, to safeguard the economic well-being of the UK against foreign threats, and to support the law enforcement agencies in preventing and detecting serious crime.'

9 LONDON, UK
www.gchq.gov.uk – Government Communications Headquarters

ART PROJECTS

1 ITALY
www.01001011110101101.org – 0100101111010110.org
Italian collective. Creators of 'biennials.py', and – running counter to the fight for privacy – activists in pursuit of total transparency and a collective deluge of personal information.

2 BLEILEFELD, WEST GERMANY
www.icebud.org – FoeBuD
Art and tech collective resources for tools, ideas, resources –see Rena Tangens interview in Cornelia Sollfrank, 'Share and Be Shared'. Also(01).

3 TORONTO, CANADA
www.eciatech.com/tpw – Steve Mann
Over a period of twenty years artist, inventor, and engineer Steve Mann has developed a body of work that undermines the efficiency and normalisation of surveillance. Borrowing from the Situationist notice of détournement, Mann has developed a number of strategies – involving wearable devices and performative routines that allow him to frame surveillance as a political problem and interrogate its banal self-justifications.

4 TORONTO, CANADA
surveil.sjsu.edu – Teleprescient Surveillance, Joel A. Slayton
Teleprescient Surveillance is an evolving artistic research project incorporating autonomous robot surveillance probes and the internet. The intent of this project is to characterise a form of media experience derived from the activities of intelligent machine agents designed to enable teleprescient roaming.

5 NEW YORK, USA AND BRISTOL, UK
surreal.org – Bureau of Inverse Technology (BIT)
BIT create nonblack loops between information systems and focuses especially on surveillance, social control and the production of data trails.

6 PITTSBURGH, USA
www.appliedautonomy.com – Institute for Applied Autonomy (IAA)
"From Sparta to DARPA, the market of tools of repression has remained a reliable outlet for technological development. However, recent history has shown that as the strength of these technologies has grown, the sustainability of this market has dwindled, indicators show that in the very near future this market will no longer be able to bear the weight of the increasingly costly technologies that it requires. In response to this crisis, the IAA has identified the already emerging market of cultural insurrection as the most stable market in the years to come. IAA research has examined the primary behaviour patterns of this market and is developing technologies that best serve the needs of the burgeoning market."

7 CHICAGO, USA
www.thefileroom.org – The File Room
Initiated as an artist's project by Muntadas, The File Room (1994) proposes alternative methods for information collection, processing and distribution, to stimulate dialogue and debate around issues of censorship and archiving.

8 UK / INTERNATIONAL
www.irational.org – irational.org
..ist, hacktivist, and disinformation seeding site

..SA
...xtbored.org/the-scp.html – The Surveillance Camera Players
...nce completely distrustful of all government would be opposed to what we are doing with surveillance cameras." NYC Police Commissioner Howard Safir, 27 July 1999.
...ance Camera Players: completely distrustful of all government."

..ANY
...littlesister – Little Sister
...4 Hour online surveillance soap.

..D, UK
...634/surveillance.htm – Police Surveillance, by David Jackson
...nce and artwork made in Sheffield to gauge the nature and degree of CCTV surveillance.

..Spook, by Conor McGarrigle
...work which explores issues of surveillance, tracking and covert activity on the web in an interactive website based on the conventions of computer

..festival
...echnology crossover, but this year cords its not around surveillance. Check the site for updates and archives of all previous events

..html – CCTV project
...a cctv system in a shopping mall. The area where this takes place is an infamous residential suburb. We are trying to subvert the use
...public sphere.

.. LAS VEGAS, NEVADA, USA
.w.defcon.org – DEF CON Convention
..year, in Vegas, in July, and they have hacker frequency loss
..is rich with links and information – the links may not always
..able, but those that are, are excellent.

..HEDE, TWENTE, NETHERLANDS
..org – Hackers at Large
..n a series that has been running every four years since 1989. 'The
..(1989), 'Hacking at the End of the Universe' (1993) and Hacking in

PRIVACY AND FREE SPEECH CAMPAIGNING

1 CAMBRIDGE, MA, USA
www.gilc.org – Global Internet Liberty Campaign
GILC is an alliance linking the American Civil Liberties Union, EPIC, Human Rights Watch, the Internet Society (ISOC), Privacy International, Association des Utilisateurs d'Internet and other civil and human rights organisations targeting censorship in particular.

2 LONDON, UK
www.privacyinternational.org – Privacy International (see State & legislation related)
Privacy International (PI) is a human rights group formed in 1990 as a watchdog on surveillance by governments and corporations. PI is based in London, England, and has an office in Washington, D.C. PI has conducted campaigns throughout the world on issues ranging from wiretapping and national security activities, to ID cards, video surveillance, data matching, police information systems, and medical privacy.

3 SEOUL, KOREA
www.freeonline.or.kr/english – Stop Korean Online Censorship
Last year, the Korean Ministry of Information & Communication (MIC) of the Kim Dae-jung government tried to pass the Communication Decency Act, which included an Internet Content Rating System provision. Many Korean progressives groups fought against the legislation and finally, before being passed, the clauses related to the Content Rating System were deleted from the Act.

4 WASHINGTON, DC, USA
www.ifea.net – Internet Free Expression Alliance
The Internet Free Expression Alliance works to 'ensure the continuation of the Internet as a forum for open, diverse and uninterrupted expression and to maintain the vital role the Internet plays in providing an efficient and democratic means of distributing information around the world.' It encourages informed public debate and discussion of proposals to rate and/or filter online content and attempts to identify new threats to free expression and First Amendment values on the Internet, whether legal or technological.

5 ITALY
www.alcei.it – Associazione per la libertà nella comunicazione elettronica interattiva (ALCEI)

6 NETHERLANDS
www.bof.nl – Bits of Freedom
"Bits of Freedom is a civil rights and privacy organisation for the information society. It aims to focus attention on the civil rights aspects of data privacy, information access, filtering and searching, as well as cryptography, wiretapping, and freedom of expression."

7 WASHINGTON, USA
www.cdt.org – Center for Democracy and Technology
"The Center for Democracy and Technology works to promote democratic values and constitutional liberties in the digital age. With expertise in law, technology, and policy, CDT seeks practical solutions to enhance free expression and privacy in global communications technologies. CDT is dedicated to building consensus among all parties interested in the future of the Internet and other new communications media."

8 UK
www.cyber-rights.org/interception/echelon – Echelon Watch, Cyber-Rights & Cyber-Liberties
Cyber-Rights & Cyber-Liberties (UK) is a non-profit civil liberties organisation whose main purpose is to promote free speech and privacy on the Internet, and to raise public awareness of these important issues. The Echelon Watch project deals with the interception of communications at a global stage, providing information related to international, governmental and non-governmental, public and secret (private) developments in relation to the interception of all sorts of communications, and with particular focus on ECHELON and UKFUSOL issues.

9 JAPAN
www.jca.apc.org/index-en.html – JCA-Net
'Empowering citizens' activities through the Internet, JCA-Net stand for peace, social & environmental justice and human dignity'

10 CA, USA
www.derechos.org – Derechos
Derechos Human Rights promotes respect of human rights all over the world, the right to privacy and campaigns against impunity for human rights violators.

11 SAN FRANCISCO, USA
www.eff.org – Electronic Frontier Foundation
The Electronic Frontier Foundation (EFF) was created 'to defend our rights to think, speak, and share our ideas, thoughts, and needs using new technologies, such as the Internet and the World Wide Web.' The organisation identifies threats to basic rights online and advocates on behalf of free expression in the digital age.

12 AUSTRALIA
www.efa.org.au – Electronic Frontiers Australia (EFA)
'Electronic Frontiers Australia Inc. is a non-profit national organisation representing internet users concerned with on-line freedoms and rights. EFA was formed in January 1994 and is focussed on the protection and promotion of the civil liberties of users and operators of computer based communications systems. It advocates the amendment of laws and regulations in Australia and elsewhere (both current and proposed) which restrict free speech and unfettered access to information.'

13 CANADA
www.efc.ca – Electronic Frontiers Canada (EFC)
Electronic Frontiers Canada (EFC) was founded to ensure that the principles embodied in the Canadian Charter of Rights and Freedoms remain protected as new computing, communications, and information technologies are introduced into Canadian society.

14 USA
www.postalwatch.org – PostalWatch
PostalWatch is a non-profit organisation which has been formed to protect individuals and the private sector business community from intrusive United States Postal Service actions and regulations. PostalWatch provides this largely underrepresented group with a powerful and unified voice in postal affairs that impact their businesses and personal lives.

15 UK
www.spy.org.uk – CCTV Surveillance Regulation
Watching Them, Watching Us, UK Public CCTV Surveillance Regulation Campaign covers CCTV and more: license plate monitoring, biometric surveillance, legislation, other campaigning organisations, open infrastructures and IT self-education.

16 HONG KONG
www.gendonet.com.hk/privacy/index.html – Privacy Hong Kong
A consumer group distributing information on their legal right to privacy and data protection.

17 VIENNA, AUSTRIA
free.nethase.org – Free Public Netbase
During a protracted series of legal conflicts with the Austrian government associated with its involvement in 'alternative' culture and discourses, media arts organisation Public Netbase set up this site to rally support to its cause and document the attacks on, and defence of, its activities.

THE METAMAP
surveillance and privacy

REVERSING THE TRANSFORMATION: From Points to Triangulations

FULLER PROJECTION
Dymaxion™ Air-Ocean World

Ascension
St Helena

Santo Domingo
Port-au-Prince
Kingston

Montréal
Ottawa
Toronto
Boston
New York
Philadelphia
Baltimore
Washington D.C.
Richmond
Charlotte
Columbia
Atlanta
Jacksonville
Tampa
New Orleans
Houston
Dallas
Memphis
St. Louis
Kansas City
Omaha
Chicago
Milwaukee
Detroit
Buffalo
Cleveland
Pittsburgh
Cincinnati
Indianapolis
Louisville
Nashville
Birmingham
San Antonio
Austin
Tucson
Phoenix
Las Vegas
San Diego
Los Angeles
San Francisco
Portland
Seattle
Boise
Twin Falls
Reno
Salt Lake City
Boulder
Denver
Santa Fe
Albuquerque
Santo Domingo
Winnipeg
Duluth
Thunder Bay

Georgetown
Paramaribo
Cayenne
Manaus
Fortaleza
Recife
Natal
Salvador
Maceió
Belo Horizonte
Rio De Janeiro
São Paulo
Campinas
Curitiba
Porto Alegre
Montevideo

Mexico City
Havana
Mérida

Cooperhaven
Baker Lake
Leshion
Jean Marie River
Churchill
Thompson
Edmonton
Saskatoon
Calgary
Vancouver
Prince Rupert
Anchorage
Fort Chipewyan
Fort Nelson
Labrador City
Arvat
Timmins
Inukjuak

Hawaii

fashion

This spread and following page: (Issue 10, 1998) Entitled 'Chesus Crust' this fashion shoot was styled by Stephen Da Silva and photographed by Richard Dawson.

A ROUND WITH ALICE

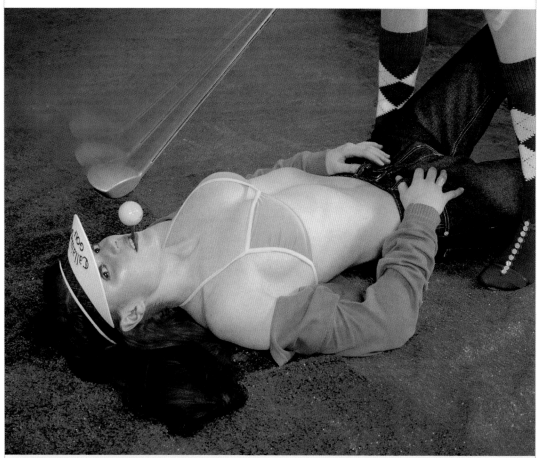

DANNIE WEARS — VISOR BY CALLAWAY GOLF, BIKINI TOP AND CARDIGAN BY DIESEL, JEANS BY CALVIN KLEIN.
SALVA WEARS — SHOES BY MANOLO BLANIK, SOCKS BY BURBERRY.

to: tallboy@metamute.com

PHOTOGRAPHY — TALLBOY

STYLING — STEPHEN DA SILVA

HAIR AND MAKE UP — JOHN CHRISTOPHER FOR RULEY & MILLIE

MODELS — DANNIE & SALVA AT STORM

I LOVE YOU, VIRUS
ARM OF THE LAW.
SUBLIME. UTILIT
DEGREES OF SEPA
AN OBSTACLE. GR
BRAIN SPACE. CRI
PUBLICS ON PARA
MEGASHOPOLIS.
TURBO-NANOTECH
THE ADVENTURE O

THE E-LONGATING
AL-TIME
IANISM. 180
TION. HOW TO BE
FITIING THE
E PAINTS.

PERFECT BOUND

O'S AFRAID OF
PHILOSOPHY AND
THE VIRTUAL.

PERFECT BOUND
FAST BREEDER MAGAZINE

However successful it was in certain pragmatic terms, the US-letter glossy was still left wanting. Images couldn't go large enough. The manga-inspired logo was nice but it confused readers as to the identity of the magazine. There was something insubstantial about the whole thing, the editors felt. With sales, subscriptions and advertising bumping along at their usual, low rate, the format became a point of discussion once again. Could *Mute* draw in more readers – and advertisers? – with something better?

Rather than engage in another drastic change, Worthington and van Mourik Broekman together with Jaques attempted to build on what was good about the existing format, including its sections and much of its design template. They broadened the page, added a spine and devised a new logo. The coffee-table format rejected outright before arguably became irresistible – further proven by the subsequent change into a weighty bi-annual journal.

Being published as a perfect-bound magazine with wider pages allowed a new approach to photographers and other illustrators and the magazine made its first forays into sustained commissioning in this area – inviting artists to respond to articles in a more exploratory way. Work by Catherine Story, Daniel Jackson, Richard Dawson and others – later to be followed by Lady Lucy and Richard Starzecki – was an important facet of drawing readers into content that was perceived as difficult and inaccessible and refining the magazine's identity overall.

It was invisible to readers, but this period also introduced a greater degree of professionalisation at the 'back-end' of the magazine. Production became more systematised, the organisation started working with the much heralded collaborative tools from the free software community, and a do-or-die approach generally came into play vis a vis adherence to production processes, often led by Worthington. The fact that the magazine had secured stable funding and was being supported to undertake ancillary software projects also influenced this turn.

Pauline van Mourik Broekman, Simon Worthington (editorial, issues 22–24); Josephine Berry (deputy editor, issues 22–24); Damian Jaques (design, issues 22–24); JJ King (contributing editor, issues 22–24); Hari Kunzru (contributing editor, issues 22–24); James Flint (contributing editor, issues 22–24); Tina Spear (website design, issues 22–24); Anja Büchele (picture research, issues 22–24); Lina Dzuverovic-Russell (web development & communications, issues 22–24); Benedict Seymour (proofing, issues 22–24); Louise Vormittag (design intern, issues 22–24); Ian Morrison (sysadmin, issues 22–24); Simon Ford (assistant editor, issues 23–24); Leonard Latiff and Julia Schneider (interns, issues 23–24).

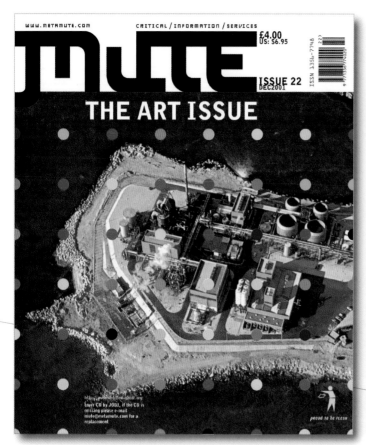

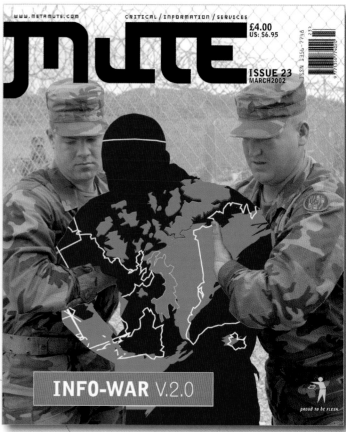

covers

(Issue 22, 2001) The first perfect bound
issue – on Art – took a detail from Peter
Fend's artist's project on oil, ecology and
power and overlaid this with the
multicoloured dots that had become a
trademark of Damien Hirst. Poles apart,
their two approaches marked out
important coordinates at a time of major
transitions for art. Digital culture made an
appearance in the form of net.art duo
Jodi's latest project, which came attached
on a CD.

(Issue 23, 2002) With the War on Terror
an inescapable reality, a new source of
visual material dominated Google
image-searches: the US Military. For
issue 23, which included several articles
on the new post-9/11 landscape, high
quality, publicly available photographs
(of training sessions in, among other
things, the handling of prisoners) formed
the base of a series of mysterious collages.

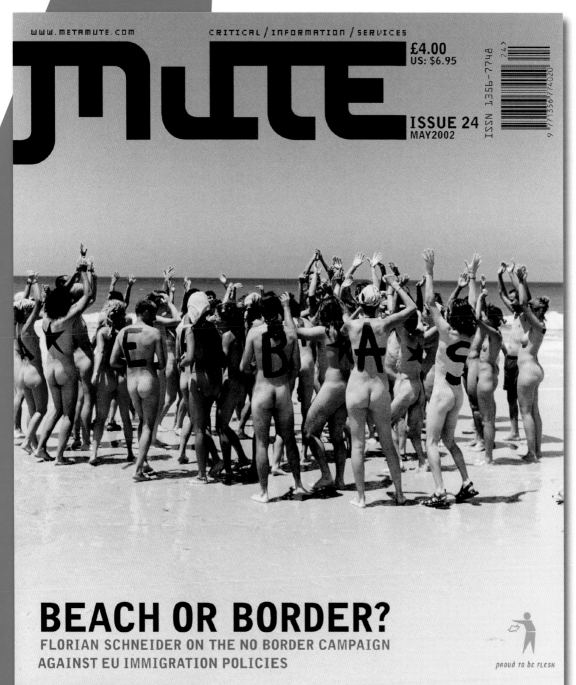

www.metamute.com

CRITICAL / INFORMATION / SERVICES

MUTE

£4.00
US: $6.95

ISSUE 24
MAY2002

ISSN 1356-7748

9 771356 774020

BEACH OR BORDER?

FLORIAN SCHNEIDER ON THE NO BORDER CAMPAIGN
AGAINST EU IMMIGRATION POLICIES

proud to be flesh

(Issue 24, 2002) Photographer Armin Smailovic had documented many No-Border campaigns against 'Fortress Europe'. His pictures illustrated a major article in issue 24 and one of the most striking was used for the cover. There was some argument internally whether 'a bunch of naked white people throwing their hands in the air' was an easily readable image – ultimately leading to the inclusion of a (for Mute) unusually descriptive strap.

E E E E

a b c d e G

Although the new logo had been used from issue 19 it wasn't until a brief hiatus in the production schedule that the underlying design was able to be expanded upon. It was immediately put to use as the logotype for the emerging Openmute web service packages. The design, that was never fully realised as a complete typeface, allowed for the use of ligatures and special pairs giving it the ability to be used across the spectrum of *Mute*'s products.

Left: The new font was also used in the page folios and, below, for indicating a web link.

Above from top:
Gridder. Fountain. Designed by Simon Schmidt.
ITC Officina Serif Bold Italic, *ITC. Designed by Ole Schäfer and Erik Spiekermann, 1990.*

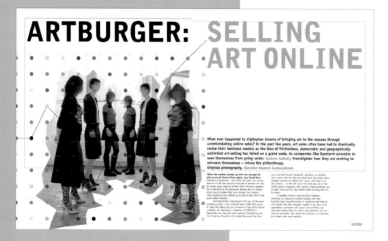

ARTBURGER: SELLING ART ONLINE

What ever happened to digitopian dreams of bringing art to the masses through unintimidating online sales? In the past few years, art sales sites have had to drastically revise their business models as the idea of frictionless, democratic and geographically unlimited art-selling has failed on a grand scale. As companies like Eyestorm scramble to save themselves from going under, Andrew Gellatly investigates how they are seeking to reinvent themselves – minus the philanthropy. Original photography, Haraldur Hannes Gudnundsson

But online art sites are another context altogether – they have become the art world equivalent of hamburger meat

'We're working on a post-Napster approach to our relationships with artists'

(Issue 22, 2001) 'Artburger', a lead feature from The Art Issue was illustrated by Haraldur Hannes Gudnundsson who invited a group of friends to stand in for the art-buying masses. This piece on the growth of online art portals such as Eyestorm and Britart.com was also the home of the 'Hirst spots' used on the cover.

photo graphics

1 160
2 129
3 130
4 131
5 132
6 133
7 134
8 75
10
11 12

TERROR IS A NETWORK – AND THE NETWORK IS YOU

WHAT HAPPENS WHEN THE 'NETWORK OF TERROR' MEETS THE 'NETWORK SOCIETY'? THE US MILITARY REACHES FOR ITS STRATEGIC GURUS. **JJ KING** UNPICKS THE LATEST THINKING ON ASYMMETRIC WARFARE IN AN AGE OF 'FULL SPECTRUM DOMINANCE'

WHAT DO TERRORIST NETWORKS LOOK LIKE? HOW DO THEY OPERATE? HOW DO THEY COMMUNICATE? HOW CAN WE ANALYSE THEM? WHAT ARE THEIR WEAKNESSES? HOW CAN WE BUILD COUNTER-MEASURES AND ULTIMATELY HOW CAN WE DISRUPT AND DISMANTLE THEM?
VALDIS KREBS, 'DISRUPTING NETWORKS OF TERRORIST CELLS' [HTTP://WWW.ORGNET.COM/TNET.HTML]

YOU HAVE TO EMPOWER THE FRINGES IF YOU ARE GOING TO BE ABLE TO MAKE DECISIONS FASTER THAN THE BAD GUY... YOU CAN'T DO IT THROUGH HIERARCHICAL SYSTEMS. IT JUST TAKES TOO LONG... WE NEED A NETWORK TO FIGHT THE NETWORK
LT. COL. ROBERT WARDELL

In the first weeks after September 11, the media fixed on the advanced information technologies putatively used by al-Qaeda to manage its fighting cells: satphones, mobile data transfer, the internet and, to conceal messages as they traversed the network, strong *<cryptography>* and *<steganography>*. One report even suggested that the hijackers had checked out of a hotel before the attack because it couldn't provide them with sufficient bandwidth.

This intense, early focus on the technologies and techniques al-Qaeda used in its communications is significant. Whilst it might have been ludicrous to cast this 'terror organisation' as a band of technophiles, American military strategists have been arguing for some time that terrorist cells do have something in common with the 'network society': their use of non-hierarchical, 'distributed' command structures to produce sturdy and flexible organisations. That, regardless of whether al-Qaeda operatives rely on the stone-age tech of face-to-face (F2F) communications, or use wireless-enabled PDAs to decrypt porn-stego'd communiqués over an air-WAN, makes it a 'networked' organisation proper – at least in the eyes of the American military. Two months ago, at a tech conference in Washington DC, the special assistant to the Chairman of the Joint Chiefs of Staff went so far as to call al-Qaeda 'a dispersed enemy who basically is operating on a *<peer-to-peer>* system, at a very low level.' That same peer-to-peer technology, Lieutenant Colonel Robert Wardell told technologists, could in future be of 'significant value' to the military – who, he explained, intended to enlist the architects of peer-to-peer networks like *<Gnutella>* and

spreads

(Issue 23, 2002) Following on from the Cover of this issue the cut-out image technique is overlaid with a no-nonsense typographic treatment.

Mens sana in corpore sano

or keep taking the tablets

The West's war on fat, free radicals, toxins and bacteria knows no such thing as a bridge too far: health and the perfect body enjoy absolute loyalty from their human footsoldiers. In the fight to keep our biological enemies at bay, the immune system is represented as the ultimate back-up system. But what is it really? And what are the politics of immunology, its parent science? Andrew Goffey makes a visit to the clinic

Mute main article **35mg**

Mute main article | Nicholas Brooks

A recent report in a broadsheet newspaper that a **favourite holiday destination in Thailand promises** eager tourists a week of colonic irrigation offers a potent image for the fate of the ethics of self-governance under global multinational capitalism. The *caput mortuum* of decades spent as an avid consumer in the West is sluiced into a South-East Asian bucket, leaving you and your intestines free to jet back West to accumulate another year of crap. Beneficiaries of this process report – after a feeling of faintness – a sense of enormous well being. Which is hardly surprising, given that the fat which can clog the intestine from decades of consumption sometimes gets so thick that the weight of one's bowels has been known to shoot up to around 40lbs.

I mention this vignette not to shock or to condemn – although there is something a little perverse about the geopolitics of it all – but to make a point about the almost neurotic medicalisation current techniques for the care of the self testify to. It is not so much the curiously solid links between the anally retentive dynamics of capital accumulation and the bourgeois concern with the clean and proper which needs emphasis. A technique of the self which involves washing out your insides the way that you might wash a car on a Sunday morning (if you had one) or unblock a sink, although not an entirely surprising development, shows us a strangely empty concept of the body. Other examples suggest that this is not an isolated phenomenon: the pill popping antics of vitamin munchers anxious to boost 'their' immune system; Michael Jackson, or Montgomery Burns from *The Simpsons*, both of them with Howard Hughes-type phobias about germs; the National Socialist regime in 1930s – '40s

Germany and their obsession with the health of its people...All point towards the pervasive medicalisation of identity. The British media and political elite's recent willingness to focus public energies onto the state of the National Health Service only confirms the issue. In fact, technologies of government here might suggest that being ascribed a medically informed identity (being 'normal' is a reputedly positive clinical condition), and being constantly enjoined to manage your own health, are functional weapons in capitalist crisis management.

I would not of course claim to be the first to have noticed this phenomenon, or wish to be interpreted as saying that the odd bit of internal hygiene or reform of the NHS is necessarily a bad thing. For starters, Michel Foucault's identification of *bio-power* as the primary form in which power exercises itself in contemporary society

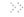

(Issue 24, 2002) Appropriating classic utilitarian medical packaging design this opening spread shows the contrast between the control of the container with that of the uncontrollable toxins and bacteria as illustrated by Nicholas Brooks.

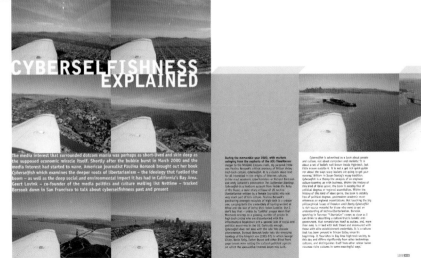

CYBERSELFISHNESS EXPLAINED

The media interest that surrounded dotcom mania was perhaps as short-lived and skin deep as the supposed economic miracle itself. Shortly after the bubble burst in March 2000 and the media interest had started to wane, American journalist Paulina Borsook brought out her book *Cyberselfish* which examines the deeper roots of libertarianism – the ideology that fuelled the boom – as well as the deep social and environmental impact it has had in California's Bay Area. Geert Lovink – co-founder of the media politics and culture mailing list Nettime – tracked Borsook down in San Francisco to talk about cyberselfishness past and present

(Issue 22, 2001) Like frames taken from a film the photographs are presented to illustrate this article that looks at the environmental and social change following on from the dot com boom in California.

WIDE
AREA
DISTURBANCE

It is something of a cliché to say that net culture is in constant flux. However, recent seismic shifts in the political and cultural landscape brought about by the economic downturn, the further militarisation of American foreign policy after September 11 and the museumification of net.art are forcing many to rethink the aims of electronic engagement. Here, interdisciplinary artist and writer Coco Fusco talks to hacktivist and Electronic Disturbance Theater member Ricardo Dominguez about the hybrid net_art_activism, past and future

m 2 3 4 2

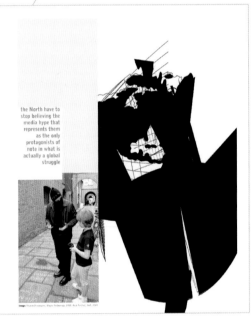

Coco Fusco:

Has there been a significant change in the focus of anti-globalisation activism in the aftermath of Genoa and the attack on the World Trade Center?

Ricardo Doming uez:

No. Activists are still asking the same questions about neo-liberalism, and they are still using the same tactics to disrupt the gatherings of the G8 and the IMF around the globe. Interaction between the NGOs and street activists is the same – one leverages the other. Everyone seems to agree that the violence of Genoa and September 11 should not derail the use of non-violent direct action. In addition, the same critiques of the anti-globalisation movement persist: that it lacks a coherent ideology; that it does not offer any workable solutions to top-down globalisation; that it disregards the last 50 years of extremely violent struggle against neo-liberalism in the South. The South's political and social thought offers possible reforms that can really challenge the North's neo-liberal agenda and which shouldn't be ignored. Many say that the cultural thought and political practices coming from Chiapas, Woomera, Porto Alegre and Kerala can displace the narcissism of activists in the North.

CF: But the activists in the North have to stop believing the media hype that represents them as the only protagonists of note in what is actually a global struggle against dehumanising policies and growing poverty. Activists in the third world have been subject to harassment, surveillance, imprisonment, torture and even disappearance for decades without receiving much attention from the North. While it may appear to the leftist activists and netizens in the North to promote the idea that, in a post 9-11 world, they have all been deemed 'the enemy' in the same way that the entire Arab world has been designated as a target by the US military, this is simply not true. No hackers in the US have been singled out for investigation as a result of the passing of the Patriot Act – at least not yet. If we focus solely on what is happening to Americans and Europeans interested in social change and whether they are

imperiled, we end up supporting the American position that posits 'our' victimisation as more significant than the rest of the world's.

RD: Another important issue is the strategic visibility of an 'eventism'. The 'tourism' of city hopping from Seattle to Genoa is becoming an empty spectacle of violent confrontations for the media and policy makers, and the movement is being constrained by events organised by global power brokers. Issues beyond protest are being forgotten. This type of 'eventism' also dictates the distribution of information produced by net.activists working for Independent Media Centres and related websites. Perhaps it is time to turn towards another form of 'eventism' in order to dismantle neo-liberalism. The Zapatistas, for example, convoke their own events rather than responding to those organised by others.

net.art now being showcased by major museums is for the most part techno-formalist and devoid of content

the North have to stop believing the media hype that represents them as the only protagonists of note in what is actually a global struggle

Left: (Issue 23, 2002) A 'clip-art' globe was disturbed using vector-based software by indiscriminate pulling of elements and re-layering colours. Oversized type was used in the layout to balance the dominance of the illustrative graphics.

5 EDITORIAL PAULINE VAN MOURIK BROEKMAN
8 EMPIRE STATE HUMANE EMILY BICK LOOKS BACK AT LONDON COUNTY COUNCIL'S FAMED ARCHITECTURAL DIVISION
9 MICRO V MACRO AUSTIN WILLIAMS REPORTS ON LONDON'S NEW SKYSCRAPERS AND MICRO-FLATS
10 HEAD TO HEAD: THE POLITICS OF HACKING PIT SHULTZ AND BORIS GRÖNDAHL DEBATE
12 HELLO COMPUTER JASON WALSH LOOKS BEYOND THE LATEST GUIs
13 COUNTER-REVOLUTIONARY TIMES MIKKEL BOLT ON OPPOSITIONAL CULTURE IN RIGHT-WING DENMARK
14 BROADCAST QUALITY LISA HASKEL SPENDS SOME QUALITY TIME WATCHING TV SWANSONG
15 WHO'S AFRAID OF TURBO-NANOTECH? CCRU ON NANOTECHNOLOGICAL NIGHTMARE SCENARIOS
16 THE BATTLE FOR BROADBAND FELIX STALDER CONSIDERS GOOD, BAD AND UGLY BROADBAND FUTURES
18 RADIO PLAYTIME DAVE MANDL TUNES IN TO RESONANCE FM
19 THE REAL, REAL THING PETER CARTY ON COCA-COLA'S COCAINE PLANTATIONS
20 404 FILE NOT FOUND HERE TODAY, GONE TOMORROW? SIMON FORD ON DIGITAL PRESERVATION
21 TRADE SHOW SCIENCE IAN MORRISON VISITS JAPAN: GATEWAY TO THE FUTURE AT THE SCIENCE MUSEUM
22 SNAPSHOTS OF TECHNOLOGY AXEL STOCKBURGER ON RICHARD FENWICK'S RND# PROJECT

25 WHITE CUBE, BLUE SKY #2: UNLEASHING THE COLLECTIVE PHANTOM BRIAN HOLMES ASKS IF THE EXPANDING VIRTUAL CLASS CAN ESCAPE THE DOMINATION OF THE FLEXIBLE PERSONALITY?

34 KNOCKING HOLES IN FORTRESS EUROPE FLORIAN SCHNEIDER ON ANTI-BORDER ACTIVISM ACROSS EUROPE

44 E-VIVA VALENCIA ÁLVARO DE LOS ÁNGELES REPORTS ON CULTURAL POLICY IN THE REGION OF VALENCIA

48 MENS SANA IN CORPORE SANO: OR, KEEP TAKING THE TABLETS ANDREW GOFFEY ON THE POLITICS OF IMMUNOLOGY

56 SPECIAL/TURN ON, MASH-UP, SELL-OUT ULRICH GUTMAIR ON BOOTLEGS
58 HEADLINE1/BEYOND GOOD AND EVIL? FANTASY LITERATURE REVIEWED BY HARI KUNZRU
60 HEADLINE2/DARK DIVIDEND JJ KING ON DAVID LYNCH AND PHILIP K. DICK
62 HEADLINE3/THE IN CROWD MARISA S OLSON ON NET ART AT THE WHITNEY BIENNIAL
64 ANTENNAE MUTE'S REGULAR CULTURE SWEEP
71 THE UNDEAD/PACK TO THE FUTURE MARINA VISHMIDT ON JETPACKS AND THE DREAM OF HUMAN FLIGHT
72 PIN-CODE/WHAT'S NEW IN NEW MEDIA? NATALIE JEREMIJENKO

7 EDITORIAL – THE IDEA OF ART
8 THE HAGUE CONVENTION FOR DUMMIES
Ted Byfield reveals an ominous lobby formulating new international law
10 PRIVATE LESSONS
Gregor Claude on the Don't Blow IT conference on IT, privacy and freedom
11 LINES DRAWN IN THE SAND OF TIME
Martin Waltenberg's map of net.art history, reviewed by Josephine Berens
12 THE LAST PICTURE SHOW
Benedict Seymour assesses the ruins of London's recently closed LUX Centre, mecca of experimental film, media and digital arts
14 READING RECESSIONS
Joan Berets visits London's East End gallery scene and reports on the recession hit artworld's reheated survival strategies
15 THE AGE OF ASYMMETRY
CCRU on the warped feedback of lopsided warfare
17 THE E-LONGATING ARM OF THE LAW
aka, the International Convention on Cybercrime – by JJ King
19 I LOVE YOU, VIRUS
The infection is the message – by Ian Morrison
20 EGO AND ID
Hammer Hrss and Sean Cubitt argue the toss over whether ID cards compromise freedom
23 REAL TIME SUBLIME
Wolfgang Staehle's recent show in ros New York and elsewhere, reviewed by Daniel Berchenko
24 ONE NATION UNDER GOD
Hari Kunzru, finding himself in Las Vegas days after 9.11, finds a simulacrum in tatters

26 H2 EARTH
Ocean Earth, re-unified art group, analyse the War on Terror and find its lowest common denominator: oil
34 SYSTEMS UPGRADE
Michael Corris on Conceptual art and the recoding of information, knowledge and technology
40 ARTBURGER
Andrew Goliath on the brave new post-utopian world of online art sales
46 CYBERSELFISHNESS EXPLAINED
Geert Lovink interviews Paulina Borsook, whose recent book Cyberselfish investigates the arise of West Coast techno-libertarianism

MUTE SPECIAL: 58 REPEAT AND WIN
JOSEPHINE BERRY TAKES NET ART'S HISTORY FOR A WALK,
66 UTILITOPIANISM: MATTHEW FULLER REPORTS ON THE WIZARDS OF OS CONFERENCE AND THE FIGHT FOR THE PUBLIC DOMAIN; 67 PAPER DOLLS – LINA DZUVEROVIC RUSSELL INTERVIEWS THE DE GEUZEN ART COLLECTIVE

contents pages

2^0

Above: (Issue 24, 2002) The page numbers are cropped by the dominant magenta block and the page edge. The 3D objects lift the type forward and play with the 'depth' by flowing over the margins and off the bottom of the page.
Left: (Issue 22, 2001) The 'staging' effect here utilises content from one of the main articles.

Right: (Issue 23, 2002) In this contents page the staging element finds a collaborator in the geometric pattern held within the main cyan box. Here, however, rather than the full geometric shape, a single line penetrates the margin. The pattern was randomly generated by AutoIllustrator developed by Adrian Ward at Signwave.

SHORT/CUTS

5 EDITORIAL PAULINE VAN MOURIK BROEKMAN
7 LETTERS TEAL TRIGGS AND MICHAEL MAZIERE
8 COMMUNITY WIRELESS NETWORKS BRUCE SIMPSON AND JAMES STEVENS
10 GRAFFITIING THE BRAIN SPACE SAUL ALBERT GOES ON A MISSION WITH THE SPACE HIJACKERS
11 ANOTHER [FIRE]WALL IS FALLING JJ KING REPORTS ON THE COMPUTER INDUSTRY'S PLANS TO HARDWIRE IP
A POX UPON THEIR CHILDREN! JAMES FLINT REPORTS BACK FROM THE PLAYGROUNDS OF CHICAGO
12 BLUNKETT'S BACKWARD BASICS MATTHEW HYLAND EXAMINES DAVID BLUNKETT'S LATEST THOUGHTS ON CITIZENSHIP
13 OPIATES FOR THE MASSES PETER CARTY ON ATTEMPTS TO STAMP OUT GLOBAL RECREATIONAL OPIATE USE
15 GHOST IN THE SHELL WHAT ARE GRAVASTARS? JAMES FLINT HAS THE ANSWER
16 MASS MAILING MADNESS IAN MORRISON RECOLLECTS...
17 CRIME PAINTS MATTHEW FULLER ON GRAFFITI ARTIST BANKSY
18 HEAD-TO-HEAD IS THE EURO A GOOD THING? KEITH HART AND STEWART HOME DEBATE
20 SURVIVAL STRATEGIES – DIGITAL STYLE DANIEL BERCHENKO ON A DAY OF TECHNOLOGY, ART AND ACTIVISM IN NYC
21 THE DARKSIDE OF THE WAVE: THEORIES FOR A BUST ECONOMY CCRU ASSESSES THE CONTENDERS

MAINS

22 UNTITLED DIAGRAM #7 THERESE STOWELL

24 TERROR IS A NETWORK – AND THE NETWORK IS YOU JJ KING ON ASYMMETRIC WARFARE IN AN AGE OF 'FULL SPECTRUM DOMINANCE'

32 GOATHERDS IN PINSTRIPES ARE DIGITAL COMMONS ADVOCATES REALLY FREE MARKETEERS BY ANOTHER NAME? GREGOR CLAUDE INVESTIGATES

38 BENEATH THE PAVING STONES, THE DESERT DAVE MANDL TALKS TO RUDY VANDERLANS, EDITOR OF EMIGRE MAGAZINE, ABOUT HIS LATEST JOSHUA TREE, A MUSICALLY INSPIRED BOOK OF PHOTOGRAPHS

42 WIDE AREA DISTURBANCE COCO FUSCO TALKS TO HACKTIVIST RICARDO DOMINGUEZ ABOUT THE HYBRID 'NET_ART_ACTIVISM' PAST AND FUTURE

REAR/VIEW

54 SPECIAL FOUND & CONSTRUCTED BRANDON LABELLE ON FOUND SOUND COMPOSITION IN TRANSURBAN SETTINGS
56 SPECIAL CONCENTRATED LISTENING FLINT MICHIGAN ON MUSIQUE CONCRÈTE
58 HEADLINE THE 'VERY CYBERFEMINIST INTERNATIONAL' CONFERENCE REVIEWED BY IRINA ARISTARKHOVA
60 HEADLINE TRANSMEDIALE REVIEWED BY JULIA SCHNEIDER
71 THE UNDEAD BIO-PICS BENEDICT SEYMOUR REVISITS PIER PAOLO PASOLINI'S FILMS
72 PIN-CODE FREE AS AIR EDDIE PRÉVOST ON SAMPLING

READ/ME

56 MUTE SPECIAL >>>
TURN ON, MASH-UP, SELL-OUT – ULRICH GUTMAIR ON THE <u>BOOTLEG PHENOM</u>

58 HEADLINE 1 >>>
BEYOND GOOD AND EVIL? – HARI KUNZRU ON <u>FANTASY LITERATURE</u>

60 HEADLINE 2 >>>
THE DARK DIVIDEND – JJ KING ON <u>WHY LYNCH MUST SHOOT DICK</u>

62 HEADLINE 3 >>>
THE IN CROWD – MARISA S. OLSON ON <u>NET ART REPS AT THE WHITNEY BIENN</u>

64 ANTENNAE >>>
THE MILGRAM RE-ENACTMENT – BY NEIL MULHOLLAND
ANNIKA LARSSON – BY TOM MORTON
CODE RED – BY SEETA PENA GANGADHARAN
UNKNOWN PUBLIC – BY ANJA BÜCHELE
PHILOSOPHY AND THE ADVENTURE OF THE VIRTUAL – BY LEONARD LATIFF
BOLD AS LOVE – BY DEBBIE SHAW
HATRED OF CAPITALISM – BY BRIAN DILLON
FIBRECULTURE READER – BY SIMON FORD
PLAYING WITH THE FUTURE – BY JULIAN KÜCKLICH
LOVEBYTES – BY LINA D. RUSSELL
MARXISM AND THE VISUAL ARTS – BY RICHARD BARBROOK
INTERMEDIUM2 – BY OLIVER FROMMEL
BUKAKA SPAT HERE – BY JOSEPHINE BERRY
REBEL CODE – BY DAVE GREEN
KRAZY & IGNATZ – BY DAVID THOMPSON
TOUR DE FENCE – BY SIMON WORTHINGTON

71 UNDEAD >>>
PACK TO THE FUTURE – MARINA VISHMIDT RECALLS <u>THE FUTURE OF JETPACKS</u>

72 PIN CODE >>>
WHAT'S NEW IN NEW MEDIA? – NATALIE JEREMIJENKO ON <u>TECHNOPUNK INSTIT</u>

(Issue 24, 2002) An image from Alexander Brener and Barbara Schurz's 'Bukaka Spat Here' explodes off the page with the use of full bleed top and bottom coupled with the cropping by the margin on the right.

IT'S ALL JUST *SO* CONFUSING

THE LAST PICTURE SHOW

(Issue 22, 2001) Catherine Story illustration for a piece on the demise of the Lux Centre in Hoxton Square, London. Story cleverly knitted together miscellaneous individual sketches – of faces on the London Underground, people in and around the City – to create both the lonely bell-ringer and the graffiti behind her.

illustration

INSPIRATION

CREATIVITY

FREE RESOURCES

PRIVATE PROJECTS

GRASS = INFORMATION

COLLABORATIVE PROJECTS

SOCIAL SPACES

CULTURE

KNOWLEDGE

FREE RESOURCES

ARCHIVES

SERVICES SALE/EXCHANGE

CULTURE

KNOWLEDGE

FREE RESOURCES

PUBLIC DISCUSSION

PERSONAL + AMATEUR PROJECTS

SUN IS THE PRINCIPLE OF ACTION
EVERYTHING IS BUILT ON THE EARTH
WATER IS THE DATA THAT BRINGS LIFE
INFORMATION IS THE GREEN FIBER EVERYBODY NEEDS
PLANTS AND ANIMALS MAY SUSTAIN PEOPLE
SKILLS AND COOPERATION IMPROVE SOCIETIES
DISCUSSION, ART AND LEISURE MAKE US HAPPY

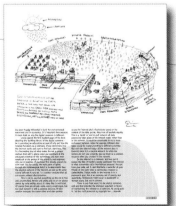

(Issue 22, 2001) Creator of the Ceci n'est pas un magazine sketch and a known advocate of the commons, network consultant Quim Gil was the perfect candidate to illustrate Gregor Claude's article on the history of this philosophical construct. Hindsight renders his deliberately child-like drawing even more optimistic than it seemed at the time.

AESTHETICIZED RITUAL

PROJECTION

LOVE AT FIRST SIGHT

ECSTASY

FILL MY EMPTINESS

FREE MARKET OF EMOTIONS

ILLUSION

TURBULENCE

UNSTOPPABLE LOVE MAGNET

MYSTERIOUS EXALTATION

ACHIEVEMENT

BEACON OF HOPE

INFATUATION

SOULMATE

ROMANCE

CONFIRMATION OF ESSENTIAL WORTH

TRANSCENDENCE

UTOPIA

LOVE

GRAND PASSION

IDEALIZATION

DESTINY

SALVATION

HIGHER AUTHORITY

OEDIPAL TENSION

SUFFERING

DESIRE

LOSING ONESELF

AUTHENTICITY

CONVENIENCE

MONOGAMY

DESPERATION

YOU COMPLETE ME

PURITY

CONFUSION

TOTAL QUALITY DATING

FALSE H

RECIPROCAL EXCHANGE

EXPRESSING ONE'S NEEDS

COMMUNICATION

SATISFYING THE OTHER'S NEEDS

SACRIFICE

WORK ON THE RELATIONSHIP

COUPLES COUNSELING

CAREFUL PLANNING

SELF-HELP

TRUST

INTIMACY

ADVANCED INTIMACY

COMPROMISE

ADAPTATION

DISILLUSIONMENT

LOWERED EXPECTATIONS

EMOTIONAL BLACKMAIL

VULNERABILITY

OPENING UP

SETTLING

HONEYMOON IS OVER

GUILT

EXPOSING ONE'S INNERMOST FEELINGS

LOSS OF INDIVIDUALITY

LOSS OF AUTONOMY

CONFESSION

KEEP THE PASSION ALIVE

SKILLFUL MANAGEMENT

TOO TIRED

IMATURE LOVE

ENTROPY

RENUNCIATION OF DESIRE

RATIONALITY

PRACTICALITY

RELIGION

SUBMISSION

VIAGRA

GOVERNMENT

Untitled Diagram #7, Therese Stowell, 2002

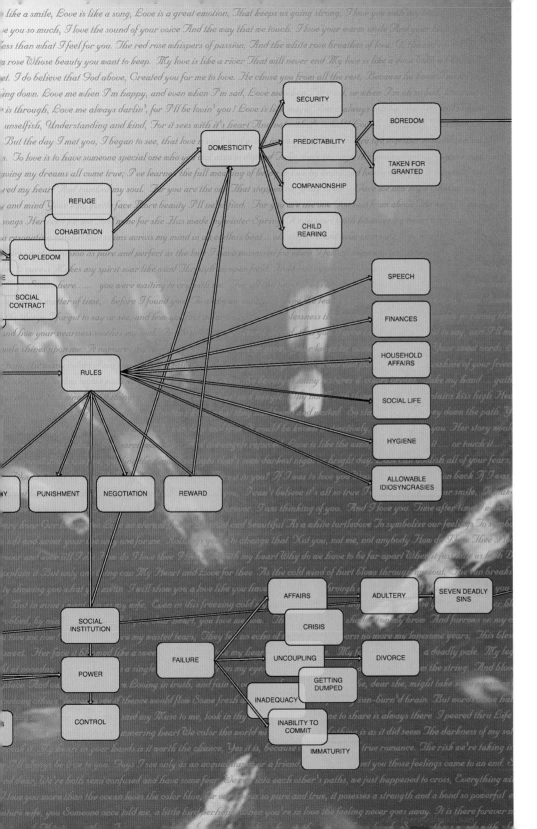

(*Issue 22, 2001*) *Artist Therese Stowell uses scientific and corporate visualisation techniques to represent subjects for which they weren't intended – often social or emotional. Further tension is created by the fact that viewers of her diagrams are drawn in to and fully conscious of the tools' inappropriateness, but cannot reject their visual authority.*

diagrams

1 letthemarketflow.com
2 we'rewatchingyoubaby.net
3 bethecoolestyoungrebel.com
4 feellikefree.com
5 culturalheritageforsale.shop
6 formsofuniqueentertainment.com
7 downloadfreetodayandyoullpaysomehowtomorrow.org
8 c'monjoinustobeyourself.com
9 buythekindofshityouredyingfor.shop
10 youcouldbewiserthanyourneighbour.edu
11 yourgenesarenotyoursanymore.shop
12 allthedigitalcrimeweapparentlyfight.xxx

(Issue 23, 2001) Using a slightly spurious
3D stage to illustrate the relative positions
of some equally spurious URLs this
diagram did not, in fact, make it to print.

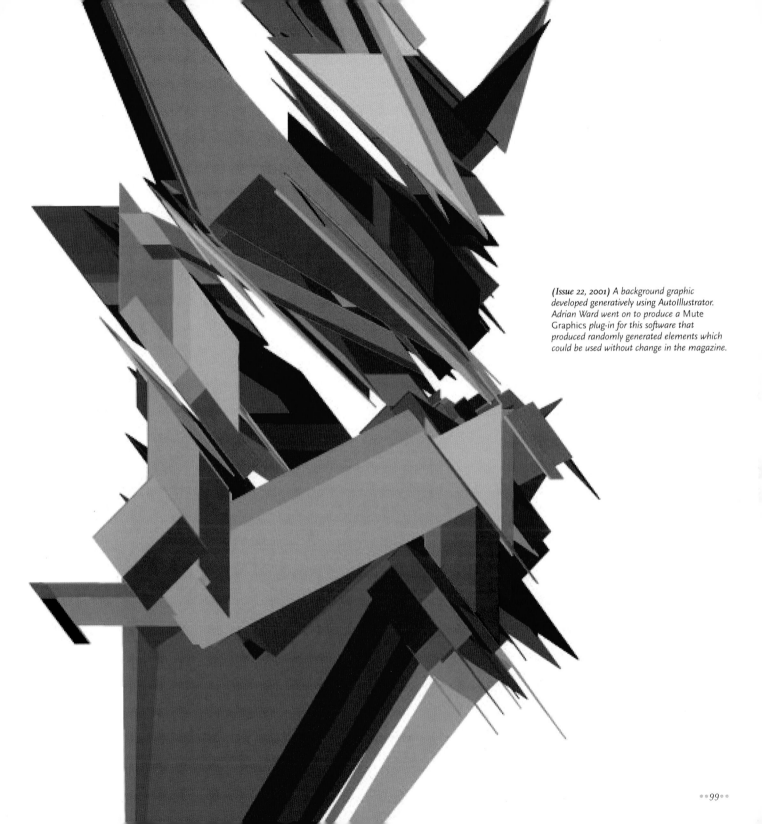

(Issue 22, 2001) A background graphic developed generatively using AutoIllustrator. Adrian Ward went on to produce a Mute Graphics plug-in for this software that produced randomly generated elements which could be used without change in the magazine.

BILL POSTERS IS G
NORMAL. DIVIDER
JUST BE FRIENDS
ABORT, RETRY, FAI
THE FUTURE. EXTR
(IN)DIFFERENT. BE
FILM COMBERS. CA
PHOTON BURP: QUA
DECODED. EXPLAI
WILD ANIMALS. PI

ILTY. WE ARE ALL
ND RULERS. LET'S
RS. SPUN SPOOKS.
FREEMASONS OF
MELY
CH BUFFS AND
TURING THE
TUM ENCRYPTION
NG URBANISM TO
CARI-US?

GOING COFFEE TABLE

GOING COFFEE TABLE
LUXURY'S LAST STAND

The publication timetable of *Mute* was never more packed than during the last years of the perfect bound and glossy formats. Before then, *Mute* had rarely attained even its quarterly schedule, but 2001–2 saw an unusual stint of hyper-activity, with this one-year period seeing the magazine actually reach a new, six-issue target.

Taking the risk of publishing more frequently didn't pay off, however; left with expenditure that dwarfed income, *Mute* now faced a more serious question. Could it in fact sustain *any* kind of high-end printed format, or should it finally take the leap and fuse theory and practice – maturing into a web-only magazine?

Ceri Hand, then director of The Women's Art Library (which also made her responsible for women's art journal *Make*), shared her experiences with *Mute*, looking in detail at its publishing model and economy. She concluded that there should be a radical reduction in frequency, that if a print issue came out it should exude desirability as a product, and that remaining funds should be spent on bringing the website up to speed as the high-turnover 'destination' site the public might expect from the magazine given its history and subject matter. Her conclusions chimed to a significant extent with those drawn by Quim Gil several years earlier, namely: *Mute* should embrace a networked model of production, be more transparent about the information circuits of which it was part – even pushing these outwards as content or shared infrastructure/resources for its community – and generally move online. The publication could then function as the slowest-output vehicle in the content armoury, providing an identifiable trace of the feedback between editors and readers as well as a notice board for upcoming research, projects and articles.

The result can be seen as high-end design's last stand. An off-white, high-absorbency art paper from Swedish manufacturers Münken was chosen for the pages. The use of this expensive stock was partly sponsored, but proved logistically complicated – importation from Sweden meant long lead times and its extreme porousness meant drying out for days after printing. A strong emphasis on photography,

Pauline van Mourik Broekman and Simon Worthington (editorial, issues 25–26; editorial board, issues 27–29); Josephine Berry (deputy editor, issue 25; contributing editor, issue 26; editor, issues 27–29; editorial board, issues 27–29); Simon Ford (assistant editor, issues 25); JJ King (contributing editor, issue 25; acting deputy editor, issue 26; information politics editor, issue 27–28; editorial board, issues 27–29); Hari Kunzru (contributing editor, issues 25–26; editorial board, issues 27–29); Benedict Seymour (assistant editor, issues 27–29; editorial board, issues 27–29); Damian Jaques (design); Luise Vormittag (design assistant); Demetra Kotouza (intern, issue 25; subscriptions, issues 26–29; editorial assistant, issues 27–29); Laura Oldenbourg (intern, issue 27; design assistant, issue 28); Matthew Hyland (editorial board, issues 27–29); Laura Sullivan (editorial board, issues 27–29); Valeska Bührer (intern, issue 28); Matthew Kabatoff (OpenMute intern, issues 28–29); Anthony Iles (assistant editor, issue 29); Vito Graffeo, Heidi Stache, James House (interns, issue 29).

illustration and unique, conceptual spreads continued. Information-synthesis through cartography, diagrams and pictograms was another firm favourite, though it took aeons to do well and thus ran directly counter to the efficiency drive the magazine was supposedly engaged in. In truth, the networked model was really only manifesting itself at the back-end, and in a second 'Ceci n'est pas un magazine' diagram, published in issue 25.

Financial Times' nightmares on colour calibration haunted Worthington as he tried to come to grips with the subtleties involved in optimising Munken's tricky stock, and a move was finally made to a straightforward coated paper for issue 29. When this issue came in, a decision had already been made to stop doing 'coffee-table'. Ironic – if a blessed relief – that it was the only faultless one ever published.

covers

Above right: (Issue 25, 2002) For the first
issue of the new format the magazine cover
is kept clear of type. The image, 'The Five
Sisters', Derelict Land West Lothian, from
John Latham's Scottish Office Placement,
1975, is wrapped around the spine and
back cover as shown in the opening spread
of the article on page 115.

Above: (Issue 26, 2003) This cover
illustration by Catherine Story humorously
integrates desk clutter from the Mute office
with magazine artwork and imagined
objects visualising the issue's content.

Right: (Issue 28, 2004) Using software
designed by Adrian Ward three images
from within the magazine are spliced
together: a copyright symbol, a drawing of
a skull and a picture of an IBM computer
installation from 1965.

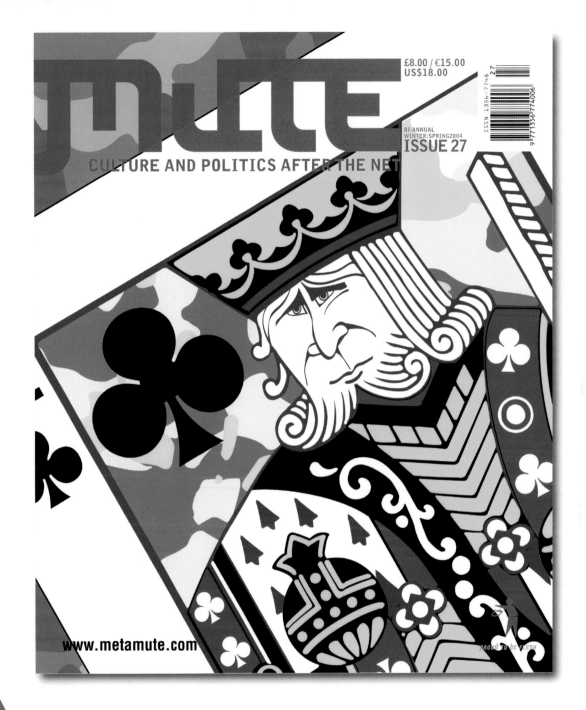

£8.00 / €15.00
US$18.00

ISSN 1356-7746

BI-ANNUAL
WINTER/SPRING2004
ISSUE 27

CULTURE AND POLITICS AFTER THE NET

www.metamute.com

(Issue 27, 2004) Art directed by Simon Worthington and designed by Laura Oldenbourg. Laura created the playing card style graphics – the logo was then integrated into the artwork to create a strong and cohesive cover design.

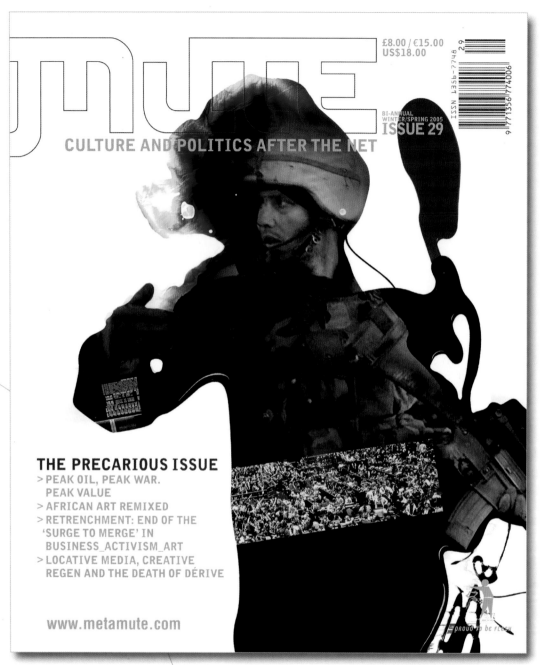

ꓟU꓿E

£8.00 / €15.00
US$18.00

BI-ANNUAL
WINTER/SPRING 2005
ISSUE 29

ISSN 1356-7748

CULTURE AND POLITICS AFTER THE NET

THE PRECARIOUS ISSUE

> PEAK OIL, PEAK WAR.
 PEAK VALUE
> AFRICAN ART REMIXED
> RETRENCHMENT: END OF THE
 'SURGE TO MERGE' IN
 BUSINESS_ACTIVISM_ART
> LOCATIVE MEDIA, CREATIVE
 REGEN AND THE DEATH OF DÉRIVE

www.metamute.com

*(Issue 29, 2005) Richard Dawson –
Mute's one-time fashion guru – returned
to the Mute pages, this time as a digital
image specialist, to collaborate with
Simon Worthington on this composite
image for the cover of the final,
conventionally-produced issue.*

covers

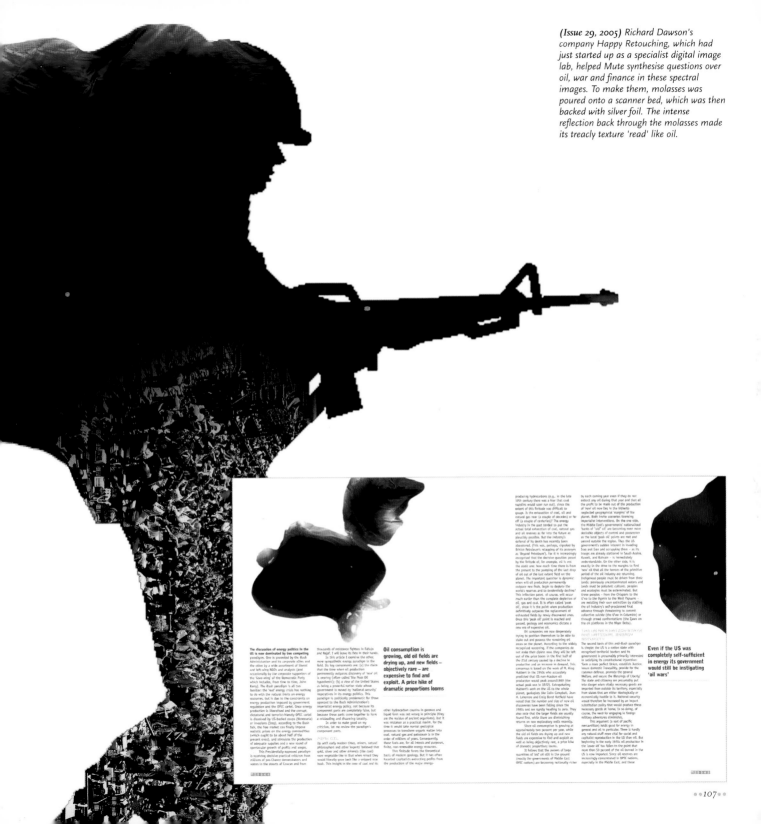

(Issue 29, 2005) Richard Dawson's company Happy Retouching, which had just started up as a specialist digital image lab, helped Mute synthesise questions over oil, war and finance in these spectral images. To make them, molasses was poured onto a scanner bed, which was then backed with silver foil. The intense reflection back through the molasses made its treacly texture 'read' like oil.

Left: (Issue 24, 2002) These figures, based on the Communication P04 icon font set, were used in a piece that discussed border control. They played with the notion of classifying human beings.

The Good, The Bad, The Ugly and The Bighead

abcdefghijklmnopqrstuvwxyz
ABCDEFGHIJKLMNOPQRSTUVWXYZ

abcdefghijklmnopqrstuvwxyz
ABCDEFGHIJKLMNOPQRSTUVWXYZ

abcdefghijklmnopqrstuvwxyz
ABCDEFGHIJKLMNOPQRSTUVWXYZ

Above from top:
Lunatix Bold and Light, *Emigre. Designed by Zuzana Licko, 1988.*
ITC Officina Serif Bold, *ITC. Designed by Ole Schäfer and Erik Spiekermann, 1990.*

Contents

MUTE
Issue 29

Short/Cuts

Mains

Rear/View

042
Peak Oil and National Security: A Critique of Energy Alternatives ▸ George Caffentzis analyses contemporary energy politics: is US national energy independence enough?

050 PROJECT SPACE
Safe Institution – Footing the Present, F*cking the Future ▸ London Rising Tide visits the 'Energy – Fuelling the future' exhibition at the Science Museum in London

SPECIAL SECTION
052 (UN)REGENERATE ART
A special section exploring the complicity, and potential oppositionality, of art in neoliberal urbanism

053
The Shape of Locative Media ▸ Simon Pope navigates the emerging genre of locative art

059
Mysteries of the Creative Class, or, I Have Seen The Enemy and They Is Us ▸ Gregory Sholette on REPOhistory and their fight to re-write the official story of urban renewal in Manhattan

062
Explaining Urbanism to Wild Animals ▸ Mark Crinson on some contemporary artists' attempts to engage with urban miracles and collective memory

067
Basic Instinct: Trauma and Retrenchment 2000-4 ▸ Anthony Davies surveys the recent history of art, business and activism and explores some disquieting parallels

078
Another Gaze ▸ Simon Njami on the changing relation of the international art world to African art

084
Oh I love freedom! But what is it? ▸ Mattin on the politics of musical improvisation

SPECIAL SECTION
087 EXPLORING PRECARIOUSNESS
A special section on the politics of precarious labour

088
Precari-us? ▸ Angela Mitropoulos on the race and gender at the nexus of precariousness as applied to the conditions of labour under neoliberalism

093
Precarious Straits ▸ Mariam Fraser on the endless variation of social labour across forms of domestic caring activities

096
Cheap Chinese ▸ John Barker on the precarious and exploitative exploitation of migrant labour essential to capitalist accumulation today

103
Wages for Anyone is Bad for Business ▸ Karen Feldman speaks to Selma James and Nina Lopez of some women's contestation of (financial) definitions of work

106 PROJECT SPACE
Micropolitika ▸ Zeigam Azizov

114
The Dissolving Fortress – Notes on the Future of WIPO ▸ JJ King on the World Intellectual Property Organisation (WIPO)'s adoption of a 'Development Agenda'

008
The War on Immigrants ▸ Alisa Solomon on what uses of 'war on terror' legislation in the US apart from hounding CAE's Steve Kurtz

010
Marketing Electoralism in the USA ▸ Scott Evans on the commercialised drive to 'get out the vote'

012
Free Speech Zones and Preemptive Detentions ▸ Daniel Burchenka analyses developments in legal protest in the US

014
The Vortex Void of Inhumanity ▸ Cameron Bain looks into the abyss of Black Metal

016
Return of the Browser Jedi? ▸ Danny O'Brien reports from the frontline of the new browser war

018
Common Property ▸ Yukiko Jungesblut on The Halle School of Common Property and the 6th Werkleitz Biennial

020
Control Freakery at the UK-ESF ▸ Laura Sullivan behind the scenes at London's European Social Forum

022
Base Resonance ▸ John Cayley on the London Design Museum's Saul Bass exhibition

025
Body Shop Hermeneutics ▸ Tirdad Zolghadr on this autumn's Black Atlantic festival in Berlin

026
The World Turned Upside Down ▸ Tadzio Müller analyses the Anti-Germans' mutant Marxism

028
Autolabz: Critiquing Utopia ▸ David Garcia reports on a non-governmental media project in Brazil's slums

031
Signing Away Subversion ▸ JJ King on the Berlin Declaration on Collectively Managed Online Rights

032
What Money Can't Buy ▸ Sebastian Hacher on Argentinian independent media activists' defeat of Benetton's PR campaign against the Mapuche

034
A Crisis of Presentation ▸ Sarah Cooke looks at the current state of new media art curation in the UK and beyond

036
Disobbedienti, Ciao – Hydrarchist on the death of the Italian Disobbedienti (Disobedients), and the rise of the precariat

Photo: Morecambe Bay, Pam Worthington, 2004. http://pansphotos.artandt.org

120 Inside Out ▸ Stella Santacatterina reviews the Helen Chadwick retrospective, at the Barbican, London

122 Network Culture ▸ Steve Wright reviews Network Culture: Politics for the Information Age by Tiziana Terranova

123 Waste Product ▸ Hari Kunzru on a new documentary about Gustav Metzger

124 Sex Cells ▸ Andrew Goffey reviews Abstract Sex: Philosophy, Biotechnology and the Mutations of Desire by Luciana Parisi

125 Terminal Platitudes ▸ Daniel Jewesbury reviews Terminal Frontiers, a show at Streetlevel Photoworks in Glasgow

127 The Dishonour of Poets ▸ Howard Slater reviews The Yale Anthology of Twentieth Century French Poetry, ed. Mary Ann Caws

128 Haunted Sublimity ▸ Ben Watson reviews David Toop's Haunted Weather

129 The Death of the Death of the Portrait ▸ Richard Wright reviews the exhibition About Face, Hayward Gallery, London

130
Bug Report ▸ Christian Nold reviews Jodi's solo show at FACT, Manchester

132 Act(s Council) History ▸ Olga Goriunova reviews New Media Art: Practice and Context in the UK 1994-2004, edited by Lucy Kimbell

133 Post-Humanism=Post-Animality ▸ Tim Savage reviews Donna Haraway's Companion Species Manifesto

134 Back to the Future – Ars Electronica at 25 ▸ Michelle Kasprzak reviews this year's festival in Linz

136 The Insecurity Lasts a Long Time ▸ Anthony Iles reviews Republicart's issue on precarious labour

137 Under the Pavement, the Id ▸ Josephine Berry Slater reviews Paul Noble's show at The Whitechapel Gallery, London

139 Something over against is (or) Accidence commenced ▸ Anja Büchele and Matthew Hyland on the works of poet Susan Howe

143 The Wireless Loveboat: ISEA 2004 ▸ Armin Medosch on the 12th International Symposium on Electronic Arts

MUTE
Issue 28

Contents
Short/Cuts
Mains
Mains/Rear/View

006
Create Creative Clusters David Panos on Creative London, the latest regeneration scheme attempting to harness the (economic) power of creativity

009
Picture Perfect People Power Kate Rich gives an eyewitness account of Georgia's newly televised velvet revolution

010
Publicising the Immaterial Labour Camp Emilia Palonen and Steffen Böhm on attempts at Essex University to discuss the baleful effects of neo-liberalism on higher education

012
End Product of Society Matthew Hyland and JJ King on the persistence of intelligence testing and its biopolitical function today

014
Bausch Baffle and Film Cannes Zoe Young reports back from the Being Vtoo Own Film Festival at Puri in Eastern India

016
Capturing the Photon Burp Brian Carty decodes Quantum Encryption

017
United RFID Benjamin Hicks Hill on the potential abuses of RFID tags

018
Real, Meet the Hacker Hackers, this is the Real Hackers of ECN, Austin1 and -etixel give an overview of Italian Hacklabs and the hacktivist scene

019
The Invisible Network
The Glocal Research Centre at Barcelona

Infrempal on the progress of the 'anti-globalisation' network Peoples' Global Action (PGA) and the challenge it faces

020
Auzh Subjectivity Anton Suttherland on the avant-garde' celebration of spam as consumer revolt

024
Learning to Love the Poetry Blog Lewis LaCook on his conversion to poetry blogs

026
Locative Literacy Saul Albert appraises the art world's new darling, locative media

028
Beautiful Ontologies Paul Ford on the sacredized potential of web ontologies

030
Mission Transmission Agnese Trocchi on the development of autonomous peer-to-peer video distribution systems

032
Copyright Nations Brian Kobe Ventura talks to techn.core founder Sebastian Lütgert about intellectual property and the control society

034
Free as in Nicked Nate interviews the Dresden for Free and Hamburg for Free groups on their campaigns inciting people to go 'proletarian' shopping

036
Reclaiming the Asturias Countryside Tadzio Mocelint investigates an activist community born in the ashes of post-industrial Asturias, North-West Spain

040
'Imperial Grooming': Iranian Cinema and the Inconvenience of Class Struggle Melancholie Troglodytes on the western liberal celebration of a dissident film culture

046
Software Art After Programming Richard Wright embeds the history of debates on computer art into the software that defined them

054
Art is Like Cancer Roger Taylor talks to Stewart Home about Larry Shiner and The Invention of Art

SOCIAL FORUM REPORT
062
Horizontally Challenged A special report on this January's World Social Forum in Mumbai and the forthcoming European Social Forum in London

063
Included Out? Rahul Rao on the opportunities and exclusions of Mumbai's WSF

065
Divisions and Missed Opportunities Olivier de Marcellus on the WSF's failure to include India's most important counter-globalisation movements

068
The Big Hug Ben Provessau on the farcical truth afflicting the planning of this year's ESF in London

072
Recomposing the University Tiziana Terranova & Marc Bousquet discuss the effects of neo-liberalism on the university and possible lines of resistance

SELF-INSTITUTIONS
082
Teach Yourself Institutions A Mute survey of self-instituted educational projects

088
Proportunal Outorganizations Howard Slater on the problem with entrepreneurial organisation

091
Call to Arms Kolinko present some of the findings from their workers' enquiry into call centre work

096
New York Prophecies Richard Barbrook on New York's 1964 World's Fair and the disguise of cold war technology as a consumer fantasy of the future

104
Puzzle – Paso It On Maya Foster on the information campaign from below that brought down the Aznar government after the Madrid bombing

106
Infernal Intifada: Workers' Struggle in Occupied Iraq Ewa Jasiewicz reports

ARTIST'S PROJECT
111
Over the Benoît Horizon Lutham Blissett on gender, networks and the PGA conference in Serbia

124 Control Society Expanded? Mark Foster reviews Alexander Galloway's Protocol

125 gOenix: The Aesthetics of Digital Poetry reviewed by Brian Kim Stefans

126 Strange Common Places A Grammar of the Multitude by Paolo Virno reviewed by Massimo de Angelis

130 AND + NOT some marginal notes Anja Büchele on Jean-Jacques Lecercle's Deleuze and Language

131 Postviral Signs Melanie Gilligan reviews Bichasus Experiments in Postviral Living by Richard Doyle

132 The Incidental Collection – Stuart Brisley's Peterlee Project reviewed by Mark Crinson

134 Beyond the Big Boys Josie Loseby on Futherbed

135 Not Vice City, Not Vice City Matthew Fuller on spring_alpha

137 The Emperor's New Clothes Anja Kirschner on Donna Sped and Harman at the Lux Luxo

137 When is Deleuze Not Deleuze? Jean-Jacques Lecercle on Slavoj Žižek's Organs Without Bodies

138 The Grave Digger from Saint-Germain-des-Pres Stewart Home on two new (vari)actions of Guy Debord

140 Lost In Translation Paul Helliwell on the second edition of Jacques Attali's Noise

141 GesamtkunstboaI Peter Suchin reviews Mark Amin Walker's latest work

143 Inside Fulfilment's Bio-Secure Room " [ote] Goldie on Whitehouse

Above: (Issue 29, 2005) This sombre contents page reflects its background image – a photograph of Morecambe Bay taken by Pam Worthington. The rising tide had killed 23 Chinese cocklers working on the beach the year before.

Left: (Issue 28, 2004) The growing size of the contents of the magazine required a more modular approach.

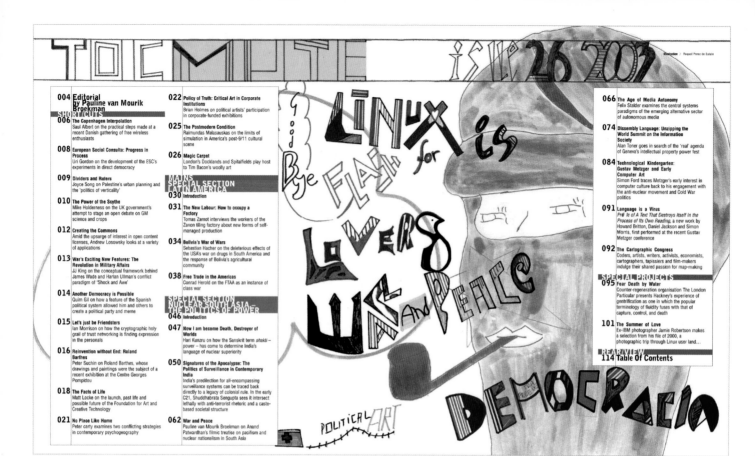

004 Editorial
by Pauline van Mourik Broekman

SHORTCUTS

006 The Copenhagen Interpolation
Saul Albert on the practical steps made at a recent Danish gathering of free wireless enthusiasts

008 European Social Consulta: Progress in Process
Uri Gordon on the development of the ESC's experiments in direct democracy

009 Dividers and Rulers
Joyce Song on Palestine's urban planning and the 'politics of verticality'

010 The Power of the Scythe
Mike Holderness on the UK government's attempt to stage an open debate on GM science and crops

012 Creating the Commons
Amid the upsurge of interest in open content licenses, Andrew Losowsky looks at a variety of applications

013 War's Exciting New Features: The Revolution in Military Affairs
JJ King on the conceptual framework behind James Wade and Harlan Ullman's conflict paradigm of 'Shock and Awe'

014 Another Democracy is Possible
Quim Gil on how a feature of the Spanish political system allowed him and others to create a political party and meme

015 Let's just be Friendsters
Ian Morrison on how the cryptographic holy grail of trust networking is finding expression in the personals

016 Reinvention without End: Roland Barthes
Peter Suchin on Roland Barthes, whose drawings and paintings were the subject of a recent exhibition at the Centre Georges Pompidou

018 The Facts of Life
Matt Locke on the launch, past life and possible future of the Foundation for Art and Creative Technology

021 No Place Like Home
Peter carty examines two conflicting strategies in contemporary psychogeography

022 Policy of Truth: Critical Art in Corporate Institutions
Brian Holmes on political artists' participation in corporate-funded exhibitions

025 The Postmodern Condition
Raimundas Malasauskas on the limits of simulation in America's post-9/11 cultural scene

026 Magic Carpet
London's Docklands and Spitalfields play host to Tim Bacon's woolly art

MAINS
SPECIAL SECTION
LATIN AMERICA

030 Introduction

031 The New Labour: How to occupy a Factory
Tomas Zamot interviews the workers of the Zanon tilting factory about new forms of self-managed production

034 Bolivia's War of Wars
Sebastian Hacher on the deleterious effects of the USA's war on drugs in South America and the response of Bolivia's agricultural community

038 Free Trade in the Americas
Conrad Herold on the FTAA as an instance of class war

SPECIAL SECTION
NUCLEAR SOUTH ASIA –
THE POLITICS OF POWER

046 Introduction

047 Now I am become Death, Destroyer of Worlds
Hari Kunzru on how the Sanskrit term *shakti* – power – has come to determine India's language of nuclear superiority

050 Signatures of the Apocalypse: The Politics of Surveillance in Contemporary India
India's predilection for all-encompassing surveillance systems can be traced back directly to a legacy of colonial rule. In the early C21, Shuddhabrata Sengupta sees it intersect lethally with anti-terrorist rhetoric and a caste-based societal structure

062 War and Peace
Pauline van Mourik Broekman on Anand Patwardhan's filmic treatise on pacifism and nuclear nationalism in South Asia

066 The Age of Media Autonomy
Felix Stalder examines the central systems paradigms of the emerging alternative sector of autonomous media

074 Dissembly Language: Unzipping the World Summit on the Information Society
Alan Toner goes in search of the 'real' agenda of Geneva's intellectual property power fest

084 Technological Kindergarten: Gustav Metzger and Early Computer Art
Simon Ford traces Metzger's early interest in computer culture back to his engagement with the anti-nuclear movement and Cold War politics

091 Language is a Virus
Préle of A Text That Destroys Itself in the Process of Its Own Reading, a new work by Howard Britton, Daniel Jackson and Simon Morris, first performed at the recent Gustav Metzger conference

092 The Cartographic Congress
Coders, artists, writers, activists, economists, cartographers, tapissiers and film-makers indulge their shared passion for map-making

SPECIAL PROJECTS

095 Fear Death by Water
Counter-regeneration organisation The London Particular presents Hackney's experience of gentrification as one in which the popular terminology of fluidity fuses with that of capture, control, and death

101 The Summer of Love
Ex-IBM photographer Jamie Robertson makes a selection from his file of 2000, a photographic trip through Linux user land...

REARVIEW
114 Table Of Contents

(Issue 26, 2003) Illustrated by Raquel Perez de Eulate, this table of contents artwork was inspired by the hand-written typography of Madrid porn cinema posters. The cinemas are not allowed to show images on the street and the foreign-made movies don't have names, so the proprietor becomes designer. This could perhaps be interpreted as an over-zealous interpretation of Mute's sometimes used strapline, 'Proud to be Flesh'.

contents pages

Above: (Issue 26, 2003) Here Perez de Eulate interprets Mute's low tech/high tech style, reworking Jaques' shard-like vector work but with the low tech felt-tip pen.

Above right: (Issue 28, 2004) An unusual absence of any contents information for the Rear View section subverts the magazine's own historical precedence.

Right: (Issue 25, 2002) The strong magenta background is cut up 'scissor style' as a simple framing device in this contents page.

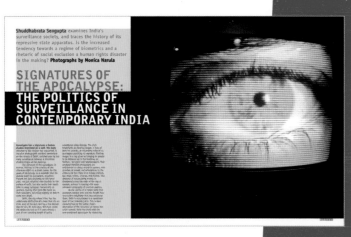

Shuddhabrata Sengupta examines India's surveillance society, and traces the history of its repressive state apparatus. Is the increased tendency towards a regime of biometrics and a rhetoric of social exclusion a human rights disaster in the making? **Photographs by Monica Narula**

SIGNATURES OF THE APOCALYPSE: THE POLITICS OF SURVEILLANCE IN CONTEMPORARY INDIA

(Issue 26, 2003) The bold colour blocks are used here to contain both the photographs by Monica Narula and the text.

Right: (Issue 28, 2004) A simplified typographic approach allows this complex photograph to be the main focus.

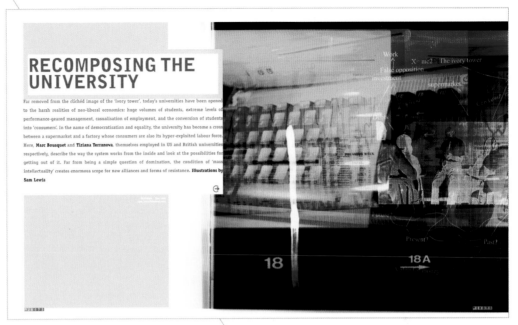

Right: (Issue 27, 2004) The 45 degree element of the headline mimics the open door of the photograph opposite.

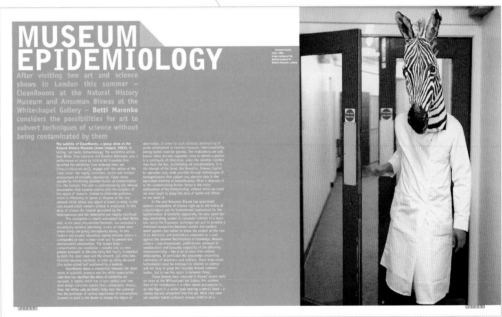

photo graphics

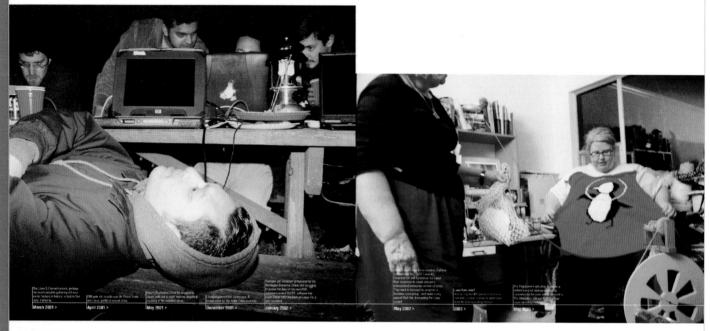

Above and left: (Issue 26, 2003) A photo essay by Jamie Robinson has a running timeline superimposed across each spread outlining the key dates in the development of the Linux operating system.

Image: *Self Rock III (Falkenstein)*, 2002, hand-made woollen wall-hanging rug, 268cm x 318cm

M26028

SHORTCUTS

Above: (Issue 26, 2003) Tim Bacon's hand-made woollen rug photographed against a contrasting gritty urban setting.

photo graphics

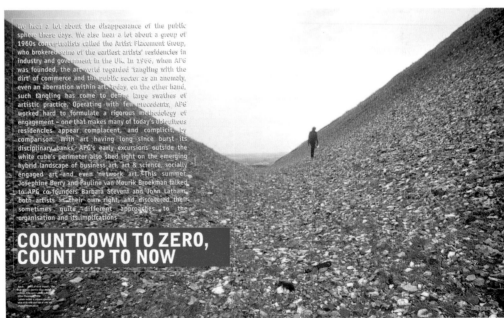

We hear a lot about the disappearance of the public sphere these days. We also hear a lot about a group of 1960s conceptualists called the Artist Placement Group, who brokered some of the earliest artists' residencies in industry and government in the UK. In 1966, when APG was founded, the art world regarded 'tangling with the dirt' of commerce and the public sector as an anomaly, even an aberration within art. Today, on the other hand, such tangling has come to define large swathes of artistic practice. Operating with few precedents, APG worked hard to formulate a rigorous methodology of engagement – one that makes many of today's ubiquitous residencies appear complacent, and complicit, by comparison. With art having long since burst its disciplinary banks, APG's early excursions outside the white cube's perimeter also shed light on the emerging hybrid landscape of business art, art & science, socially engaged art and even 'network art'. This summer, Josephine Berry and Pauline van Mourik Broekman talked to APG co-founders Barbara Steveni and John Latham, both artists in their own right, and discovered their sometimes quite different approaches to the organisation and its implications

COUNTDOWN TO ZERO, COUNT UP TO NOW

Right: (Issue 25, 2002) 'The Five Sisters', Derelict Land West Lothian, from John Latham's Scottish Office Placemen used both as the cover image and for this opener.

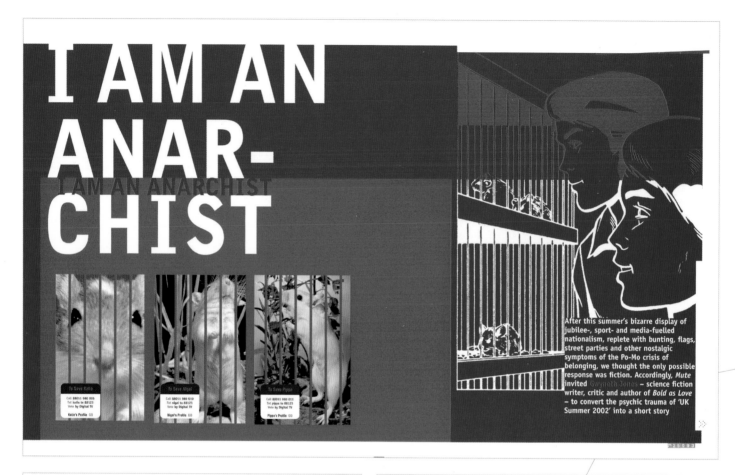

I AM AN ANAR-CHIST

I AM AN ANARCHIST

After this summer's bizarre display of jubilee-, sport- and media-fuelled nationalism, replete with bunting, flags, street parties and other nostalgic symptoms of the Po-Mo crisis of belonging, we thought the only possible response was fiction. Accordingly, *Mute* invited Gwyneth Jones – science fiction writer, critic and author of *Bold as Love* – to convert the psychic trauma of 'UK Summer 2002' into a short story

(Issue 25, 2002) With images culled from an old book on hamster-rearing, a pallet change stays within the style rules and run of the magazine, while the split-colour images add a level of day-glo-dynamism.

Right: (Issue 27, 2004) Reflecting the phrase '... an empty display case...' the title takes over as the main occupier.

Right: (Issue 23, 2002) For this opener an A3 scanner was used (and abused) as a pizza plate by Simon Worthington and Richard Dawson. A cooked pizza was flipped onto the scanner bed to create a highly visceral background for this imitation of a pizza joint menu. Brush Script was the obvious typeface to use.

PRECARI-US?

Menu 1
Mega-No-Lunch

Menu 2
Hipodda Feast

Menu 3
Death By Delivery

Menu 4
Misery Meal (living loosin' good)

Menu 5
Call Centre Cola

Menu 6
Postmodern Chicken Farm

Menu 7
All Day (and night) Brain Buffet

Menu 8
Ebay Bid Bot Banquet
Assemble Your Own
Fu©kin' Meal

spreads

ART BASEL 34

Art Basel is an empty display case open for occupation by smooth commercial operators, gullible wannabes and tactical artivists alike. Here Gwynneth Porter explores the fair and its surroundings, a setting in which the uneasy relationship between money, culture and Swiss cheese is played out

(Issue 28, 2004) Liz Turner illustration for an article exploring the Semantic Web and user-defined online information systems.

illustration

ART IS LIKE CANCER:

Stewart Home is already well known to many for his anti-art antics, but his early inspiration and fellow iconoclast, Roger Taylor, is rather less familiar. The recent publication of Larry Shiner's *The Invention of Art*, which rehearses Taylor's account of the historical novelty and specificity of art some 30 years later, seemed like a good excuse to meet up. In an era when art is increasingly promoted as accessible and desirable for everyone, Taylor explains why art remains 'an enemy of the people'

ROGER TAYLOR TALKS TO STEWART HOME ABOUT LARRY SHINER & *THE INVENTION OF ART*

ILLUSTRATIONS BY RAQUEL PEREZ DE EULATE

Above: (Issue 28, 2004) Part of Mute's design remit is to give artists freedom to interpret articles and be experimental. This illustration, created by Raquel Pereze de Eulate, is a good example of the multi-layered, process-based approach that is so fundamental to the magazine's ethos.

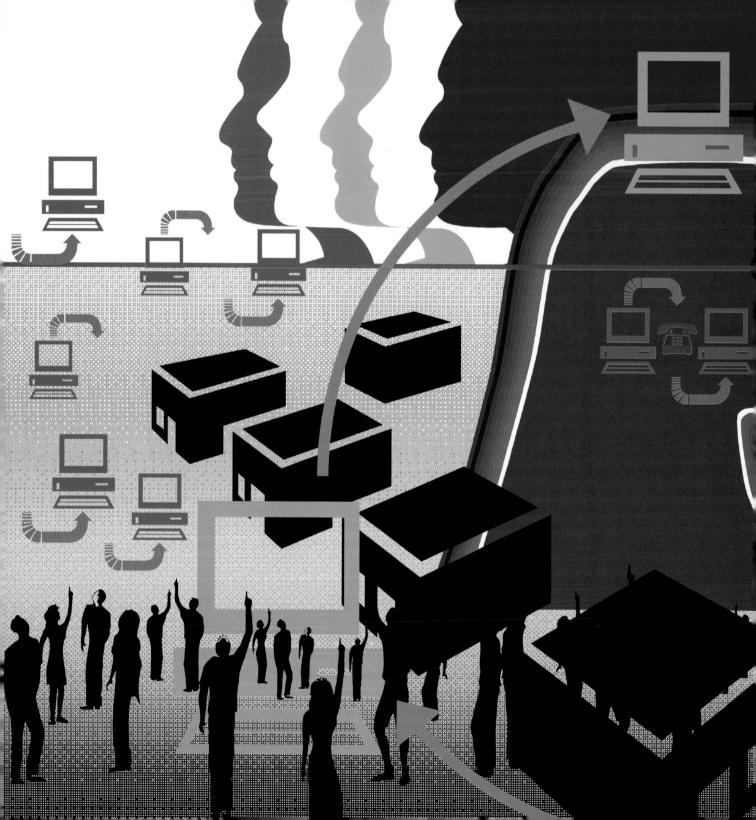

(Issue 26, 2003) This cyber-psychedelic illustration by Simon Worthington is, somewhat surprisingly, born out of the work of the designer Paul Rand: the classic IBM logo and UPS shield. Post Electric Kool-Aid Acid Test era meets cyberpunk.

BOMBS AND BYTES: SOVEREIGN POWER AND GLOBAL INFORMATION FLOWS

Can the intense economy of information short-circuit knowledge? **Anustup Basu** follows Gilles Deleuze in analysing fascism as a hijacking of linguistic potential. Facsism, he argues, realises itself through a technology of habituation parasitic on our willingness to be informed – a biopolitical sovereignty that percolates individuals and communities at the micro-level. No longer is world-order decreed by the word of the sovereign, but by an inhuman sovereign will constituted on the plane of information

INTRODUCTION

During the publicity drive towards building up domestic and international support for the 2003 war on Iraq, no functionary of the United States government actually made a public statement to the effect that Saddam Hussein had an active part to play in the devastation of September 11, 2001. Nevertheless, it was subsequently noted in the opinion polls that an alarming number of American people believed that the Iraqi despot was involved in the conspiracy and its execution. Hence the two propositions – Saddam the evil one, and 9/11, the horrible crime – seem to be associated in a demographic intelligence without having any narrative obligation to each other; that is, without being part of the same 'story'. The outcome, it seems, was achieved by a mathematical chain of chance, by which two disparate postulates, in being publicised with adequate proximity, frequency, and density, gravitate towards each other in an inhuman plane of massified thought. They, in other words, are bits and bytes of newspeak which have come to share what I will call an 'informatic' affinity with each other, without being organically conjoined by constitutive knowledge. The formation of the latter entity is of course something

we are prone to consider a primary task of the philosophical human subject, who is also the modern citizen with rights and responsibilities. Attaining knowledge by reading the world is how we are supposed to self-consciously exercise reason, form views, and partake in an enlightened project of democratic consensus and legislation. Hence, insofar as these much hallowed protocols of liberal democracy are concerned, this 9/11 opinion poll poses some disconcerting questions:

1. How does one account for the fact that what is, at face value, the most sophisticated technological assemblage for worldly communication and dissemination of 'truth', should sublimate what, in Kantian terms, must be called an unscientific belief or dogma?

2. To be mediatised literally means to lose one's rights. Hence, what happens to the idea of government by the people and for the people if the 'false' is produced as a third relation which is not the synthetic union of two ideas in the conscious mind of the

All of us are Hitlers who command attention, or nigger-infants (the Greek etymology of the word infant, as in *in-fans*, refers to the being without language) who listen without speaking, but only in differential degrees of hierarchised mediation

be engaged in tauto-talk, repeating what the dictator has already said or warned about. Benjamin calls this an eclipse of the order of cosmological mystery and secular miracles that the European humanist sciences of self and nature, and an enlightened novelisation of the arts sought to delineate and solve. There can for neither veracities in fascism, nor anything unknown. Conspiracies in that sense can only be manifestations of what is already foretold and waiting to be confessed. The SS can of course procure and store 'classified information', but it can never say anything that the Führer does not know better. Information therefore becomes as incessant and emphatic localisation of the global will of the dictator; in its seriality and movement, it can only keep repeating, illustrating, and reporting the self-evident truth of the dictatorial monologue.2 For Deleuze, it is in this immanence of dictatorial will that Hitler becomes information itself. Also, it is precisely because of this that one cannot wage a battle against Hitlerism by embarking on a battle of truth and falsehood without questioning, and taking for granted, the very pandouls of information and its social relations of production. 'No information, whatever it might be, is sufficient to defeat Hitler'.

Hence, like any other individual, Adolf the Aryan anti-semite does not exhaust the figure of Hitler. Informatics has not ceased after the death of Adolf and his propaganda machine, or the passing away of the particular discourse of the Abelphic oracle and its immediate historical context. As a figural diagram, as a special shorthand for a particular technology of power, Hitler subsequently must have only become stronger, that is, if indeed we are to still account for him as an immanent will to information that invests modern societies. But how can one conceptualise him without the formalist baggage, in other words, without the grotesque, arborescent institutions of repression, like the secret police or the concentration camps, which constitute a historicist definition of fascism? If one were to put the question differently, that is, occasion it in

terms of a present global order of neo-liberalism, marked by American style individualism, consumer choices, democracy, and free markets that supposedly come to us after the agonistic struggles of liberation in the modern era are already settled, how can one enfigure the dead and buried tyrant in our midst in such an 'untimely' manner? Here is Hitler possible in a liberal constitution? The question is a complicated one, because if we go back to the example we began our essay with, we will see that it actually satisfies the conditions of democratic accountability in terms of the human lie (the President never said this). Besides, it is also not the result of the state, as collective capitalist, monopolising the public sphere for propaganda purposes.

Perhaps one has to begin by not trying to enfigure Hitler in the contours of the human, as the irrational apex of the suicidal state, or the pathological Goebbelism for who converted the tools of human communication into mass propaganda machines. Hitler in that sense, would not simply be the mediocre and grotesque madman who uses or abuses technology. He would still be a proper name for technologism itself, but in his latest neoliberal incarnation, he would not be one who simply imprisons the human in enclosed spaces like the death camp or exercises a Faustian domination over him through arborescent structures like the Nazi war/propaganda machine. The 'postmodern' technology of information that we are talking about quo Hitler is neither external nor internal to the human; it is one that is a part of the infant's self-making as well as that of the bio-anthropological environment he lives in. Hitler enters us through a socialisation of life itself, through a technology of habituation that involves our willingness to be informed. It is a diffuse modality of power that perpetually communicates between the inside and the outside, erasing distance between the home and the world. It is in this context that Deleuze's statement, that there is a Hitler inside us, modern abjects of capital, becomes particularly significant. Hitler, as per this formulation, becomes an immanent form of sovereignty that is biopolitically present, percolating individuals and communities in so socially remanent micro-fascisms, is not the addressee who speaks to us while we listen. It was only Adolf who did that in the old days, as the anachronistic caricature of the sovereign who had not yet had his head cut off, but had simply lost it'. Information on the other hand, is a metropolitan habit of instant signification; it is an administered social automaton that does not generate a

Above and left: (Issue 27, 2004)
Illustrations by Simon Worthington, Damian Jaques and Laura Oldenbourg. To integrate the graphically strong images on the cards with the title and text, card colours were borrowed for the title blocks and then run behind the artwork.

Right: (Issue 26, 2003) Globalisation's multiple scales of impact were here illustrated by making several representational devices collide. The scratched lines of transport routes, stock photos and clip-art sought little integration, creating a sense of violent encounter.

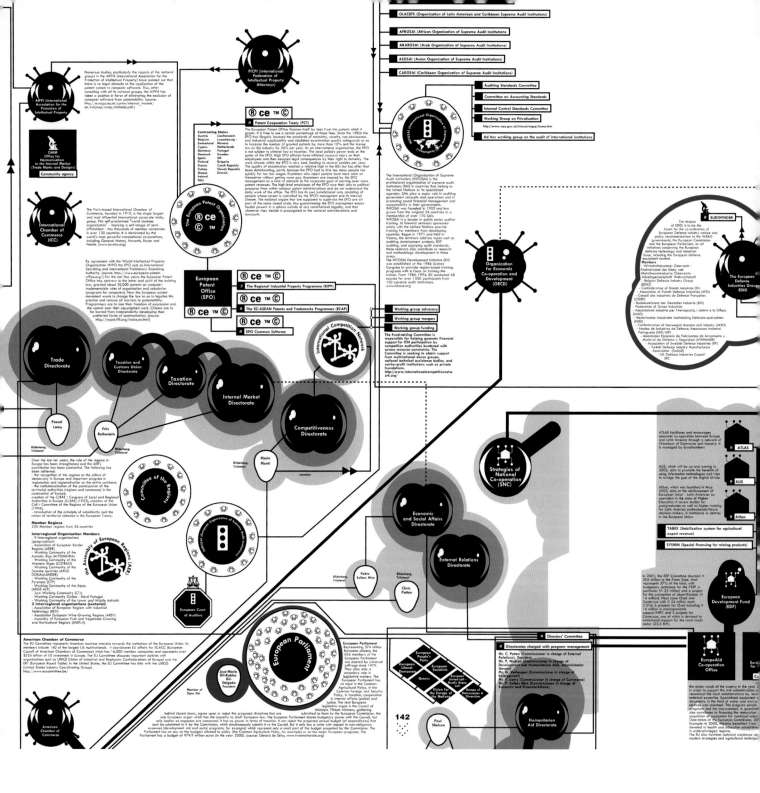

OLACEFS (Organization of Latin American and Caribbean Supreme Audit Institutions)

AFROSAI (African Organization of Supreme Audit Institutions)

ARABOSAI (Arab Organization of Supreme Audit Institutions)

ASOSAI (Asian Organization of Supreme Audit Institutions)

CAROSAI (Caribbean Organization of Supreme Audit Institutions)

Auditing Standards Committee

Committee on Accounting Standards

Internal Control Standards Committee

Working Group on Privatization

http://www.nao.gov.uk/intosai/wgap/home.htm

Ad hoc working group on the audit of international institutions

AIPPI (International Association for the Protection of Intellectual Property)

FICPI (International Federation of Intellectual Property Attorneys)

Numerous studies, particularly the reports of the national groups in the AIPPI (International Association for the Protection of Intellectual Property) have pointed out that there is no legal obstacle to the application of the patent system to computer software. Thus, after consulting with all its national groups, the AIPPA has taken a position in favor of eliminating the exclusion of computer software from patentability. (source: http://europa.eu.int/comm/internal_market/en/indprop/comp/michelet.pdf.)

OHIM Office for Harmonisation in the Internal Market (Trade Marks and Designs)
Community agency

International Chamber of Commerce (ICC)

The Paris-based International Chamber of Commerce, founded in 1919, is the single largest and most influential international corporate lobby group. This self-proclaimed "world business organisation" - implying a self-image of semi-officialdom - has thousands of member companies in over 130 countries. It is dominated by the world's most powerful transnational corporations, including General Motors, Novartis, Bayer and Nestlé. (www.iccwbo.org)

By agreement with the World Intellectual Property Organization WIPO the EPO acts as International Searching and International Preliminary Examining Authority. (source: http://www.european-patent-office.org/) For the last few years the European Patent Office has, contrary to the letter and spirit of the existing law, granted about 30,000 patents on computer-implementable rules of organisation and calculation (programs for computers). Now the European patent movement wants to change the law so as to legalise this practice and remove all barriers to patentability. Programmers are to lose their freedom of expression and the control over their copyrighted work. Citizens are to be barred from independently developing their preferred forms of communication. (source: http://swpat.ffii.org/index.en.html)

The European Patent Organisation
® ce ™ ©

Patent Cooperation Treaty (PCT)

Contracting States
Austria	Liechtenstein
Belgium	Luxembourg
Switzerland	Monaco
Cyprus	Netherlands
Germany	Portugal
Denmark	Sweden
Spain	UK
Finland	Bulgaria
France	Czech Republic
Turkey	Slovak Republic
Greece	Estonia
Ireland	
Italy	

The European Patent Office finances itself by fees from the patents which it grants. It is free to use a certain percentage of these fees. Since the 1980s the EPO has illegally lowered the standards of technicity, novelty, non-obviousness and industrial applicability and abolished examination quality safeguards so as to increase the number of granted patents by more than 10% and the license tax on the industry by 26% per year. As an immoral organisation, the EPO is not subject to criminal law or taxation. The local police's power ends at the gates of the EPO. High EPO officials have inflicted corporal injury on their employees and then escaped legal consequences by their right to immunity. The work climate within the EPO is very bad, leading to several suicides per year. The quality of examination reached a relative high in the 80s but has after that been deteriorating, partly because the EPO had to hire too many people too quickly for too low wages. Examiners who reject patent load more work on themselves without getting more pay. Examiners are treated by the EPO management as a kind of obstacle to the corporate goal of earning ever more patent revenues. The high-level employees of the EPO owe their jobs to political pressures from within national patent administrations and do not understand the daily work of the office. The EPO has its own jurisdictional arm, consisting of people whose career is controlled by the EPO's managment and its internal climate. The national organs that are supposed to supervise the EPO are all part of the same closed circle, thus guaranteeing the EPO management enjoys feudal powers in a sphere outside of any constitutional legality, and that whatever they decide is propagated to the national administrations and lawcourts.

The International Organization of Supreme Audit Institutions (INTOSAI) is the professional organization of supreme audit institutions (SAI) in countries that belong to the United Nations or its specialized agencies. SAIs play a major role in auditing government accounts and operations and in promoting sound financial management and accountability in their governments. INTOSAI was founded in 1953 and has grown from the original 34 countries to a membership of over 170 SAIs. INTOSAI is a leader in public sector auditor training. Its biennial seminars sponsored jointly with the United Nations provide training for members from developing countries. Begun in 1971 and held in Vienna, the seminars address topics such as auditing development projects, EDP auditing, and applying audit standards; these seminars also contribute to research and methodology development in these areas. The INTOSAI Development Initiative (IDI) was established at the 1986 Sydney Congress to provide region-based training programs with a focus on training-the-trainer. From 1986-1994, IDI conducted 68 courses for over 1500 participants from 150 supreme audit institutions. www.intosai.org

INTOSAI (International Organization of Supreme Audit Institutions)

Organization for Economic Co-operation and Development (OECD)

‡ EUROFINDER

The Mission of EDIG is to be the forum for the co-ordination of European Defence Industry advice and policy recommendations to the WEAG governments, the European Commission and the European Parliament, on all initiatives concerning the European defence technology and industrial base, including the European defence equipment market.
Members
- Wirtschaftskammer Österreich - Fachverband der Eisen- und Metallwarenindustrie Österreichs - Arbeitsgemeinschaft Wehrwirtschaft - Belgian Defence Industry Group (BDIG)
- Confederation of Danish Industries (DI)
- Association of Finnish Defence Industries (AFDI)
- Conseil des Industries de Défense Françaises (CIDEF)
- Bundesverband der Deutschen Industrie (BDI)
- Federation of Greek Industries
- Associazione Industrie per l'Aerospazio, i sistemi e la Difesa (AIAD)
- Nederlandse Industrie inschakeling Defensie-opdrachten (NID)
- Confederation of Norwegian Business and Industry (NHO)
- Núcleo de Indústria de Defesa/Associação Industrial Portuguesa (NID/AIP)
- Asociación Española de Fabricantes de Armamento y Material de Defensa y Seguridad (AFARMADE)
- Turkish Defence Industry Manufacturers Association (SaSaD)
- UK Defence Industries Council DIC

The European Defence Industries Group EDIG

> The Regional Industrial Property Programme (RIPP)

European Patent Office (EPO)
® ce ™ ©

> The EC-ASEAN Patents and Trademarks Programme (ECAP)

EPO Common Software

Working group advocacy
Working group mergers
Working group funding

The Fund-raising Committee is responsible for helping generate financial support for ICN participation by competition authorities burdened with severe resource constraints. The Committee is seeking to obtain support from multinational donor groups, national technical assistance bodies, and not-for-profit institutions such as private foundations.
http://www.internationalcompetitionnetwork.org/

International Competition Network

Trade Directorate

Taxation and Customs Union Directorate

Taxation Directorate

Internal Market Directorate

Competitiveness Directorate

Pascal Lamy
Bilderberg, Trilateral

Frits Bolkestein
Bilderberg, Trilateral

Mario Monti
Bilderberg, Trilateral

member

Committee of the Regions

Over the last years, the role of the regions in Europe has been strengthened and the AER's contribution has been substantial. The following has been achieved:
- the recognition of the regions as the pillars of democracy in Europe and important progress in regionalism and regionalisation on the entire continent;
- the institutionalisation of the participation of the territorial authorities (regions and communes) in the construction of Europe;
- creation of the CLRAE (Congress of Local and Regional Authorities in Europe (CLRAE) (1993), creation of the CoR = Committee of the Regions of the European Union (1994);
- introduction of the principle of subsidiarity and the notion of territorial cohesion in the European Treaty.

Member Regions
250 Member regions from 26 countries

Interregional Organisation Members
- 9 Interregional organisations (geographical)
- Association of European Border Regions (AEBR)
- Working Community of the Adriatic Alps (ALPENADRIA)
- Working Community of the Western Alps (COTRAO)
- Working Community of the Danube countries (ARGE DONAULÄNDER)
- Working Community of the Pyrenees (CTP)
- Working Community of the Alpes (ARGE ALP)
- Jura Working Community (CTJ)
- Working Community Galice - Nord Portugal
- Working Community of the Lower and Middle Adriatic

3 Interregional organisations (sectorial)
- Association of European Regions with Industrial Technology (RETI)
- Association European Wine-Growing Regions (AREV)
- Assembly of European Fruit and Vegetable Growing and Horticultural Regions (AREFLH)

The Assembly of European Regions (AER)

INTOSAI (European Organization of Supreme Audit Institutions)

European Court of Auditors

European Parliament

Strategies of National Co-operation (SNC)

Economic and Social Affairs Directorate

External Relations Directorate

Pedro Solbes Mira
Bilderberg, Trilateral

Chris Patten
Bilderberg, Trilateral

José Maria Gil-Robles Gil-Delgado
President

Member of Opus Dei

European Parliament
Representing 374 million European citizens, the 626 members of the European Parliament are elected by universal suffrage since 1979. They play only a secondary role in legislative matters. The European Parliament has no input in the Common Agricultural Policy, in the Common Foreign and Security Policy, its taxation, cooperation in internal affairs (police) and justice. The real European legislative organ is the Council of Ministers. Fifteen ministers, gathering

European People's Party
European Liberal Democrats
Greens
European Socialists
European United Left - Nordic Green Left
Union for the Europe of the Nations
Europe of Democracies & Diversities

Directors' Committee

Directorates charged with program management

Mr. C. Patten (Commissioner in charge of External Relations), President
Mr. P. Nielson (Commissioner in charge of Development and Humanitarian Aid), Administrator General
Mr. G. Verheugen (Commissioner in charge of Enlargement)
Mr. P. Lamy (Commissioner in charge of Commerce)
Mr. P. Solbes Mira (Commissioner in charge of Economic and Financial Affairs)

ATLAS facilitates and encourages economic co-operation between Europe and Latin America through a network of Chambers of Commerce and Industry. It is managed by Eurochambres.

ATLAS

AUS, which will be up and running in 2002, aims to promote the benefits of using information technologies and tries to bridge the gap of the digital divide.

AUS

AlSon, which was launched in May 2002, aims at the reinforcement of European Union - Latin American co-operation in the area of Higher Education. It covers studies for postgraduates as well as higher training for Latin American professionals/future decision-makers, in institutions or centres in the European Union.

AlSon

TABEX (Stabilization system for agricultural export revenue)

SYSMIN (Special financing for mining products)

In 2001, the EDF Committee devoted 11 204 million to the Franc Zone. Mali represents 37% of the total, with budgetary assistance for the FSRP in particular (11 25 million) and a project for the prevention of desertification (11 14 million). Next come Chad and Cameroon with 11 24 million each (12%) & projects for Chad (relating to 11 projects in microeconomic support/HIPC and 2 projects for Cameroon, one of which is devoted to institutional support for the rural roads sector (23.5 MFI).

European Development Fund (EDF)

EuropeAid Co-operation Office

American Chamber of Commerce

American Chamber of Commerce
The EU Committee represents American business interests towards the institutions of the European Union. Its members include 140 of the largest US multinationals. It coordinates EU affairs for ECACC (European Council of American Chambers of Commerce) which has 16,000 member companies and represents over $23S billion of US investment in Europe. The EU Committee discusses important policies with organizations such as UNICE (Union of Industrial and Employers Confederations of Europe) and the ERT (European Round Table). In the United States, the EU Committee has links with the USICG (United States Industry Coordinating Group).
http://www.eucommittee.be/

behind closed doors, agree upon or reject the proposed directives that are submitted to them by the European Commission, the sole European organ which has the capacity to draft European law. The European Parliament shares budgetary power with the Council, but only insofar as expenses are concerned. It has no power in terms of taxation. It can reject the projected annual budget (of expenditures) that must be submitted to it by the Commission, which simultaneously submits it to the Council. But it only has a voice with respect to non-obligatory expenses (development aid and social programs, for example) which represent only a small part of the budget presented by the Commission. The Parliament has no say on the budgets allotted to policy (the Common Agriculture Policy, for example) or on the major European programs. The Parliament has a budget of 979.9 million euros (in the year 2000). (source: Gérard de Selys, www.transnationale.org)

142

Paul Nielson

Humanitarian Aid Directorate

the major roads of the country in the year [...] in order to support the civil administration and reconstruct the local administrations by new technical expertise. Specialized equipment + documents. In the field of water and sanitation services was launched. This program entails programs and the improvement, in particular who contributes to financing the restoration, acquisition of equipment for municipal enterprises. Operations of the European Commission. [...] Example: In 2000, Albania benefited from [...] devoted to health and education administration in underprivileged regions. The EU also furnishes technical assistance on modern strategies and agricultural technique

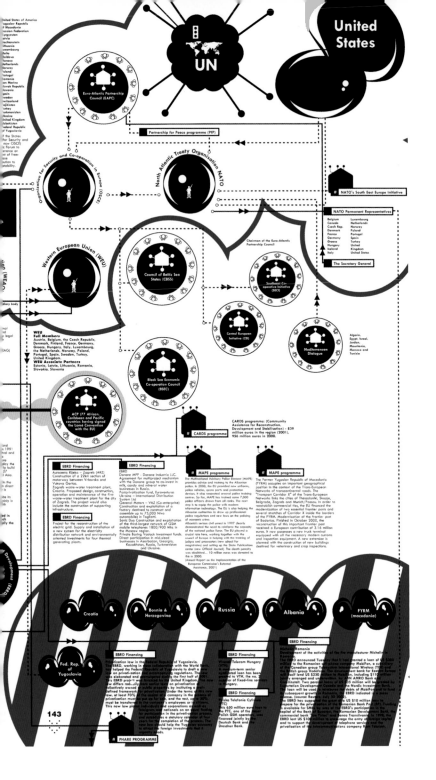

(Issue 25, 2002) 'European Norms of World Production' – a diagrammatical map that featured in the final three spreads of this issue. Designed by Université Tangente.

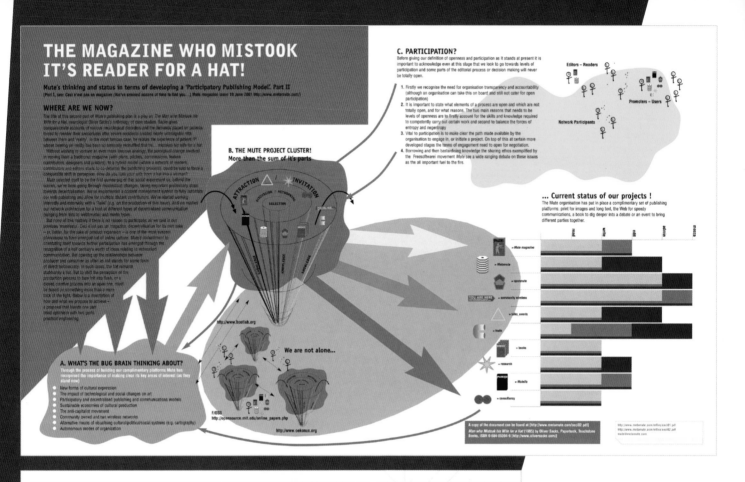

THE MAGAZINE WHO MISTOOK IT'S READER FOR A HAT!

Mute's thinking and status in terms of developing a 'Participatory Publishing Model'. Part II
(Part I, see: Ceci n'est pas un magazine (We've crossed oceans of time to find you...), Mute magazine Issue 19 June 2001 http://www.metamute.com/)

WHERE ARE WE NOW?

The title of this second part of Mute's publishing plan is a play on *The Man who Mistook his Wife for a Hat*, neurologist Oliver Sacks's anthology of case studies. Sacks gives compassionate accounts of various neurological disorders and the demands placed on patients forced to reorder their sensoriums after severe accidents created nearly unimaginable rifts between them and 'reality'. In the most famous case, he relates the experience of patient 'P' whose bearing on reality has been so severely reshuffled that he... mistakes his wife for a hat.

Without wishing to venture an even more pretentious analogy, the perceptual change involved in moving from a traditional magazine (with plans, puzzles, commissions, feature contributors, designers and printers), to a hybrid model (where a network of readers, contributors and editors starts to co-determine the publishing process), could be said to force a comparable shift in perception. How do you fuck your self-image from a hat into a woman?

Mute selected itself to be the first guinea-pig of this social experiment so, behind the scenes, we've been going through incremental changes, taking important preliminary steps towards decentralisation. We've implemented a content management system to fully automate our web publishing and allow for students student contributors. We've started working internally and externally with a 'Twiki' (e.g. on the production of this issue). And we're pushing our network architecture for a host of different types of decentralised communication ranging from links to 'webfora/tas' and media types.

But many of this matters if there is no reason to participate, as we said in our previous 'manifesto', Ceci n'est pas un magazine, decentralisation for its own sake – or, better, for the sake of product expansion – is one of the most suspect phenomena to have emerged out of online culture. Mute's commitment to orientating itself towards further participation has emerged through the recognition of a half century's worth of ideas relating to networked communication. But opening up the relationships between producer and consumer is often as not stands for some form of direct technocracy. In such cases, the flat remains stubbornly a hat. But to shift the perception of the production process to turn limp into flesh, or a closed, coercive process into an open one, must be based on something extra than a mere trick of the light. Below is a description of how and what we propose to achieve – a proposal that blends one part titled optimism with two parts practical engineering.

A. WHAT'S THE BUG BRAIN THINKING ABOUT?

Through the process of building our complimentary platforms Mute has recognised the importance of making clear its key areas of interest (as they stand now)

- New forms of cultural expression
- The impact of technological and social changes on art
- Participatory and decentralised publishing and communications models
- Sustainable economies of cultural production
- The anti-capitalist movement
- Community owned and run wireless networks
- Alternative means of visualising cultural/political/social systems (e.g. cartography)
- Autonomous modes of organization

B. THE MUTE PROJECT CLUSTER!
More than the sum of it's parts

ATTRACTION / INVITATION
DISCUSSION / NETWORKING
SELECTION

http://www.bootlab.org

We are not alone...

F/OSS
http://opensource.mit.edu/online_papers.php

http://www.oekonux.org

C. PARTICIPATION?

Before giving our definition of openness and participation as it stands at present it is important to acknowledge even at this stage that we look to go towards levels of participation and some parts of the editorial process or decision making will never be totally open.

1. Firstly we recognise the need for organisation transparency and accountability (although an organisation can take this on board and still not cater for open participation)
2. It is important to state what elements of a process are open and which are not totally open, and for what reasons. The two main reasons that needs to be levels of openness are to firstly account for the skills and knowledge required to competently carry out certain work and second to balance the forces of entropy and negentropy
3. Vital to participation is to make clear the path made available by the organisation to engage in, or initiate a project. On top of this at certain more developed stages the terms of engagement need to open for negotiation.
4. Borrowing and then bastardising knowledge the sharing ethos exemplified by the Freesoftware! movement Mute see a wide ranging debate on these issues as the all important fuel to the fire.

Editors – Readers
Promoters – Users
Network Participants

... Current status of our projects !

The Mute organisation has put in place a complimentary set of publishing platforms: print for images and long text, the Web for speedy communications, a book to dig deeper into a debate or an event to bring different parties together.

- Mute magazine
- Metamute
- openmute
- permanently wireless
- talks, events
- trade
- books
- research
- Mutella
- consultancy

A copy of the document can be found at [http://www.metamute.com/ceci02.pdf]
Man who Mistook his Wife for a Hat (1985) by Oliver Sacks, Paperback, Touchstone Books, ISBN 0-684-85394-9 [http://www.oliversacks.com]

http://www.metamute.com/reffiles/ceci01.pdf
http://www.metamute.com/reffiles/ceci02.pdf
metatime/amute.com

OPEN SOURCE SOFTWARE PRODUCTION: FACT & FICTION

The production and development of open source software (OSS) has received substantial attention recently, following the success of projects like Apache, Perl and Linux. But what are the real dynamics of this 'new' mode of production? The National Institute for Space Research surveyed the production landscape of GIS OSS looking for answers. **Gilberto Câmara**, its director of Earth Observation, shares the findings and argues for a new conceptual paradigm

Above: (Issue 25, 2002) There are certain things for which visualisation is essential. At Mute, it was explaining to readers how the many processes of organisational change, embarked upon since publishing its 'Ceci n'est pas un magazine' in 2001, were actually panning out. The resulting diagram illustrates this developing landscape with a slightly unconventional use of icons and figurative elements.

Left: (Issue 27, 2004) An ephemeral diagram floats in the sky capturing the complex structures out of which Open Source Software is held to emerge.

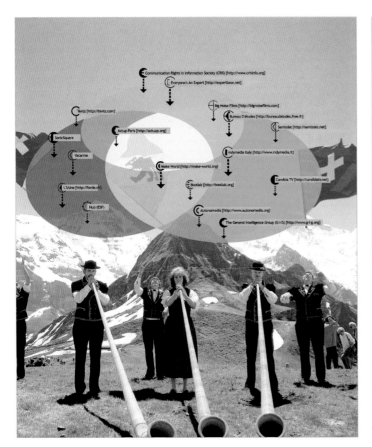

(Issue 26, 2003) In this article, Damian Jaques and Simon Worthington worked with Sneha Solanki, creator of the overlay diagram (top right), to illustrate some of the many issues associated with the World Summit on the Information Society (WSIS) taking place in Geneva that year. Alan Toner's article enjoyed widespread circulation and influence.

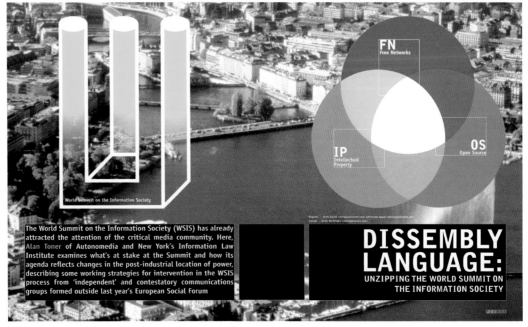

The World Summit on the Information Society (WSIS) has already attracted the attention of the critical media community. Here, Alan Toner of Autonomedia and New York's Information Law Institute examines what's at stake at the Summit and how its agenda reflects changes in the post-industrial location of power, describing some working strategies for intervention in the WSIS process from 'independent' and contestatory communications groups formed outside last year's European Social Forum

DISSEMBLY LANGUAGE:
UNZIPPING THE WORLD SUMMIT ON THE INFORMATION SOCIETY

I DON'T WANT TO B
AND I DON'T WANT
F**KING MUSIC

YOUR FRIEND
O HEAR YOUR

HYBRID: WEB AND PRINT

••129••

YOUR FRIEND
O HEAR YOUR

HYBRID: WEB AND PRINT

HYBRID: WEB AND PRINT
THE BEST OF BOTH WORLDS?

A meeting was held in November 2004 during which the full editorial group considered all the publishing models on the table. Each of these involved an upgrade of Metamute.com, whose software was out of date and whose content urgently needed transferring. The new site, Metamute.org, was to finally embrace the by now widespread 'community' model of publishing in which readers could be writers and consequently define and direct the content. Extensive software evaluation had already been commissioned from Interactors, a company founded by old-time *Mute* advisor Quim Gil, and Drupal was the platform of choice. This tool possessed the modules, flexibility, ease of use and capacity *Mute* required to build its readership base and was being taken up by many comparable organisations. Editors could easily do their own content management with it and it integrated fully the sales, web-banner and other arcane administration tasks that threaten to make small publishers 'go entropic', as *Mute* staff used to say. It was a free software (FLOSS) platform, which was also an important factor.

There was scepticism from the off regarding any flatly egalitarian model of authorship, which editors deemed a disingenuous means of acquiring free labour and, moreover, a sure way of muddling editorial remit as publications reached out for the chimera of democracy. Instead, people favoured a two-stream model in which *Mute*'s reputation for original commissioning would be held high and reader-discussions would inform future direction, but never determine it. Anecdotal evidence from close associates of the magazine – especially those who had a familiarity with the so-called attention economy of the Internet – told editors there was a real threat of throwing the baby out with the bathwater if it took any other course.

Most of 2005 was taken up in creating the new website. It was only a small and seemingly incidental experiment with the new technology of Print On Demand (POD) that forced this printing method into view as a possible solution to the Web/Print dichotomy (earlier proposals had suggested printing newspapers to distribute at special events but they weren't persuasive). PODs were cheap, could be produced on

Pauline van Mourik Broekman (co-publisher, issues 0–; editorial board, issues 0–); Simon Worthington (co-publisher, issues 0–); editorial board, issues 0–; art direction, issues 0–2; redesign, issue 3; technology design, Metamute); Benedict Seymour (editor, issue 0; deputy editor, issues 1–; editorial board, issues 0–); Anthony Iles (deputy editor, issue 0; assistant editor, issues 1–; editorial board, issues 0–); Josephine Berry Slater (editor, issues 1–; editorial board, issues 0–); Demetra Kotouza (editorial assistance and subscriptions, issue 0; editorial board, issues 0–); JJ King (editorial board, issues 0–3), Matthew Hyland, Hari Kunzru, Laura Sullivan (editorial board, issues 0–); Damian Jaques (template, issue 0–2; redesign, issue 3); Laura Oldenbourg (design production, issues 0–4; redesign issue 3; interactive and graphic design, Metamute); Raquel Perez de Eulate (interactive and graphic design, Metamute); Darron Broad (technology, Mute; design coding, Metamute); Interactors.coop (initial Drupal consultation and installation, Metamute); Jose A. Reyero (e-commerce modification for multi-currency; multi-region payment on account tool); Jörg Baach and Stephan Karpischek

(web to POD-PDF, Metamute; contextual and multi-dimensional menu, Metamute); Finn Smith (intern, issues 1–3); Zara Hughes (intern, issue 1); Esiri Erheriene-Essi (intern, issues 2–6); Samantha Stern-Leapheart (intern, issue 2); Helene Dams (intern, issues 4–5); Sarah Bailey (advertising & marketing, issues 5–6); Sam Gul (Administration, issue 5–); Alex Czincel (design, issue 5); Katie Allan (intern, issue 5); Eva van Ingen (intern, issue 6).

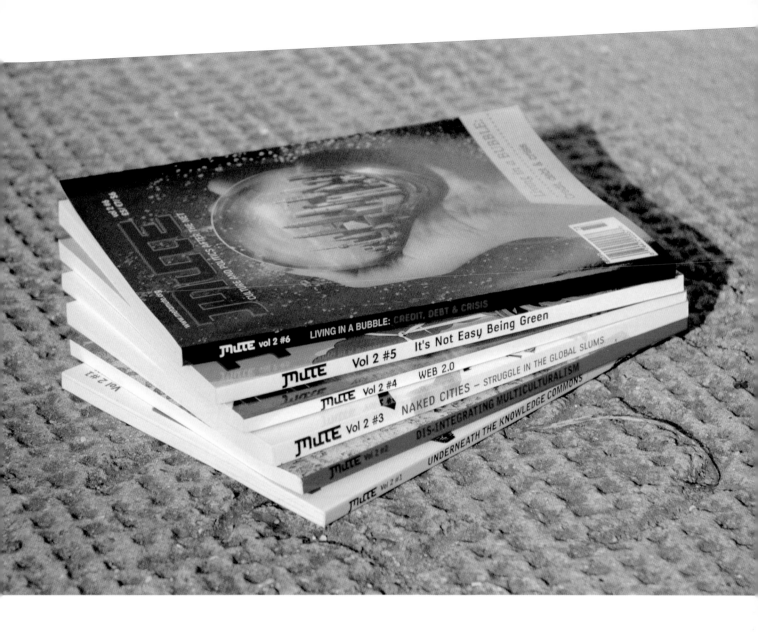

demand, and thus allowed for more gradual and calculated expenditure. Restrictions on the interior, which could be only black and white, seemed to force a re-prioritisation of content. In spite of itself, its unsuccessful forays into the formats of the lifestyle press had proved that this was 'always already' *Mute*'s main interest. Basic black and white. Newsprint-like paper. 'Specialist' content and irreverent graphics. A DIY distribution portal in development. The magazine had gone full circle! To mark the occasion, new issues came out under the heading Volume 2.

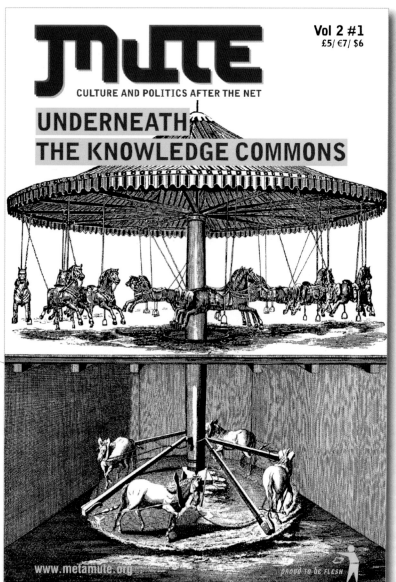

Mute

Vol 2 #1
£5/ €7/ $6

CULTURE AND POLITICS AFTER THE NET

UNDERNEATH THE KNOWLEDGE COMMONS

www.metamute.org

miniMute #0

PRECARIOUS READER

CALL

www.metamute.com

Mute

CULTURE AND POLITICS AFTER THE NET

DIS-INTEGRATING MULTICULTURALISM

www.metamute.org

Above right: (Vol. 2, Issue 0, 2005) Mute's Precarious Reader, *building on content from issue 29, was an immediate success. In design terms, the POD format was low-key but its cheapness and flexibility liberated the production process, thus allowing the website to finally achieve parity with the magazine. The cover, 'Maternita', is a Chainworkers poster by Angela Rindone.*

(Vol. 2, Issue 1, 2005) Per Wizen's image perfectly captured the duality of the knowledge commons. His black-and-white image also threw the logo and its reference to CMYK printing processes into relief.

Right: (Vol. 2, Issue 2, 2006) Fractures in multiculturalism found visual form in the crumbling facade of a GLC-era community mural. Another testament to Mute going full circle – the themed issue returns, now using succinct, explanatory headlines and back-cover texts.

Right: (Vol. 2, Issue 3, 2006) Guy Debord's iconic Naked Cities was repurposed to express the politics of the planetary growth of slums.

Far right, clockwise: (Vol. 2, Issues 4, 6 and 5, 2006–07) Dogs, frogs and blobs!? The allegorical tendencies of the first POD covers became increasingly baroque, combining ad-busting (issue 6 – the credit, debt & crisis issue was based on a concurrent Financial Times campaign), original artists' commissions (issue 5 – Nils Norman's created a fantasia on the cult science fiction film Silent Running for the Climate Change issue) and Dada 2.0 (for issue 4 on social networking).

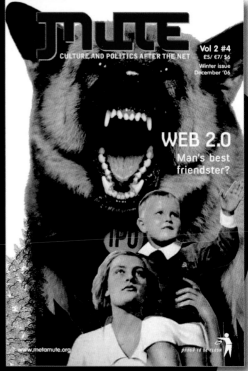

covers

abcdefghijklmnopqrstuvwxyz
ABCDEFGHIJKLMNOPQRSTUVWXYZ
0123456789

abcdefghijklmnopqrstuvwxyz
ABCDEFGHIJKLMNOPQRSTUVWXYZ
0123456789

abcdefghijklmnopqrstuvwxyz
ABCDEFGHIJKLMNOPQRSTUVWXYZ
0123456789

abcdefghijklmnopqrstuvwxyz
ABCDEFGHIJKLMNOPQRSTUVWXYZ
0123456789
abcdefghijklmnopqrstuvwxyz
ABCDEFGHIJKLMNOPQRSTUVWXYZ
0123456789

abcdefghijklmnopqrstuvwxyz
ABCDEFGHIJKLMNOPQRSTUVWXYZ
0123456789

Above from top:
Bahamas Light and Bold.
Milibus Regular, Typodermic. *Designed by Ray Larabie, 2006.*
Adobe Caslon Pro, Adobe. *Designed by William Caslon (c. 1725), updated by Carol Twombly.*
VAG Rounded, *Adobe/Linotype. Designed by Volkswagen AG, 1979.*

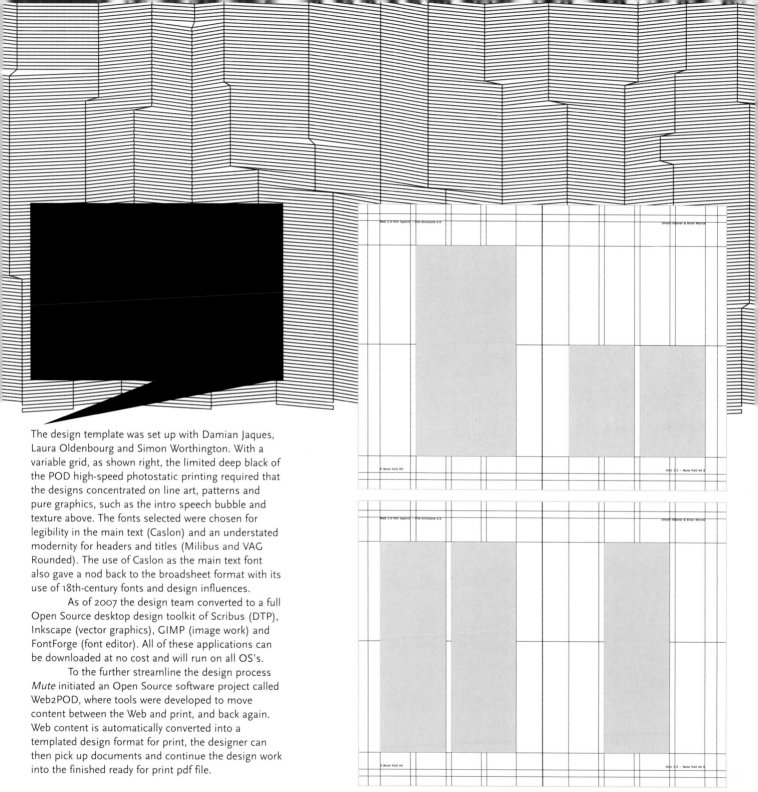

The design template was set up with Damian Jaques, Laura Oldenbourg and Simon Worthington. With a variable grid, as shown right, the limited deep black of the POD high-speed photostatic printing required that the designs concentrated on line art, patterns and pure graphics, such as the intro speech bubble and texture above. The fonts selected were chosen for legibility in the main text (Caslon) and an understated modernity for headers and titles (Milibus and VAG Rounded). The use of Caslon as the main text font also gave a nod back to the broadsheet format with its use of 18th-century fonts and design influences.

As of 2007 the design team converted to a full Open Source desktop design toolkit of Scribus (DTP), Inkscape (vector graphics), GIMP (image work) and FontForge (font editor). All of these applications can be downloaded at no cost and will run on all OS's.

To the further streamline the design process *Mute* initiated an Open Source software project called Web2POD, where tools were developed to move content between the Web and print, and back again. Web content is automatically converted into a templated design format for print, the designer can then pick up documents and continue the design work into the finished ready for print pdf file.

Above: (Vol. 2, Issue 4, 2006) Belgian-Dutch art group Constant produced this illustration taking its cue from the icons and emoticons used by users of irc and instant chat networks. The speech bubbles are filled with handwritten comments, conditions of use and other related internet chat text.

Top right: (Vol. 2, Issue 4, 2006) The user icons from the main illustration were simplified for use within the issue articles and take on a Cluedo-like aesthetic comically re-enforced by cutting and toppling them over.

Bottom right and following pages: (Vol. 2, Issue 5, 2007) Nils Norman's artwork in the Climate Change issue used the editors' central hook – Kermit the Frog's 'It's Not Easy Being Green'. Having illustrations of this quality enabled the POD 'book' format to come into its own and they were used liberally throughout the magazine.

THE SOCIAL SOFTWAR
by Angela Mitropoulos

Do blogs and social network-based sites offer the prospect of a democratic sociability without borders or wars? Should unpaid producers of content struggle for fair compensation? Or does the very sense of ownership, justice and right founded on labour need to be shaken up?
Angela Mitropoulos takes a critical look at the dissident pragmatism of the startup and the 'alternative' economies of the digital commons

'B eing social' is often understood as the opposite of 'being at war'. 'Social software', even if implicitly, retains this distinction and its premises. Let's begin, then, with the topic of war – and technology. As Clausewitz once famously complained, 'War is regarded as nothing but the continuation of politics by other means.'[9] That is, war is conceived as an instrument – to be defended, opposed, or explained according to ends that are external to it, usually political, but also economic, civilisational, humanitarian, theological and so on. In this sense, war is often reckoned as technology, which is to say, with all the associated connotations according to which technology is considered an instrument. That is, as Aristotle defined technics: a man-made thing, distinguished from *manu* by not having the origin of motion or rest within it.

In another but related sense, the question of war, no less than that of technology, is frequently posed in such a way that the nexus between politics, life and technics is denied – often for the purposes of clinching either a pessimistic or optimistic stance – or credited with an infinite sway. In this way, the question of technology too often becomes, and perhaps parallels, the theologization of politics (and history) that has repeatedly animated both conservative and radical critiques of capitalism. Whether assigned with almighty powers from which, according to Heideggerian humanism, 'only a God can save us', or serving as placeholder of eschatological hopes for the reclamation of a divine-like mastery over the world, the question of technology presents itself in the answer to a political question that has – to modify Althusser's remark on the structure of ideology – not been overtly posed. In this respect, Arthur Kroker is right to ask whether 'technology is the name given today to the ancient language of metaphysics.'[3] Foucault's similarly famous reply to Clausewitz – 'that politics is war continued by other means' – suggests the intersection of technics, politics and life as the circumstance of war. Differently put, that war is not outside society, but a condition of it, as an often diffuse and permanent war that, also, marks the perimeter of any given society.[2]

In discussions of the internet, the association between the temporality of this seemingly permanent global war and the entanglements of politics, technics and life has barely begun to

It did not take long, for instance, for the political valorisations of, say, immaterial workers as the new revolutionary subject to shift into an explicitly hipster-entrepreneurial gear, notable in Richard Florida's talk of the 'creative class'. Alongside these revivals of Lockean notions of property, labour and right on the net, there are increasing and predictable suggestions to 'switch off'. Displacing questions about work into fears of technology as an 'inhuman force', the tendency here is toward moral panics and the proliferation of surveillance and control (mostly of children), and often through software (such as i-Kids mobile phones with a parent-prescribed set of numbers that can be received or dialled and which can act as a leash to Government-subsidised distributions of 'net nanny').

Therefore, it may be better to ask what technology's displacement and dispersion of work might mean for reformulating the very sense of work itself, against concepts of work as appropriation of the world, or work of one's self (self-positing and self-possession), or work as the rejection of what is deemed foreign, including what is regarded (as Werner Hamacher argues) as 'foreign to work.[3]' That is, all along the various registers of not-work, not proper work, inappropriate and inappropriable, unemployed, populations deemed superfluous, propertyless, without value – 'what in work does not correspond to an ergological figure … and does not come back to itself.' Undoubtedly, there are

aspects of net-work that are significant to this respect: from the 'wasting of time' at work in the form of 'networking', to the risk that 'exposure' on the net might overflow, depose or even expose its (self-)marketing aspects.

And so, the political question which I alluded to earlier – the question that is not posed by presenting it as a *question of technology* – is not that of reinstating the nobility of politics – or humanity – over technics, along the lines of, say, Andrew Feenberg's arguments for democratic control over technology, or Graham Longford's calls for a 'democratic reinvention of cyberspace.'[4] Nor, along similar lines, is it a matter of suggesting that the invocation of the YouTube community' in the announcement of YouTube's sale to Google was the cynical deployment of sociality for commercial appropriation, as John McMurtria has argued.[5] Contrary to McMurtria and others, neither democracy nor community nor society can exist without recourse to borders and, in each of these cases, the mythologised semblance (and therefore denial) of those borders. Particularly with democracy, juridico-commercial subjectivity is conceived as the very idea of political subjectivity, right down into the confluences between equality and abstract labour and the structural rifts they are constituted through: that is, inequality and concrete indifference.

Indeed, insofar as blogs and other 'user-generated' sites assume the model of democracy or community, the question of exclusion (of what/who is included and

dissident pragmatism is the very form of the startup

what/who is not), between depoliticised. That is, less a question of differences than numerical calculations. Thus, the purportedly open character of blogs and social networks takes its cue from money as the universal equivalent, assuming the same structure of concrete indifference (and exclusion). It is no coincidence that one 'how to blog successfully' site recommends regarding blogs as pieces of 'real estate' – the model of landed property is insistent. Even if such property is digital, it is made intimate, as the technics of self – and through the conduit of a 'labour theory of right'. In this way, relation, and non-relation, are no longer questions, an experiment in

politics, but a market to be expanded.

The specificity of the political, then, is difference – but it is also the *cut* of difference that can, perhaps, cut both ways. But it will have to be politics conceived otherwise. Neither the difference of competition which puts difference *to work*. Nor the difference of a dialectics which sorts out differences. Nor, for that matter the difference as the work of self (as in Schmitt's existential theology of friend and enemy, toiling on the vocabularies and borders of identity and self-determination). On the contrary, it will have to be difference and relation posed *as a question*, each time. To be sure, the argument which follows cannot be

CLIMATE CHANGE CO$_2$LONIALISM

Tim Forsyth and Zoe Young

In their tango with grassroots green activists, inter-governmental policy makers are taking the lead. Tim Forsyth and Zoe Young analyse the 'new green order' and the carbon offset colonialism that accompanies it

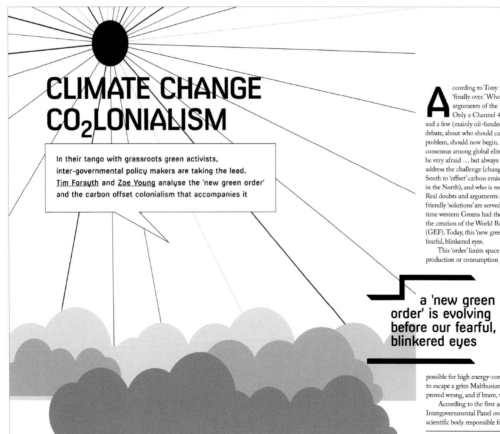

a 'new green order' is evolving before our fearful, blinkered eyes

According to Tony Blair, the climate change debate is 'finally over.' Who can dismiss the economic arguments of the *Stern Report on Climate Change*? Only a Channel 4 controversialist or two, perhaps, and a few (mainly oil-funded) scientists. The bigger policy debate, about who should carry the burden of tackling the problem, should now begin. Instead, however, there seems to be consensus among global elites about where to start (be afraid, be very afraid … but always trust the government), how to address the challenge (change development patterns in the South to 'offset' carbon emissions produced by business as usual in the North), and who is responsible (mainly you and me). Real doubts and arguments are suppressed while market-friendly 'solutions' are served up on a nice, glossy plate. Last time western Greens had the ear of their governments it lead to the creation of the World Bank's Global Environment Facility (GEF). Today, this 'new green order' is still evolving before our fearful, blinkered eyes.

This 'order' limits space for collective rethinking of energy, production or consumption policies. There is no room to challenge the political assumptions that inform them nor the pattern of investment in public energy infrastructure. Mainstream 'climate' discourse focuses instead on marginal interventions such as switching to more efficient light bulbs and expanding pine plantations. For as long as the 'logic' of capitalist economic expansion remains unchallenged, it seems hardly possible for high energy-consuming societies to adapt in time to escape a grim Malthusian fate. But Malthus wanted to be proved wrong, and if brave, we still could be.

According to the first assessment in 1990 by the Intergovernmental Panel on Climate Change (IPCC), the scientific body responsible for assessing recent research into

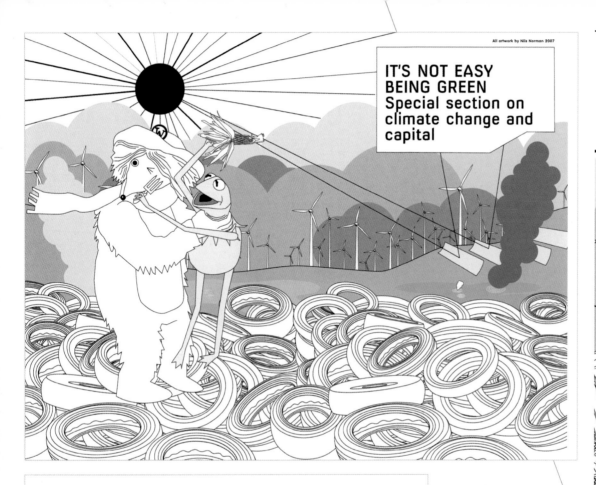

All artwork by Nils Norman 2007

IT'S NOT EASY BEING GREEN
Special section on climate change and capital

APOCALYPSE AND/OR BUSINESS AS USUAL? THE ENERGY DEBATE AFTER THE 2004 US PRESIDENTIAL ELECTIONS

Since 2004 the rhetoric of Bush's republican party has turned curiously green, integrating climate change as a legitimation for neoliberal imperialism. At the same time the unintended consequence of America's unsuccessful adventures has been to enrich an 'anti-neoliberal' class of oil rentiers in Africa, Latin America and Asia. George Caffentzis plots the changes in the US energy policy as it turns from eco-naysayer to ecowarrior

illustration

The 2004 Presidential Election was in part a referendum on energy policy in the US. The Bush campaign expressed scepticism about both the Global Warming and Peak Oil hypotheses and claimed that the unleashing of the free market (including the lifting of some environmental restrictions) is the proper path for dealing with the energy problems of the US and the planet. In other words, there are no problems concerning energy that a dose of neoliberal privatisation and globalisation can't cure. The Bush 'Deal' with the US working class was that if workers supported his policies (including financing and staffing the required imperial military), the bulk of the costs of the new energy regime will be borne by the proletarians in the oil producing countries of Africa, Latin America and Asia. An important corollary to the 'Deal' was that there would be no need for a drastic wage decrease (caused by high oil prices) in the US.

g for Life

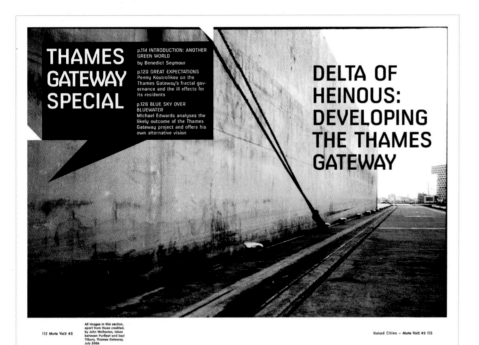

Left: (Vol. 2, Issue 3, 2006) The brutal urban photography is exaggerated by the POD printing technology. Angled 'nicks' from the margin make visual references back to the use of pseudo 3D devices prevalent in pre-POD issues.

Left bottom: (Vol. 2, Issue 3, 2006) Because of the basic requirements of the printing process full black was used as shown here with a patterned background and what seem to be inaccurately cut black paper box shapes.

Right: (1998) One of the earliest surviving Mute *webpages*, this ascii-converted image of a tuber toyed with the popular metaphor of the rhizome and proudly displayed allegiance to a lo-tech web design creed. It was designed by Micz Flor and linked to content via minuscule x-es shooting off the main root.

spreads

[x] special subscription offer

[x] mute on-line

[x] mail

[x] office

[x] projects

[x] subscribe

mutate

web

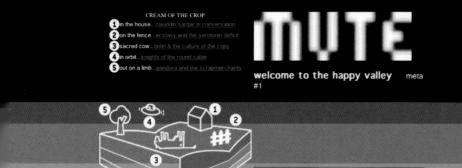

Left: (2000) The cartoon aesthetic of the Jamie King-edited 'meta' Mute took things up where the first multi-page website, designed by Tina Spear, had left off. This meant spatial illusions using the capabilities inherent in html (rather than 3D) and generally drawing attention to the Web as a hypertext system. A good structure was put in place – combining Assembler (stand-alone pieces; interviews), The Modem Review (miscellaneous reviews) and Mute-online (a simple archive) – but the site proved too ambitious to maintain with no real budget.

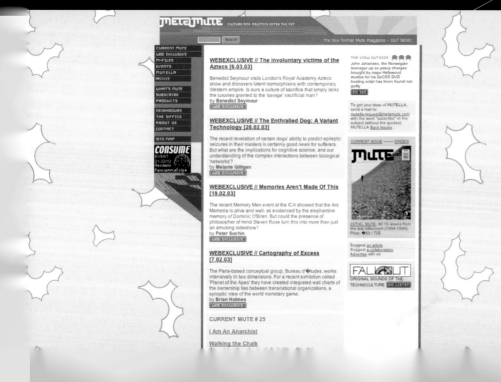

Left: (2000) Mute's first database-driven website was launched in 2001 and designed by AVCO's Tina Spear. It carried over old visual motifs such as cartoon-style graphics, a play on space and 'modernist' foregrounding of the medium's toolkit (adopting traditional blue colour for the hyperlinks, for example). The CMS, Campsite, was a FLOSS tool from Czech NGO Camp where Micz Flor was working. Thanks to new Web editor Lina Dzuverovic-Russell's efforts, Metamute.com experienced its first sustained attempt to operate a Web-exclusive content strand.

web

Sisters of Mute | Network Distribution Services - OpenMute - OpenMute development & support - Linkme2

MUTE BETA
CULTURE AND POLITICS AFTER THE NET

the thing is... online magazine

Search

Content Submit Content Filter Network Shop Membership Advertise Site Info

Home Page Magazine Articles News & Analysis Calendar Discussion Images Public Library POD Park Projects

donate

sitemap help

Living in a BUBBLE:
Credit, debt & crisis

Current Issue >>
Living in a Bubble: Credit, Debt and Crisis

Mute

Readership survey

This year we are launching an annual survey to make sure that we know what you think about Mute. We've tried to design the survey to be as short as possible and you only need to complete the sections you want to feedback on. Read more

Submit Content

You can post articles, news and much more to this site.

Submit Content here

Latest News

- A Note on Post-March Militancy in Copenhagen
- Bizarre Politics untold news in the global economic arena
- The fight for equal pay for women: Britain's 'Guardian' defends union's dirty deals
- Three Talks by Loren Goldner

Three Talks by Loren Goldner Editorial content | News & Analysis
Submitted by mute on Monday, 31 December, 2007 - 15:46

By **Mute Events**

THREE TALKS BY LOREN GOLDNER
London, Jan 19th, 21st and 22nd, 2008

New York-based Marxist Loren Goldner is giving a series of talks in London this month, hosted by Mute magazine [http://metamute.org]

subject: Credit Debt Events Fictitious Capital Finance & Trade Financial Crisis History Literature

1 comment | view pdf | read more | 475 reads

Mute Vol 2 #6 - Living in a Bubble: Credit, debt and crisis Editorial content | Vol II
Submitted by mute on Monday, 3 September, 2007 - 09:36

Panic in the credit markets! Sub-prime crash! The new issue of *Mute, Living in a Bubble: Credit, Debt and Crisis* looks at the social costs of an era of debt-backed boom now showing signs of busting.

Featuring articles by Dave Beech, Committee for Radical Diplomacy, Loren Goldner, James Heartfield, Suhail Malik, Stanley Morgan, Brett Neilson, Rob Ray, Mark Saunders, Jeff Strahl. Poems by Andrea Brady, William Fuller, Howard Slater, Keston Sutherland, John Wilkinson.

subject: Art Credit Debt Fictitious Capital Financial Crisis Marxist Poetry

view pdf | 2 comments | read more | 8770 reads

Organising in the Dark: Interviews about Migrants' Struggles Editorial content | Articles
Submitted by mute on Monday, 7 January, 2008 - 17:09

By **Jaya Klara Brekke**

Jaya Klara Brekke talks to four UK based groups working to improve conditions for migrants and asks 'how does one organise in the dark?'

subject: Activism Border Activism Globalisation Immigration Labour Struggles

login or register | view pdf | read more | 198 reads

Soft hands from baby bonds | News & Analysis

PROUD TO BE FLESH

ACKNOWLEDGEMENTS

By funding a series of developmental changes and then, ultimately, the magazine itself, Arts Council England have granted Mute the kind of stability that allows for formal experimentation as described in this book. We'd like to thank ACE for its continued support.

To gather the material for *Mute Magazine Graphic Design*, extensive data retrieval was done on a rather patchy archive – thanks to interns Lars Dittmer and Stefano De Cicco for their heroic mining efforts, and to Happy Retouching for allowing us the use of their studio to scan the Mute broadsheet. Finally, Mute would like to thank all its past and present contributors, editors and designers, together with the readers for whom the magazine is ultimately made.